EVERYTHING YOU EVER WANTED TO KNOW ABOUT
art materials

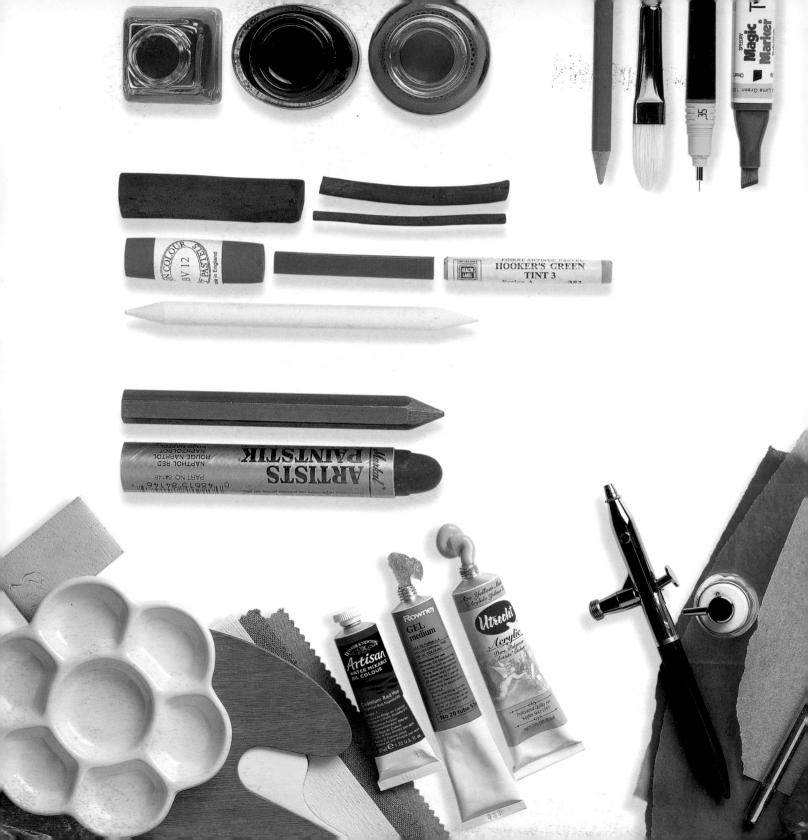

EVERYTHING YOU EVER WANTED TO KNOW ABOUT
art materials

Ian Sidaway

NORTH LIGHT BOOKS
Cincinnati, Ohio

A QUARTO BOOK

First published in North America
in 2000 by North Light Books,
an imprint of F&W Publications, Inc.,
1507 Dana Avenue, Cincinnati, OH 45207
1-800/289-0963

ISBN 1-58180-082-7

QUAR.AGTM

Conceived, designed and produced by
Quarto Publishing plc
The Old Brewery
6 Blundell Street
London N7 9BH

Editor Steffanie Diamond Brown
Senior Art Editor Penny Cobb
Copy Editor Ian Kearey
Designer Sheila Volpe
Photographer Paul Forrester
Proofreader Neil Cole
Indexer Dorothy Frame

Art Director Moira Clinch
Publisher Piers Spence

Manufactured by Regent Publishing Services Ltd,
Hong Kong.
Printed by Leefung-Asco Printers, China.

Contents

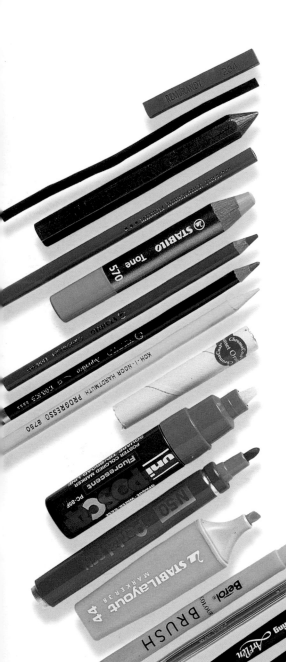

INTRODUCTION

The choice and diversity of materials available to the artist has never been greater. Art store shelves are crammed to collapsing point with a wealth of products, which, as manufacturers cater to demand, increase almost by the day. Art materials are seductive: lift the box lid of a large set of new pastels, or open a shiny, black, enamel box containing rows of moist watercolor pans, or peel the protective wrapping from a prepared linen canvas, and you will see what I mean. This widespread availability and vast range of choice is, in the context of the history of art materials, a relatively new thing.

A workshop environment

From the Middle Ages through to the 17th century, artists went about their trade in a workshop environment. Apprentices who aspired to becoming artists in their own right spent years learning craft, technique, and method, and a substantial part of their training involved the making and preparation of the tools and materials of their trade.

Preparation of materials

Artists prepared their materials from limited resources out of necessity rather than desire, but in doing so they came to know the full potential and possibilities of their materials intimately. It should be noted that the reason so much fine work has survived for such a long time is not just due to superior materials; good craft and workshop practice deserves much of the credit as well.

A trade develops

Gradually, materials began to be made outside of the workshop, and a trade came to develop: that of artists' colorman. In time the trade grew, with art materials becoming standardized and manufactured in bulk. Artists gradually forgot the technical knowledge so carefully handed down, and instead placed their trust in the art materials trade. Two factors resulted from this shift in the mode of art materials creation: the quality of painting in general was seen as having declined (the artists placed the blame on inferior materials), which in turn prompted tighter controls on the trade. As well, amateur artists began to appear, due in part to the ease with which art and craft materials could be obtained.

The availability of art materials today

Today, the manufacture of art materials is a huge concern. Winsor & Newton, one of the world's largest art material manufacturers, carries over 6,500 different lines, made from over 26,000 components, sourced from all around the world; the figures for other major manufacturers like Daler-Rowney, Talens, Sennelier, and Grumbacher are equally impressive. For consumers, be they uninitiated amateurs, students, or even professionals, the sheer amount of choice can be bewildering. However, many of the materials available, while often desirable, are not always entirely necessary. Art materials are expensive, and buying superfluous materials does not make good financial sense. The aim of this book is to help all levels of artists, from amateurs to professionals, discern from amongst the vast pool of materials available which ones are necessary for the art they seek to create—and which ones are not.

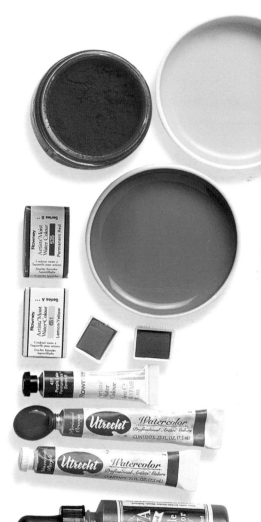

An objective assessment

Generally speaking, the art materials available today from major manufacturers and distributors—and indeed those from many lesser-known manufacturers as well—are of an extremely high quality. This book makes no judgement or opinion as to which materials are good and which ones are bad. What it does do, however, is attempt to objectively assess the merits and intrinsic characteristics and qualities of the materials available in today's marketplace. The book also provides opinions on which materials may be considered necessary, and which ones it is possible to do without.

Getting to know your materials

Expectations are high today in all walks of life, including that of the artist; quality results are expected and demanded quickly, as much by ourselves as by others. We no longer seem to have the time to fail, but failure in most spheres of art creation is inevitable. Ambition, inspiration, vision, and aspiration are seldom the problem; we often stumble when it comes to craft and technical ability. Given some time and effort, however, both types of skills can be learned and acquired. Many people find watercolor difficult to use, for example, but the solution is often as simple as changing the type of paper, or adding a little ox-gall solution to the water. In order to become familiar with art materials, you must not only explore their potential and capabilities—you must also be aware of their limitations. The only sure way to discover the true nature of art materials is through use and experimentation. A thorough knowledge of your tools and materials is only part of the story, of course, and will not in itself turn you into a great, or even a successful artist; it will, however, go a long way to helping you become a more proficient one.

How to use this book

A general overview of each type of medium is provided.

The characteristics of the different formats in which each medium can be found are described, and their relative advantages, disadvantages, and costs are assessed.

Where applicable to the medium, a basic palette of colors is suggested, from which other colors can be mixed if necessary.

The core techniques for each medium are explained and illustrated using photographs. Step-by-step directions for many techniques are also included.

Frequently asked questions regarding the use and application of each medium are answered.

Some of the newest and most exciting product innovations in today's marketplace are detailed.

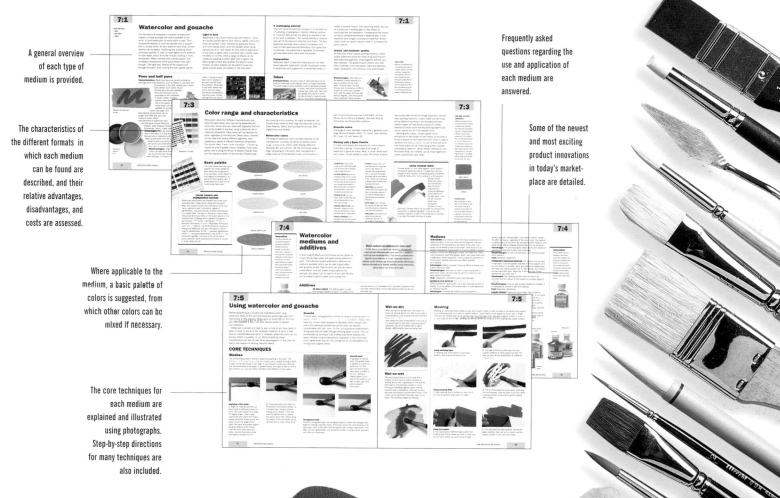

THESE TWO PAGES
- CHARCOAL STICKS
- COMPRESSED CHARCOAL STICKS
- WOODEN CHARCOAL PENCILS
- WOODEN PENCILS
- MECHANICAL PENCILS

MAKING OIL CHARCOAL

To make oil charcoal, simply soak a stick of charcoal in linseed oil for a few hours—or better, overnight. Remove the charcoal, then wipe away any excess oil. Work as usual, and you will notice that the charcoal line will not smudge or need fixing.

SHARPENING CHARCOAL

Thicker charcoal sticks can be sharpened to a point with a sharp knife, a glasspaper block, or fine- or medium- grit sandpaper. Sharpen compressed charcoal with a knife or glasspaper. Wooden charcoal pencils are best sharpened using a sharp knife. Some charcoal pencils are wrapped in paper that is removed by pulling on a thread of string on the side of the charcoal strip.

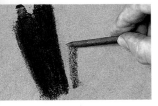

Drawing media

Drawing is one of the very first skills we acquire as a child. It is intuitive and instinctive, yet it is one of the skills we tend subconsciously to neglect or forget as an adult. Drawing plays a fundamental role in the visual artist's repertoire of skills. It is the simplest and most direct way the artist has of conveying a thought, idea, emotion, or vision in visual terms; it is also the basis or foundation upon which all art is based, and as such, should be practiced constantly, at every opportunity.

A drawing is made by moving a mark-making tool or implement over a receptive surface, so that a trace of that tool is left. Drawings can be made with any mark-making implement—tracing designs in sand on a beach with a stick, or rubbing away frost or condensation from a window creates a drawing, albeit a short-lived one. Drawing is usually the first stage in any artistic work. Sometimes it is the only stage, with the drawing itself being the end result.

A drawing can be simple in the extreme, consisting of a single line that takes but a second to make, or a highly complex work that might take hours, days—even weeks to complete. Drawings can be tiny, thumbnail-size sketches, or vast works, the size of which is limited only by the size of support available.

Charcoal sticks

Characteristics: Charcoal sticks are made in varying lengths up to 6 in (150mm), and are usually graded according to diameter: ³⁄₁₆ in (4-5mm), ¼ in (6-7mm), ⅜ in (8-10mm), and ½ in (12-13mm). The charcoal is also graded as soft, medium, or hard. Large rectangular blocks and thicker sticks known as scene-painters' charcoal are also available, and are ideal for working on large areas.

Charcoal sticks can be messy to use, but fingers can be kept clean by wrapping a piece of kitchen tinfoil around the part of the stick that is being held, or by using a holder (see page 19). One of the biggest charcoal manufacturers in the UK is PH Coates and Son.

Advantages: Charcoal is very forgiving and easy to remove prior to fixing—a flick with a rag or a soft bristle brush is all that is needed to remove most of the mark. It can also be used quickly, making it ideal for sketching.

Disadvantages: Enthusiastic work and heavy pressure can shatter the stick. Also, the marks made by sticks can easily be smudged or disturbed by a carelessly placed hand or sleeve. The only sure way to preserve charcoal work is to fix it (see page 19). Further, charcoal sticks can be messy to use, despite efforts to keep hands clean.

Cost: Inexpensive.

Foil is wrapped around the stick to help keep the hands clean.

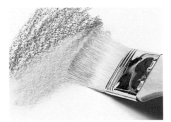

A brush can be used to remove unfixed charcoal.

Stick charcoal

Compressed charcoal sticks and wooden charcoal pencils

Characteristics: Compressed charcoal, sometimes known as Siberian charcoal, is made from powdered charcoal dust mixed with a binder, then pressed into short sticks. These sticks are substantially stronger than stick charcoal. Several manufacturers grade their sticks according to hardness: from the hardest (3H) through the softest (HB); and by blackness: from the blackest (4B) to the lightest (2B). Compressed charcoal sticks can also be found in a range of grays, the charcoal dust having been mixed with binder and chalk. They are available with both round and square profiles. Wooden charcoal pencils contain thin strips of compressed charcoal, and are found in grades of soft, medium, and hard.

Advantages: Compressed charcoal and wooden charcoal sticks are less messy to use than stick charcoal. As well, finer lines are possible.

Disadvantages: If the work involves a great deal of erasing, or if it involves working back into highlights and correction, compressed charcoal must be used with care, as it leaves a mark that is denser and more difficult to remove than standard stick charcoal.

Cost: Inexpensive.

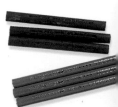

Compressed charcoal sticks and wooden charcoal pencils

A wide range

For many people, the word "drawing" is synonymous with the pencil, but, as stated, drawings can be made by any implement capable of leaving a mark. Before the pencil was invented, drawing tools included short metal rods made of silver, copper, lead, or gold. These were combined with chalk and used on a slightly abrasive support that had been prepared with gesso. You can try making this implement yourself using a short length of thick silver solder. The drawing tools dealt with in this section of the book are "dry" materials, and include the traditional lead pencil, as well as graphite stick, stick charcoal, charcoal pencils, compressed charcoal, various monochrome artists' pencils, colored pencils, and carrés.

Monochrome drawing media

Charcoal is perhaps the oldest and simplest of all drawing materials. It is completely pure, consisting only of carbonized wood. While its manufacture into a usable art material has become marginally more sophisticated, production methods remain as they have been for centuries. The wood is slowly cooked or burned in the controlled environment of a kiln, from which just enough air is excluded to prevent the wood from bursting into flames, but not enough to extinguish the fire entirely. Jars of powdered charcoal dust can also be obtained, and can be used by spreading it around with the fingers, or with a torchon or stump (see page 19). Forgiving and easily erasable, charcoal is an excellent medium for beginners.

SHARPENING PENCILS
Pencils can be sharpened with a pencil sharpener, but it is best to sharpen them using a sharp knife. With practice, the pencil can be sharpened to a very thin point, which is often needed for fine or detailed work. A pencil sharpened with a knife also holds its point much longer. Hard pencils can cut right through paper if used with too much pressure, while very soft pencils wear down at a surprising rate.

Wooden pencils

Characteristics: The graphite strip is sealed into a wooden case, usually made from cedar, which is then given a coat of paint. Pencils are invariably a standard 7 in (180mm) long, although the graphite strip can vary in diameter according to the manufacturer. The wooden case can have either a round or hexagonal profile. A round profile allows the pencil to be rolled between the fingers, making it possible for different sides of the graphite strip to come into contact with the drawing surface. A hexagonal profile is more stable and less tiring to hold, but requires the artist to pause in order to alter the grip slightly, which can result in a less fluid line.

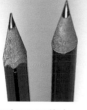

The wooden case can either be round or hexagonal in profile.

Advantages: The most versatile of all drawing mediums, with a huge range of grades. Clean and easily transported.
Disadvantages: Today's pencils are remarkably resilient, but beware of dropping them onto a hard surface—trying to sharpen a pencil with a shattered lead can be very frustrating.
Cost: Inexpensive.

Wooden graphite pencils

Mechanical pencils

Characteristics: Mechanical pencils hold a graphite strip similar to that found in wooden pencils. They are comfortable to use, and can take refill leads of varying degrees, from soft to hard. Many have a device in the clutch press (the lead-releasing device) to sharpen the lead. The different grades of lead have different diameters, so several different pencil bodies may be needed. Mechanical pencils for technical work tend to hold short, hard, thin leads that produce very fine, exact lines of a standard width. Faber Castell, Pentel, and Rotring make excellent mechanical pencils.
Advantages: Can be more economical than wooden pencils, because less of the lead is wasted each time they are sharpened.
Disadvantages: Cannot be sharpened to your own requirements.
Cost: More expensive than wooden pencils.

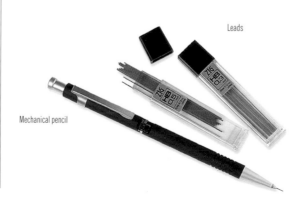

Leads

Mechanical pencil

THESE TWO PAGES
• STUDIO PENCILS
• GRAPHITE STICKS
• GRAPHITE POWDER
• ARTISTS' PENCILS
• CARRÉ STICKS
• COLORED PENCILS

Pencils are another type of monochromatic media. All traditional pencils contain graphite strips. They are available in a range of grades that runs from the hardest (9H, 8H, 7H, 6H, 5H, 4H, 2H, H, and HB) through F ("fine"); and from the lightest black (B, 2B, 3B, 4B, 5B, 6B, 7B and 8B) to the darkest, 9B, which is also the softest. The hardness of graphite is increased by adding clay and heating—the more clay added, the harder the graphite becomes. It is worth paying extra for high-quality pencils. Good pencil manufacturers include Faber Castell, Staedtler, Rexel Cumberland, and Berol.

Graphite sticks are made in the same way as traditional pencils: powdered graphite is mixed with clay and a binder. As with traditional pencils, the hardness of the graphite can be altered, depending on the proportion of clay added. Unlike traditional pencils, however, the extruded strip or "lead" that is as thick as—or thicker than—a pencil, is not encased in wood. These solid lengths of graphite can be found in various shapes and sizes. Faber Castell and Conté both make high-quality graphite sticks.

Colored drawing media

There are two types of colored pencil: non-water-soluble and water-soluble. Traditional colored pencils are non-water-soluble, and are made in much the same way as graphite pencils: pigment is mixed with gum binder and clay filler. This mixture is then impregnated with wax,

Innovation

Solid colored pencils resembling long graphite sticks—and possessing all of their advantages—have been recently introduced in a limited range of colors, and are available from Koh-i-noor, Hardmuth, Berol, Prismacolor, and Chromatix. They are sharpened using a pencil sharpener, and can be used in the same way as traditional colored pencils.

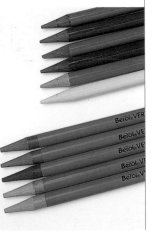

Studio pencils

Characteristics: Studio pencils, sometimes called sketching pencils, are standard pencil length, but are rectangular in profile, with a rectangular graphite strip. They are produced in varying degrees of hardness. The thickness of the line created by the distinctive shape of the strip will depend upon how the pencil is held. Faber Castell, Conté, and Derwent all produce good-quality studio pencils.

Studio pencils contain a rectangular graphite strip.

Advantages: The wider thickness of the graphite makes a great range of marks possible.

Disadvantages: Only a small range of grades is available.

Cost: Inexpensive.

Studio pencils

Graphite sticks and powder

Characteristics: Short lengths of graphite with a square, rectangular, or round profile are produced, along with thicker, hexagonal sticks that are 4 in (100mm) long and are sharpened to a point at one end. Longer, thinner sticks, the same size and shape as a traditional pencil, sharpened to a point at one end and round in profile are also available. In order to keep the hands clean, some manufacturers give these sticks a thin layer of paint or a plastic coat—this is chipped away as the graphite is used and sharpened. Graphite sticks are graded like pencils. The shorter, hexagonal sticks can be found in grades (from hardest to softest) 4B, 6B, and 9B, while the longer sticks are graded (from hardest to softest) HB, 3B, 6B, and 9B.

Graphite powder can be mixed with acrylic medium.

Powdered graphite is used to cover large areas with tone, and to create special effects. The powder is worked into the support using a torchon, finger, rag, or brush, and can be worked back using an eraser (see page 16). Graphite powder can also be added to acrylic and other mediums to create a range of effects.

Advantages: Short, round sticks can be used sharpened to a point, on end, or along their length; stumpy, hexagonal sticks can be used in the same way. Graphite sticks are clean and easy to carry, and make an ideal material with which to sketch.

Disadvantages: Thinner graphite sticks can shatter if dropped onto a hard surface, and softer sticks will break if they are held too high up the shaft when pressure is applied. Resharpening the point on thick sticks can be hard work, as they do not fit into standard pencil sharpeners; sharpening is best done by shaping the point on glasspaper. Pencil-shaped sticks do, however, fit into most sharpeners.

Cost: Inexpensive.

Graphite sticks

Graphite powder

which acts as a lubricant, enabling the pencil to move freely over a support. Water-soluble pencils are made in much the same way, but the gums that are used to bind the ingredients together become soluble when wet.

The range of colored pencil colors available varies greatly. Manufacturers like Faber Castell, Caran d'Ache, Conté, Lyra, Derwent, and Berol produce up to 120 different colors. Karisma make a range of water-soluble pencils in medium-soft and very soft. Stabilo produce a stumpy range of colored pencils called Tone; these have thick, water-soluble leads, the points of which can be heated and melted with a hair-dryer and used in a similar way to wax crayon.

Colored pencil leads vary in consistency and hardness.

As a rule, the thicker the lead, the softer it will be. Softer leads, which are prone to crumbling, should be sharpened using a sharp craft knife. The best colored pencils have rich, strong, lightfast colors, with no grittiness.

Other types of colored drawing media available include artists' pencils, and short sticks with a square profile known as carrés. Artists' pencils can also be found as thin "leads" that will fit in some mechanical pencils. Both artists' pencils and carrés are made in the same way as traditional pencils: by using pigment, binder, and a clay extender, together with a wax lubricant similar to that used in colored pencils. Faber Castell and Conté both produce a wide range of artists' pencils and carrés.

Artists' pencils and carré sticks

Characteristics: Artists' pencils and carré sticks are available in a range of traditional colors: white, which is made from chalk; sanguine, which is made from iron oxide; bistre, a dark brown made by boiling the soot from burnt beech wood; sepia, which is obtained from the ink of the cuttlefish; and black, which is made from graphite.

Advantages: All of the advantages of other dry drawing materials apply to artists' pencils and carré sticks. The combination of chalk, black, sanguine, and bistre used on a tinted support makes for subtle drawings with an antique feeling.

Carré sticks are sharpened using a sharp knife.

Disadvantages: As with other stick drawing materials, artists' pencils need a lot of care, and must not be dropped onto a hard surface. As well, the slightly waxy content of these pencils means that they erase less easily than charcoal or graphite, and drawings must be fixed in order to avoid smudging.

Cost : Inexpensive.

Colored pencils

Characteristics: Colored pencils are usually 7 in (180mm) long, although a range of shorter, thicker pencils is available. Standard-length colored pencils have a lead diameter that can vary from make to make, but usually falls between ⅛ in and ³/₁₆ in (3.5mm and 4mm). The wooden case that holds the lead can be round or hexagonal. The pencils are available in sets, but it is more economical to buy them individually, as you can select only those colors that match your needs and subject matter.

Colored pencils from one manufacturer can be mixed or used together with pencils from another manufacturer. Water-soluble pencils can be used together with non-water-soluble pencils, and interesting effects can be achieved by combining the two.

Advantages: Colored pencils are quick and clean to use, and are easy and light to transport. It is possible to make complex drawings using only a limited palette.

Disadvantages: The wax used in the manufacture of colored pencils can rise to the surface in heavily applied areas of work, causing a film to form, deadening the color. As well, applications of water-soluble colored pencil that have been made using pressure do not always dissolve and blend completely when wet.

Cost: Sets can be moderately expensive. Individual pencils are generally inexpensive.

Carré sticks

Artists' pencils

Colored pencils

Water-soluble pencils

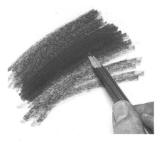

The application of pressure will result in the build-up of strong, solid color.

Using drawing media

Charcoal encourages a broad approach, making it a good teaching material. It mixes well with other materials, and is often used for underdrawing prior to painting in oil or acrylic. It also works well in mixed-media pieces in which pastel, ink, or gouache have been used.

Because graphite sticks are made from solid graphite, every part of the implement can be used to make marks. Pencil-shaped graphite sticks have all of the potential of a standard pencil, with one added advantage: by turning the stick as it is used—and thereby altering the angle of presentation—a range of expressive lines can be made, from very thin to very thick.

Soft pencil work is easily erased and corrected, and can be used with speed. It is possible to work with some precision, even on a small scale, and the material mixes well with other mediums.

Artists' pencils and carrés possess a unique beauty, characterized by an antique, old-fashioned feel. They are particularly expressive when used on tinted or colored drawing paper.

When using colored pencils, the amount or depth of color will depend on the amount of pressure used. Harder leads will give a lighter layer of pigment, while softer brands deliver richer, deeper colors. With water-soluble pencils, the more and the deeper the color deposited on the drawing surface, the deeper the color will appear when wetted.

CORE TECHNIQUES

Charcoal

Line
Charcoal is an expressive material, and responds well to fluid drawing movements and variations in pressure. These characteristics make it possible to produce drawings that contain a great variation in line quality. Both regular charcoal sticks and compressed charcoal sticks can be used by bringing the side or the end of the stick into contact with the support.

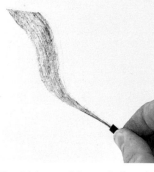

The thickness of the stroke is varied by the angle of the mark.

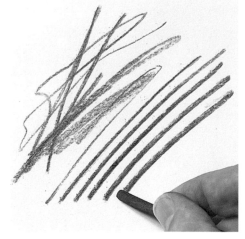

Thin stick charcoal produces expressive, linear strokes.

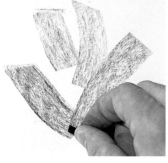

Thick marks can be made by using the charcoal on its side.

Hatching and crosshatching
Areas of tone and texture can be built using a web of hatched or crosshatched lines or marks. These lines or marks can be precise and controlled, or loose and random.

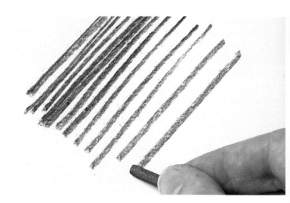

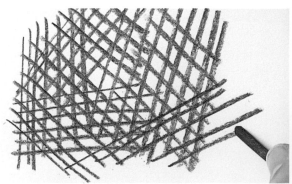

Textural effects

Textural effects are easily achieved with charcoal. When the charcoal is brought into contact with the support, the immediacy of the medium means that every tremor of the hand results in a well-defined mark. Charcoal is also known for its ability to bring out the grain and texture on all but the smoothest paper.

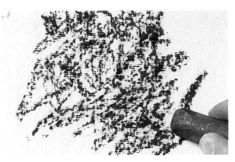

When used on rough paper, charcoal shows off the texture of the surface.

Constantly altering the direction of the mark results in a regular scumble-like texture.

Irregular dots and dashes produced in varying densities suggest tone.

Used on its side, a thick stick of charcoal can cover a large area quickly and easily.

Tone

Areas of tone can be quickly scribbled or blocked in with wide strokes, using the edge of the stick. A full range of tone can be achieved by blending with a finger, rag, blending stump, or brush (see page 19).

Erasing

Charcoal is particularly receptive to being worked into with a range of various erasers (see page 19). These will produce a variety of effects, from fine, crisp, sharp lines to texture and highlights.

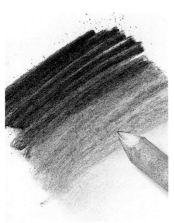

Here the charcoal is spread using a paper-blending stump.

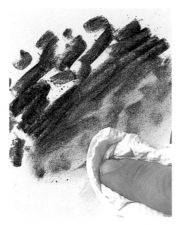

A finger wrapped in paper towel makes a good blending tool.

The use of a soft eraser results in a broad erased area, creating texture.

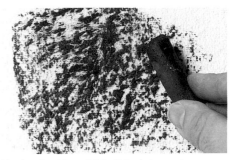

In charcoal, hard vinyl erasers create thin, sharp lines.

Graphite sticks

Line

A wide variation in line quality and width can be achieved with graphite sticks due to their shape and their composition of solid graphite. Every technique that is possible to achieve with pencil is also possible using graphite stick.

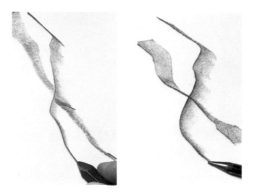

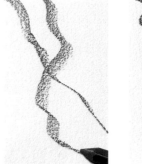

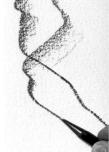

Marks made on smooth paper result in fluid lines that can vary in thickness.

Marks made on rough paper result in a rich, textured line quality.

Tone

Using the stick along its length, the laying or blocking in of tone can be done quickly and easily.

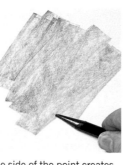

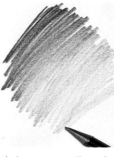

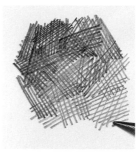

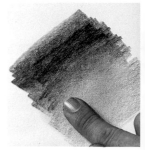

The side of the point creates consistent tone.

Varied pressure on the point results in altered tone.

Hatching and crosshatching build controlled tone.

Soft graphite can be blended with the finger.

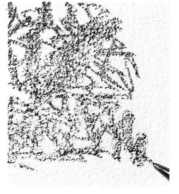

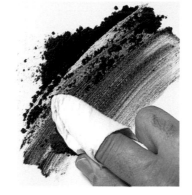

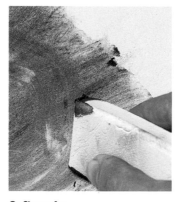

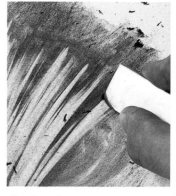

Texture

A wider range of marks can be made with a graphite stick than is possible with a pencil. This is due to the thickness of its end—there is simply more of a mark-making area to work with.

Using graphite powder

Large areas can be covered using graphite powder. The powder is placed on the support and distributed with the finger, or a blending stick or brush. Excess powder can be returned to the jar.

Soft marks

Putty or soft erasers tend to push the powder into the paper fibers, and so they should be used with care. The marks resulting from their use are soft and ghost-like.

Hard marks

A hard vinyl eraser makes sharper, more precise marks. It can be used for toning, or to create highlights or textural effects.

Wooden Pencils

Line

A wooden pencil can be used on a variety of different surfaces. When pressure, speed of application, and grades are varied, pencils are capable of producing a wide range of linear effects.

Tone

Tone is built up and graduated using several methods that can be applied individually or together in the same work. Lines can be hatched or crosshatched to build up areas of varying density. Areas of tone can be scribbled and made darker or lighter, depending on the amount of pressure applied. Alternatively, areas of tone created using a soft pencil can be blended with a finger, torchon, or soft eraser (see page 19).

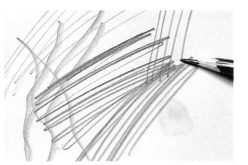

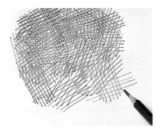

Crosshatching builds tone and density in a controlled way.

The heavier the pressure, the darker the tone.

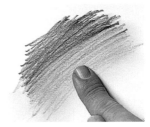

Tone can be varied and lightened by blending.

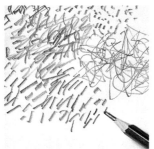

Texture

A single soft pencil is capable of a wide visual vocabulary. A number of textural effects are possible, utilizing a variety of marks such as dots, dashes, short jabbed lines, loose scribbles, fast scribbles, fat lines, thin lines, dark lines, light lines, ticks, and squiggles.

Erasing

An eraser can be used to make corrections, as well as to produce specific tonal or textural effects. It can also be used to lift out highlights.

Artists' pencils and carrés

Artists' pencils and carrés can be used to apply the same techniques as those that are possible with other dry drawing materials.

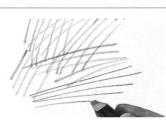

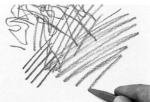

Used on its edge, an artists' pencil makes thin strokes. A carré stick makes expressive, linear strokes.

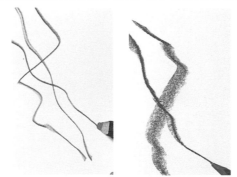

The shape of the artists' pencil allows for lines of varying width. Altering the angle of the carré stick also results in a varied line width.

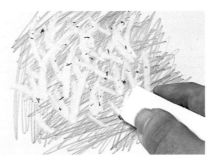

The artists' pencil gives a solid, wide mark, while the unsharpened end of a carré stick gives a darker mark.

Colored pencils

Line

All of the traditional line techniques and marks that are possible with graphite pencils can also be made using colored pencils.

Solid color sticks can be used to create clean lines of varying width and quality.

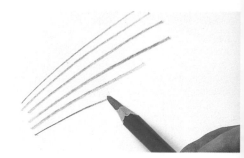

Colored pencil, like graphite pencil, can create fluid lines of varying thicknesses.

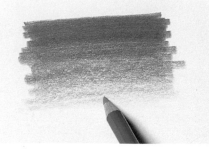

Tone/color saturation

Lighter pressure will result in lighter color or tone. Heavy pressure, or multi-layered application, will result in darker or deeper color and tone.

Optical mixing

Colors that are placed separately, yet close to each other, will mix optically when viewed from a distance. For example, pure blue hatched over pure yellow, while not physically mixed together, will appear as a green. Highly complex areas of color can be achieved using this technique.

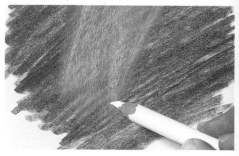

Burnishing

Burnishing is the technique of blending together colors using pressure. The darker color is applied first, and the second, lighter color is worked over the first. The pigment is thus pushed into the grain. This process invariably results in a shiny, waxy bloom that can be reduced by spraying with fixative (see right).

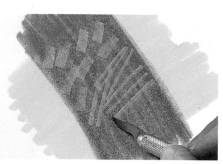

Sgraffito

Heavy applications of colored pencil can be scraped away from the support, or incised into using a sharp implement. This technique can create lines and texture, or reveal a previously laid layer of color. A hard-surfaced support is best for this technique.

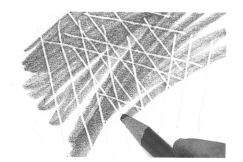

Impressed line

Indented lines and marks in a paper support remain white when worked over with pencils. This technique is used to create textural effects, or to accentuate detail. A variation on the effect can be achieved using frottage.

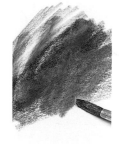

Wet-on-dry

After colored pencil work is completed, it is worked into with brushes and clean water.

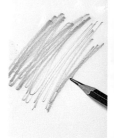

Dry-on-wet

Water is spread onto the support, and then the colored pencil is worked into the wet areas.

Accessories

Stumps

STUMPS Stumps, torchons, or tortillions (pronounced tor-tee-yons) are usually made of soft, rolled paper, although they can be made from felt, or even chamois leather. They are used to manipulate or blend loose, dry pigment left by a drawing material on a drawing surface. They can be found in a variety of sizes, and are suitable for both very fine and broad work. Stumps are usually pointed at both ends, and quickly become dirty by picking up traces of the drawing material being used. They can be cleaned (and the point can be preserved at the same time) by lightly rubbing them on fine-grit glasspaper.

A stump can be sharpened by lightly rubbing on fine-grit glasspaper.

KNIVES AND SHARPENERS

A sharp knife is invaluable for sharpening drawing materials. Various heavy-duty craft knives with replaceable retractable blades can be purchased, as can smaller hobby knives and scalpels; one of each kind is ideal. A knife makes it possible to shape the lead to suit the type of work involved, but a pencil sharpener may also be used.

Small, portable sharpeners tend to have holes for different diameter materials; if a lot of sharpening is to be done, it would be best to invest in one that clamps onto a table or drawing board and works by turning a handle. Electric sharpeners, though something of a luxury, can eat pencils at an alarming rate. Small sandpaper blocks are available for shaping graphite pencils or carrés; however, ordinary fine glasspaper from a hardware store works just as well—and is less expensive.

Even the smallest stump of pencil or crayon is useable with an extender.

EXTENDERS These are made of plastic, metal, or wood, and are designed to hold the small, otherwise unusable stump of a pencil, crayon, or graphite stick. Special holders are made for gripping square and round pastels and stick charcoal.

Plastic extender

Metal extender

Fixative bottle and diffuser

Spray fixative

Large and small retractable craft knives

Scalpels

Replaceable scalpel blades

Pencil sharpeners

Sandpaper block

Cleaning pad

FIXATIVE Fixative is made from resin dissolved in a colorless spirit solvent. When sprayed onto a drawing, the solvent evaporates, leaving a thin, matte layer of resin that coats and holds any loose pigment dust in place. Fixative is available in bottles, where the solution is sprayed onto the support using a mouth-spray diffuser. Bottles with a hand-operated spray are also available, but by far the most convenient form of fixative comes contained within aerosol cans.

These are CFC-free, and should be used according to the manufacturer's directions. Winsor & Newton, Daler-Rowney, Sennelier, Lukas, and Grumbacher are among the brands available.

ERASERS Erasers are available in a variety of materials, shapes, and sizes. They should not be seen solely as a means of correcting a mistake; they can also be used to alter and lighten tone, create texture, add highlights, and as a drawing tool in their own right. A good eraser should not disturb the support.

The most adaptable eraser is the kneaded putty eraser; this type of eraser can be molded and shaped into a point, and is extremely gentle on drawing surfaces. Soap gum erasers are a good choice for cleaning up light marks and dirt on paper. India-rubber erasers can be efficient if used with care, but avoid colored ones, as these can smudge work and tear supports. Plastic erasers are excellent for drawing in sharp lines. Erasers with a long strip of rubber that is gradually revealed by tearing off a paper surround work well on detail. Another option are cleaning pads. Used by paper conservators, these consist of a bag of rubber granules which, when gently rubbed over the support, can remove light marks.

Faber Castell make an erasing knife that is used to gently scrape away mistakes. Erasing shields, made from thin metal with shapes punched out, can be laid over the work to protect surrounding areas from the eraser's action; they are very useful when working on small areas.

Precise corrections can be made with the help of an erasing shield.

Rubber erasers

Putty eraser

Erasing knife

THESE TWO PAGES
- WATERPROOF INKS
- NON-WATERPROOF INKS
- LIQUID ACRYLIC INKS AND LIQUID WATERCOLOR
- PEN-HOLDERS AND NIBS
- BAMBOO AND REED PENS
- QUILL PENS

Ink

Ink is a wonderfully flexible medium that has been popular for centuries. It played a notable role in ancient Chinese art, and was also used by Chinese scholars in the writing of calligraphic ideograms. It remains a popular medium today, as it is relatively easy to work with, and is capable of a wide range of techniques and effects using simple materials and tools. Pens, markers, and brushes are the usual means of applying ink to the support.

single ink color, and explains why one ink color is often used to represent many. A relatively limited palette of watercolors is sometimes used to embellish ink works, but the majority of work is done using a range of tones within a single color, produced by diluting the ink. Indian ink is popular with artists, being both waterproof and permanent. Other ink colors commonly used for monochromatic works include sepia and blue-black.

Monochromatic drawings

There is a Chinese saying, "in ink are all colors." This refers to the wide range of tonal possibilities within a

Colored inks

While not as widely used as traditional blue and black inks, colored inks can add substantial interest to a

Innovation

Chromacoal is heat-fixable pigment powder made by D'Uva (it is also available in pastel format; see page 28).

The powder is mixed with a solvent to make an ink or watercolor, or it can be used dry to color large areas with tone. The powder is fixed by heating the work to 250° F (121°C)—a kitchen oven is recommended, though any radiant heat source will do (including a hair-dryer set on "high").

Waterproof inks

Characteristics: A range of waterproof colored inks is made by various manufacturers, as is traditional black Indian ink. Manufacturers include Winsor & Newton, with 26 colors; Sennelier Encre, offering 28; Ocaldo, with 20; and Pelikan, with 12; the 22 colors in the Daler-Rowney Kandahar range are slightly less waterproof than most other shellac-based inks. Sizes range from small 0.4 fl oz (14ml) bottles up to 33.8 fl oz (1L) bottles.

Waterproof ink is diluted with water.

Shellac-based inks dry slightly glossy.

Advantages: The colors are quick-drying, and they mix well, giving a brilliant color range.
Disadvantages: The permanence of the colors is questionable.
Cost: Expensive if used at full strength.

Non-waterproof inks

Characteristics: Not as widely available as waterproof inks, soluble inks can give an added dimension to your technique. Chinese inks, which need to be ground on an ink stone with water, are water-soluble, as are certain brands of Indian ink. Writing and calligraphic inks made by Osmiroid, Waterman, and Pelikan are soluble too.

Mixing stick ink on a stone.

Advantages: Corrections can be made by re-wetting and then blotting off the wet ink with a paper towel.
Disadvantages: The range of colors is limited.
Cost: Can be expensive if used at full strength.

Calligraphic inks

Chinese inks

Non-waterproof inks

Liquid acrylic inks and liquid watercolor

Characteristics: Liquid acrylic inks are completely waterproof when dry, and most standard colors are lightfast. They are used in the same way as shellac-based waterproof inks, but cannot be mixed with them. Winsor & Newton offers 36 colors; Royal Sovereign Speed Dry make 44 colors; and FW Artists' Acrylic Inks come in 30 colors.

Acrylic inks are waterproof when dry.

Liquid concentrated watercolor is made by Luma, which offers 86 colors; as well as Dr PH Martin, with 56 colors; and Winsor & Newton, with 36 colors.
Advantages: Available in a wide range of colors.
Disadvantages: Liquid watercolor will fade if subjected to bright light.
Cost: Can be expensive if used at full strength.

Liquid watercolor

Liquid acrylic inks

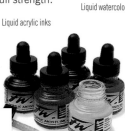

Waterproof inks

drawing. The waterproof variety can be used to apply a wash or tint on top of a line drawing, while non-waterproof inks can only be used to lay washes over waterproof-ink drawings. Colored inks can be diluted with distilled water to improve their flow; this will also produce lighter tones of the color. Because these inks consist of soluble dyes, and not pigments, they are not lightfast. Finished drawings should thus be protected from prolonged light exposure, or they will fade.

Waterproof inks

Non-soluble when dry, these inks are made using soluble dyes in a shellac base. Denser than the non-waterproof varieties, shellac-based inks dry to a slightly glossy finish,

and are capable of very precise work. Waterproof ink has a tendency to clog up easily, however, due to its shellac component, and thus brushes and pens must be cleaned thoroughly after use. Do not use waterproof ink in technical or fountain pens. Liquid acrylic ink is another type of waterproof ink, and should not be mixed with the shellac-based variety.

Non-waterproof inks

These inks do not contain shellac. When dry, they will soften and dissolve if washed over with water. They sink into the paper more than their waterproof counterparts, and then dry to a matte finish. They are widely used for laying washes over waterproof-ink drawings.

INK EVAPORATION
Ink may evaporate slightly as it is exposed to the air. As it does so, the color will become deeper, and the ink will become thicker. The addition of distilled water will restore it to its original consistency, and will even out the flow.

PREPARING TO USE INK
Because mistakes are difficult to rectify, ink can be a challenging medium for beginners. During the Renaissance, art teachers would advise their students to spend one year drawing in charcoal before graduating to ink. Underdrawings for ink works were done using charcoal, then partially erased and inked in.

Dip pens and nibs

Characteristics: Dip pens that take inter-changeable nibs are made from both wood and plastic. Shapes and sizes vary, so test a few out until you find one that is comfortable to use.

A wide range of nib shapes and sizes is available; not all fit into every dip pen, however, so make sure that your choice of nib will fit your pen. Nibs are made for specific purposes, but all nibs can be used for drawing, and several different nibs may be used during the course of a single work. If the nib seems reluctant to accept the ink, rub a little saliva onto it. A flexible nib allows for a range of line thickness and quality; simply vary the pressure applied to it.
Advantages: Available in a wide range of shapes and sizes.
Disadvantages: Can be easily damaged if dropped.
Cost: Inexpensive.

Plastic dip pen

Dip pens and nibs

Bamboo and reed pens

Characteristics: Bamboo pens are cut from a short length of bamboo. They vary in thickness, and some are shaped in such a way as to give a different-sized nib at each end. They last a long time. The nib makes a line of a consistent thickness with an irregular, coarse texture. The overall line quality lends itself best to large, bold drawing, as opposed to smaller, more detailed work.

Reed pens have a far more flexible nib than bamboo, and can be easily re-cut and shaped using a sharp knife.
Advantages: Both types of pen add additional interest to a work, having a different effect than metal nibs.
Disadvantages: Both types of pen are stiff to use. Line width cannot be varied with pressure, and the nib runs low on ink very quickly. Reed pens are made from a weak material that chips easily.
Cost: Inexpensive.

Bamboo and reed pens

Quill pens

Characteristics: Quill pens are made from the large, primary flight feathers taken from the wings of birds such as swans, geese, and turkeys. Quills can often be found in art stores, but failing that, ask at your local game butcher. If already prepared, the quill will wear with use, and will need to be re-cut periodically. When choosing a quill, note the curve of the feather: if you are right-handed, use a quill taken from the right wing of the bird; if you are left-handed, use one from the left wing.
Advantages: A joy to use, giving a unique line quality.
Disadvantages: Needs to be re-cut and shaped periodically, and can be difficult to find.
Cost: Inexpensive.

Quill

SHAPING A QUILL
1. Cut the underside at an angle.

2. Shape both sides of the quill.

3. Split the end, to allow the ink to flow.

CARING FOR PENS

Nib pens are as delicate as they look. If dropped onto a hard or semi-hard surface, they may become permanently damaged. In the case of art or technical pens, this can become expensive, so be careful when using them. Even those inks designed to coagulate as little as possible can clog up a pen, so make sure you clean all pens thoroughly, even before taking a break from drawing.

Ink-cleaning solvent

SOLVENT-BASED PENS AND MARKERS

Up until recently, the only marker and fiber-tip pens that offered any degree of permanence were solvent-based. This was problematic for those who suffer ill effects from solvents. Much research has been put into this problem, and today the available range of non-solvent-based pens and markers is much greater.

Art pens and fountain pens

Characteristics: Art pens resemble traditional fountain pens, and hold a cartridge that delivers a steady flow of ink to the nib. They are available with different-sized and -shaped nibs, giving a range of line thickness. Rotring make an excellent range of sketching pens. Fountain pens can be used for drawing, but should only be used with water-soluble inks. Good calligraphy fountain pens are made by Osmiroid and Pelikan, while Grumbacher have recently introduced a disposable artists' pen in three different nib sizes.

Advantages: Easy, clean, and convenient to use.

Disadvantages: The line created is of a standard width, and can lack interest.

Cost: Relatively inexpensive.

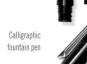

Calligraphic fountain pen

Ink cartridges

Drawing pens

Ballpoint and rollerball pens

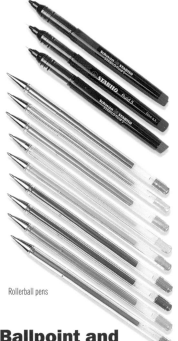

Rollerball pens

Characteristics: The range of ballpoint and rollerball pens today is huge. Easy to find and transport, they are a very useful drawing tool. Although only available in a limited nib size, they can be found in an ever-growing range of colors, none of which are lightfast. Rollerballs tend to be slightly "wetter" than ballpoints, and seem to deliver more ink. Both types of pens last a long time. They are made by countless manufacturers, including Bic, Pilot, Pentel, Papermate, Uni-ball, and Rotring.

Advantages: Readily available and easy to transport.

Disadvantages: The ink is non-permanent.

Cost: Inexpensive.

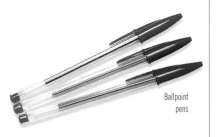

Ballpoint pens

Technical pens

Characteristics: Technical pens deliver ink to the support through a narrow metal tube, giving a mechanical line of a standard width that cannot be varied. In order to make a line of a different width, you will need another pen with a different width tube. Pens are available in sizes ranging from 0.13mm up to 2mm. One problem that used to plague smaller-sized pens was ink clogging up the finer tubes, but this happens less often now that technical pen ink contains an anti-coagulating agent; special cleaning kits are also available. Technical pens either have a reservoir filling system, or accept ink cartridges. Manufacturers include Rotring, Koh-i-noor, Faber-Castell, and Staedtler. Good disposable technical pens are made by Faber-Castell, Edding, Pilot, and Staedtler.

Advantages: The unvarying line width is unaffected by hand pressure.

Disadvantages: Refillable pens are easily damaged, and, if not looked after, can become blocked. The ink color range is limited.

Cost: Initial costs are expensive for refillable pens. Disposable pens are inexpensive.

Changeable nibs

Colored technical pen ink

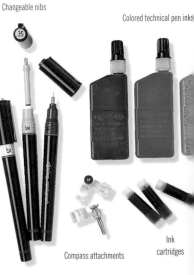

Compass attachments

Ink cartridges

Pen barrels

Marker and fibertip pens

Characteristics: An extensive range of marker and fibertip pens is available in a wide range of colors. Their only immediate drawback is the lack of ink lightfastness. They are, however, excellent for planning and preliminary work, and for work that can be kept out of the light, such as that contained within the pages of a sketchbook.

Markers divide into those that are water-based and those that are solvent-based, but both are difficult to remove once dry. Special blenders containing solvent can be used to blend and lighten colors. Marker tips can be wedge-shaped, chisel-shaped, or pointed; some markers have a different-shaped tip at each end. Different brands of markers can be mixed with one another, and a surprising range of interesting effects and color combinations can be made. Letraset makes a Pantone range which has 298 colors; Berol Prismacolour offers 144 colors; Chartpak AD Markers come in 100 colors; and Royal Sovereign Magic Marker offers 150 colors. Magic Marker also has a complete range of inks available that matches the marker colors exactly. Other popular ranges include those made by Stabilo, Sakura, Crayola, and Faber-Castell.

Advantages: Easy and clean to use.
Disadvantages: The ink is non-permanent.
Cost: Relatively inexpensive.

Brush pens

Characteristics: A relatively new product, brush pens have a flexible, brush-like, nylon tip which make fluid calligraphic strokes, as opposed to the wedge-shaped marks made by most markers; many brands also have a fine-liner tip at the other end. Using a clear-fluid blending pen, colors can be blended together. These pens can also be used with traditional markers. Manufacturers include Tombow, which offers 144 colors; Lyra, with 36 colors; Staedtler, with 80 colors; and Zig, with 80 colors. Pentel makes a brush pen which accepts replacement ink cartridges.

Advantages: Easy and clean to use.
Disadvantages: Non-permanent.
Cost: Relatively inexpensive.

Brushes

Characteristics: All and any of the brushes used for oil, acrylic, and certainly watercolor can be used with ink, but perhaps the best results come from using oriental brushes. These are increasingly available in art stores, and, like western-style brushes, they are made in a wide range of sizes and materials.

The essential difference between oriental and western-style brushes are the way in which they are meant to be used and held. Oriental brushes are intended for making long flowing strokes. In order to achieve this style, they should be held at a right angle to the support, with the hand clear of the drawing surface.

Advantages: Oriental brushes are capable of giving a very distinct and varied quality of line.
Disadvantages: They require practice to be used correctly.
Cost: Comparable with standard brush prices.

Goat-hair brush
Wolf-hair brushes
Hake brushes

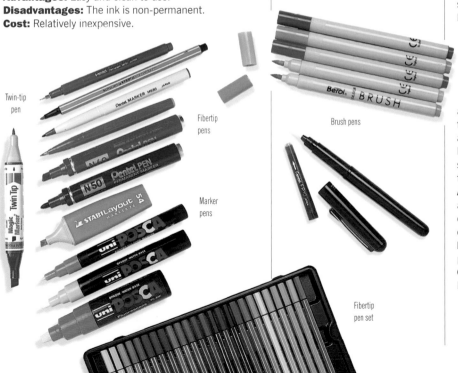
Twin-tip pen
Fibertip pens
Brush pens
Marker pens
Fibertip pen set

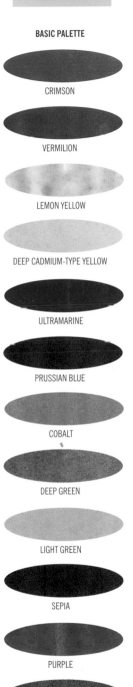

BASIC PALETTE

CRIMSON

VERMILION

LEMON YELLOW

DEEP CADMIUM-TYPE YELLOW

ULTRAMARINE

PRUSSIAN BLUE

COBALT

DEEP GREEN

LIGHT GREEN

SEPIA

PURPLE

BLACK

Using ink

Working with ink has been likened to a trapeze artist working without a safety net, because any mistakes that are made can be difficult, if not impossible, to rectify. For this reason, the medium demands concentration and a decisive hand, qualities that are often absent in a beginner or novice. While challenging, these characteristics make inks an excellent tool for teaching.

An exciting medium

While difficult to learn, once mark-making in ink has been mastered, it is one of the most spontaneous, and therefore exciting, mediums available to the artist. When starting to draw in ink, try to make your marks and lines as confident as you can. Unlike most other drawing media, mistakes are not erasable, and thus more time must be spent learning about and mastering the technical aspects of the medium; for instance, knowing when to reload a pen or brush—so as not to leave a line unbroken—is vital, and can only come through experience. You will most likely go through a lot of paper, but the immediacy and straightforwardness of a good ink work make the effort worthwhile. One trick for beginners is to make a light, fluid drawing in soft pencil or charcoal first, which can then be used as a guide for the pen work. Another hint is to practice marking the line on a piece of paper before marking it on the actual drawing.

CORE TECHNIQUES

Mark-making

Ink can be applied using virtually all of the tools that are used to apply traditional watercolor. The mark-making potential of sponges, rags, fingers, or feathers should also not be overlooked.

Although ink is commonly thought of as an essentially linear medium, a wide range of textural marks is possible. The nature of the medium tends to draw attention to unsteady marks, but even these can be used to advantage. The potential of color should also be considered. While the strength of colored inks can be overpowering, they can easily be toned down through dilution with water. The use of diluted ink in a dip pen will produce a beautiful, subtle line.

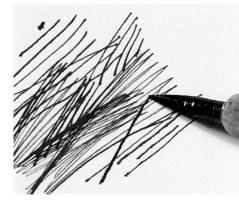

Dip pen
The dip pen's capacity to accept a wide range of nibs makes it a versatile tool.

Bamboo pen
A bamboo pen runs out of ink quickly, and can feel dry and stiff as it moves over the paper surface.

Quill
The natural feather quill makes a unique quality of marks.

Art pen
These pens are quick and clean to use, making them good sketching tools.

Ballpoint pen
Ballpoint and biro pens produce lines of uniform width.

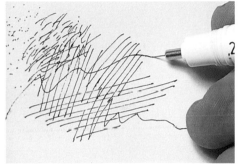

Technical pen
The line made by this pen is of uniform width, with the paper lying on a smooth surface.

Marker pen
Marker pens of different shapes and sizes can produce a variety of marks.

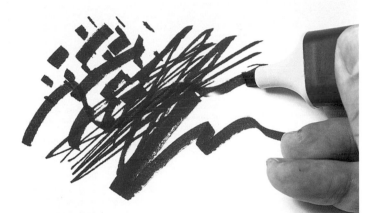

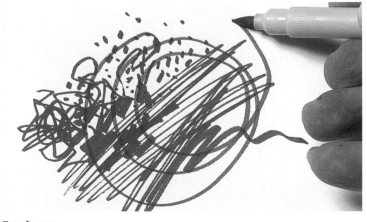

Brush pen
Brush pen marks vary in thickness according to the amount of pressure applied.

Oriental brush
This type of brush is made specifically for drawing with ink, and creates particularly expressive marks.

Pen line

The pen is essentially a tool for making lines. Contrary to popular belief, a line is capable of expressing far more than just the edge of something. Shades of light and dark can be hinted at by simply altering the weight or thickness of the line. This effect is achieved by applying less or more pressure to the nib, or by changing the angle at which the nib runs across the paper. If water-resistant ink is used, tonal washes can be applied. Use of water-soluble ink enables corrections to be made simply by brushing over the mistake with clean water, and then blotting off the dissolved ink with a paper towel.

Line
The flexibility of the dip pen results in expressive lines of varying widths.

Wash
Pen line coupled with a brush wash is a classic combination of techniques.

Correction by wetting
1. As long as the ink is water-soluble, the marks made can be easily erased by re-wetting.

2. The final stage in the correction process is blotting, which removes the ink from the paper.

Pen and brush tone

To create tone with a pen, it is necessary to build up a network or web of marks or lines that vary in density. The types of marks used include hatching, crosshatching, scribbling, and a range of stippled dots and dashes.

With a brush, tone is usually painted on using ink at various dilute strengths. Manufacturers advise using distilled or boiled water to dilute ink, but tap water works just as well. If the line-work has been carried out using waterproof ink, any accompanying tonal brushwork can be carried out without fear of the line-work dissolving.

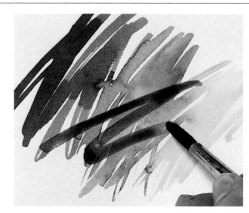

Ink can be diluted with water to give a wide range of tones.

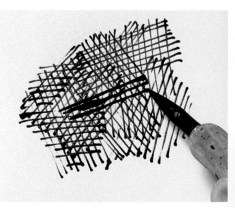

Hatching and crosshatching creates light and dark tones, with the paper acting as a middle tone.

Brush line

A brush loaded with paint will create a long line. As with pen marks, this can be made to suggest tone and direction by varying the pressure or angle of presentation. The best brushes to use for line work are oriental brushes, which are held differently to western brushes. The brush is held at 90 degrees or at a right-angle to the paper, and the hand does not rest on the work—the movement comes from the whole arm, not just the wrist. This allows for very fluid line work, but requires some practice.

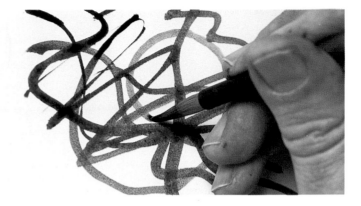

Texture

In order to create texture, ink can be spattered or dabbed on with a sponge, rag, or finger. Coarse fabrics can also be used to make imprints, as can leaves, feathers—or anything else with a definite texture of its own. Try using watercolor resist techniques with a wax candle or spirit solvent (see page 70), or try masking techniques using liquid frisket (see page 69).

The thumb can be used to make imprint marks, thereby adding interest and texture.

A clear wax candle is used to draw the design, which is then washed over with diluted ink.

Working with markers

Marker pens have only relatively recently been utilized by the fine artist. The initial reluctance to use them stemmed in part from the fact that they are non-permanent, and will almost certainly fade with time if the drawing is subjected to bright light. Today, artists are discovering that markers offer great potential for preliminary work, or work carried out in sketchbooks. The marker medium is also a prime candidate for experimentation. Correction or blending markers are easy to use. Interesting effects can also be made by working into drawings with water, spirit solvents, or bleach (take all necessary safety precautions when working with the latter two substances).

Markers are usually laid one color over another, working light to dark.

Blending pens contain a solvent, and can thus be used to mix marker colors on the support.

THESE TWO PAGES
• SOFT PASTELS
• HALF-LENGTH PASTELS
• HARD PASTELS
• PASTEL PENCILS
• PASTEL SETS

Innovation

Chromacoal is a heat-fixable pastel made by D'Uva (it is also sold in powder format; see page 20). The pastels are soft, and are protected by a paper wrapping. They are fixed by heating the work to 250° F (120°C)—a kitchen oven is recommended, though any radiant heat source will do.

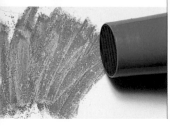

Dry pastels

Pastels are made by mixing pure pigment together with an inert extender, such as French chalk. The pastel is held together with a weak binding medium, usually gum tragacanth, obtained from *Astragalus gummifer*, a shrub found in the Middle East. Adding various amounts of titanium white or zinc white to the pure color pigment results in a range of pastels; the more white added, the lighter the tint. Pastels can have either a square or round profile. They can also vary in length, but are usually about 2½ in (63mm) long. Half-length pastels are also available, and are particularly useful for blocking in color, using direct strokes made with the side of the pastel.

What is the best way of fixing pastels on paper?

A good-quality paper will lessen the need for spraying with fixative, which can diminish certain hard-won effects. A gentle spray can, however, assist in keeping looser pigment on the paper. Framing under glass keeps a drawing free from dust and accidental smudging, but the image should be kept clear of the glass.

Soft and half-length pastels

Characteristics: Soft pastels are the most commonly used pastels, and offer the largest choice of tints and tones. Most have a round profile, and are usually between 2–3 in (50–75mm) long. They sometimes come wrapped in paper to help keep them together, as certain brands are extremely soft and can break very easily.

Ranges of half-length pastels are also available. These are half as long as standard-length pastels. Some better-known brands include Daler-Rowney, which offers 196 colors; Rembrandt, with 20; Schmincke, with 298; Unison, with 162; and Sennelier, who make 552 different color tints and tones.

Advantages: Very bright color range; they take easily to supports.

Disadvantages: Can be messy to use and can crumble easily.

Cost: Pastels are relatively inexpensive, but costs vary from brand to brand. The standard-length pastels may seem expensive, but are actually good value in that they last a long time.

Dry pastels crumble easily.

Large soft pastels

Small soft pastels

Hard pastels

Characteristics: Hard pastels are usually square. Due to their greater density and increased stability, they are generally not wrapped in paper. Their relative hardness is due to more binder being used during manufacture, and results in less crumbling, and the shedding of slightly less pigment powder. They are ideal for blocking in the initial stages of a painting, because they are less likely to fill up the tooth or texture of the support early on. Hard pastels can be sharpened to a point using either a sharp craft knife, or by rubbing the pastel on a fine-grit sandpaper. Daler-Rowney and Conté each offer 48 colors, and Faber-Castell makes a range of 100 colors. Prismacolor has a range of 96 colors that are slightly harder and longer than most other brands of hard pastel, making them much easier to control.

A sharp craft knife is used to sharpen hard pastels.

Advantages: Easier than soft pastels to control as they are less prone to crumbling and shed less pigment powder.

Disadvantages: The color range is less comprehensive than that of soft pastels.

Cost: Relatively inexpensive.

Hard square pastels

Pastel pencils

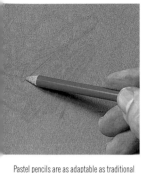

Characteristics: Pastel pencils are made of a strip of hard pastel secured inside a wooden case; they are slightly thicker than traditional colored pencils. While capable of covering large areas with tone and color, pastel pencils really come into their own when used for line work. They are also great for working in detail with soft or hard pastels, and are excellent for sketching. The pencils can be sharpened using a traditional pencil sharpener or a sharp craft knife.

Pastel pencils are as adaptable as traditional colored pencils and graphite pencils.

Some well-known brands include Stabilo Carb Othello, with 60 colors; Derwent, with 90; Conté à Paris, with 48; and Faber Castell, with 60.

Advantages: Very easy to control and clean to use.

Disadvantages: The range of colors is limited. As well, if dropped, the pastel strip will break, making sharpening impossible.

Cost: Inexpensive.

A pencil sharpener or a sharp knife can be used to sharpen pastel pencils.

Hard pastel sets and torchon

Pastel sets

Characteristics: Pastels can be bought either individually or in boxed sets. Some sets offer as few as 12 colors, while others offer many more; Sennelier, for example, offers a huge range of 525 colors (needless to say, this wonderful set is expensive). Some manufacturers also produce boxed sets geared specifically toward artists who wish to paint landscapes and portraits; these hold a selection of colors particularly useful for these subjects.

Advantages: There is no need to agonize over which colors to purchase.

Disadvantages: The initial cost is high, and the color selection may not be ideal.

Cost: Ranges from relatively inexpensive to very expensive.

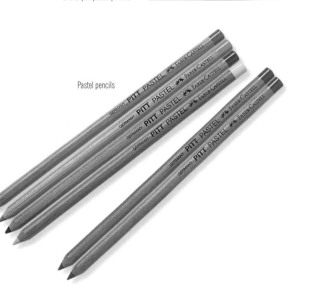

Pastel pencils

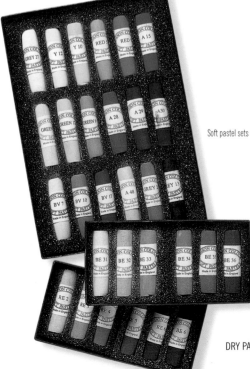

Soft pastel sets

WORKING ON TONED PAPER

A pastel painting can be made on any surface which has a sufficient tooth or textured surface to hold the pigment dust. Working on a surface with a tone or color that is sympathetic to the subject is beneficial for two reasons. First, the inherent dusty quality of pastels means that parts of the support will inevitably show through, and the tone or color can thereby lend an overall harmony to the colors. As well, pastel colors look richer and more intense when placed on a dark or tinted surface.

MIXING PASTELS WITH OTHER MEDIA

Pastels mix particularly well with other painting and drawing media, including colored pencil, watercolor and gouache— even acrylic and oil paints. They also take well to the textured surface of linen or cotton canvas, and to gessoed or primed boards.

Color range and characteristics

Manufacturers' color charts

With pastels, the choice of palette can depend upon the choice of subject—portrait and landscape works, for example, often call for very different color ranges. Any basic set of pastels will give a good color range, which can then be added to as the need arises.

Tints and shades

Pastels can be obtained in an extensive range of tints and shades. Most manufacturers produce a tint chart, in which each tint is coded to indicate its degree of lightness or darkness. This coding is by no means standardized across all brands,

however. For instance, Daler-Rowney codes their colors from 0 (lightest) through 8 (darkest), while Sennelier simply codes each color and tint with its own number; Schmincke gives each color a number, followed by a letter denoting the tint. Further, the color names of one manufacturer may differ from those of another. It is thus worth checking the manufacturer's catalog or color chart to see what the colors look like, and to determine the meaning of the symbols used.

Most brands indicate pigment permanence by a system of stars: the more stars, the greater the degree of permanence (see page 134 for further details). Cheaper

Basic Palette

The palette below is based on the Daler-Rowney range. Note that the names given to specific colors can vary from manufacturer to manufacturer.

CLEANING PASTELS

Using pastels can be a dirty and dusty occupation. Color from one pastel is transferred easily to another of a different color on your fingers; pigment dust from pastels stored together is dispersed, and soon one pastel looks very much like another. In order to clean them, fill a glass jar or box three-quarters full with rice. Place the dirty pastels into the container and secure the lid, then give it a firm shake for a few minutes. The abrasive action of the rice takes away the dirty outer layer of pigment dust, revealing the pastels' true colors hidden beneath.

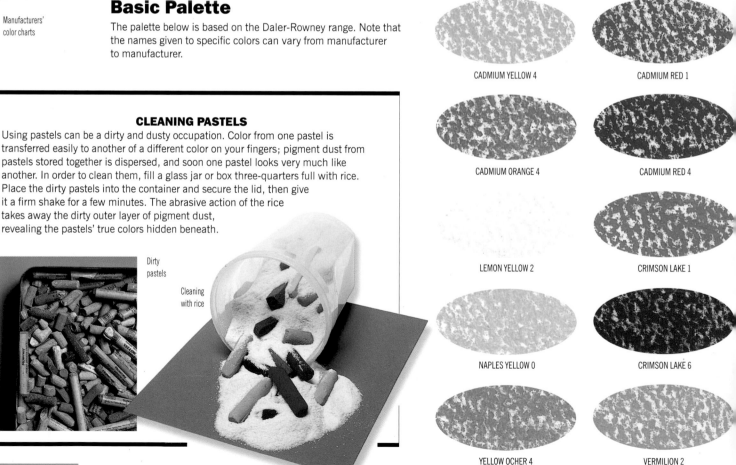

Dirty pastels

Cleaning with rice

CADMIUM YELLOW 4

CADMIUM RED 1

CADMIUM ORANGE 4

CADMIUM RED 4

LEMON YELLOW 2

CRIMSON LAKE 1

NAPLES YELLOW 0

CRIMSON LAKE 6

YELLOW OCHER 4

VERMILION 2

pastel brands are often given descriptive names, with no indication of their permanence. Many manufacturers also list a number or letter indicating the price group into which the color falls (color price varies in accordance with the price of the pigment).

Working with a basic palette

A few carefully chosen colors mixed together are all that is needed to create beautiful pastel paintings. However, if you plan on working in pastel often, it may be worth building up a more extensive color range, tailoring the colors to suit your interests. If your work involves landscape, greens and browns should dominate; if you wish to paint portraits, pinks and ochers may feature heavily.

Can the broken pieces of pastel that accumulate while I work be put to any use?

Put the small, broken bits of pastel aside, as they accumulate. When you have a fairly substantial amount, you can crush them into dust. This dust can be used dry, rubbed into the support to create a colored background. Or, for a different effect, mix the dust with a little bit of water and matte acrylic medium and use it wet.

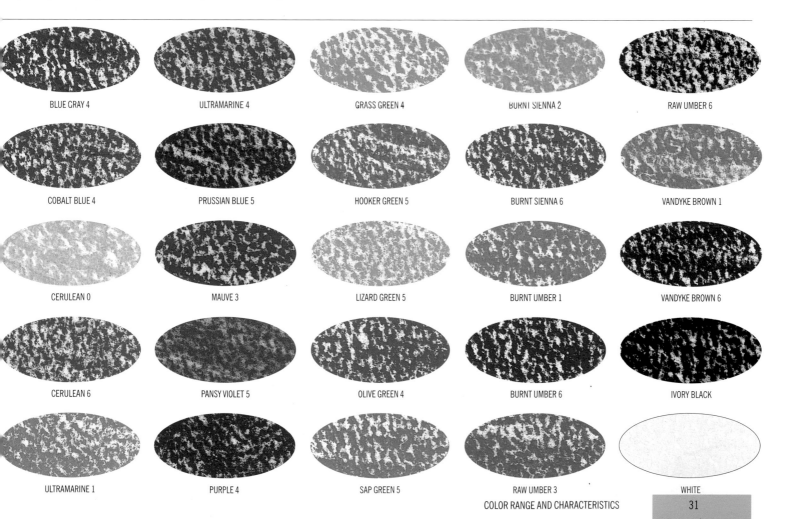

BLUE GRAY 4	ULTRAMARINE 4	GRASS GREEN 4	BURNT SIENNA 2	RAW UMBER 6
COBALT BLUE 4	PRUSSIAN BLUE 5	HOOKER GREEN 5	BURNT SIENNA 6	VANDYKE BROWN 1
CERULEAN 0	MAUVE 3	LIZARD GREEN 5	BURNT UMBER 1	VANDYKE BROWN 6
CERULEAN 6	PANSY VIOLET 5	OLIVE GREEN 4	BURNT UMBER 6	IVORY BLACK
ULTRAMARINE 1	PURPLE 4	SAP GREEN 5	RAW UMBER 3	WHITE

COLOR RANGE AND CHARACTERISTICS

Using dry pastels

There is nothing quite as inspirational as a large tray or box containing a range of new, bright-colored pastels. Using pastels is almost like having color pour from your fingertips. The medium is unique in that it takes many of its techniques from both painting and drawing. A pastel crayon can be used on its side to create broad, painterly strokes that emulate those of an oil painting. Working with the tip of the crayon will allow you to make thinner, crisper marks. With practice, pastel can be an astonishingly versatile medium, capable of producing everything from large, colorful abstract paintings to highly realistic works. Pastels also sit well alongside other materials, and thus work nicely in mixed-media pieces.

Do finished pastel works require special protection?
Pastels should always be kept in dry conditions to prevent them being attacked by mold. One solution is to frame them with an absorbent cardboard backing sheet which has been sprayed with a 25 per-cent disinfectant solution, and then placing a waxed sheet between that and the back board. Pastels bound with a cellulose binder are not as prone to mold as those that are bound with a natural gum binder.

CORE TECHNIQUES

Linear strokes

Linear strokes are usually made using the end or sharp edge of the pastel. These marks can be mechanical and precise, or loose and expressive. Only a small part of the pastel needs to be in contact with the support at any one time in order for it to make linear marks. Using such a small segment of the pastel can, however, be problematic, as the crayon can wear down in that particular place at an alarming rate. Fortunately, a sharp edge can be achieved in several other ways: either by constantly turning the pastel as it is being used, so as to bring a new, sharper profile into contact with the support, or by snapping off pieces of pastel. Another option is to sharpen the pastel to a point, using a sharp craft knife or a razor blade.

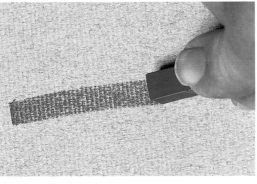
Making a stroke using the square end of a pastel results in a thick line.

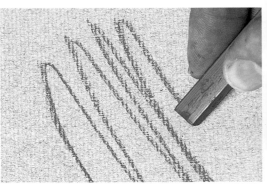
Using the sharp edge of the pastel end gives a finer, more delicate line.

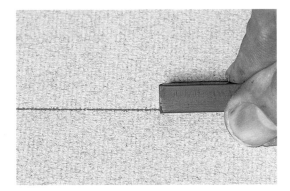
Applying the pastel on the edge which runs down its length results in a straight line.

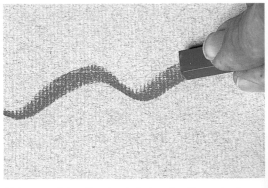
Using a pastel on its edge, but changing the angle of presentation gives a line of varying width.

Side strokes

Side strokes are used to lay in broad, sweeping areas of solid color, or to glaze or scumble one color over another. These techniques can be achieved using either the whole of the pastel, or a shorter length or piece that has been broken off. Applying the pastel using varying pressure results in more or less pigment color being transferred to the support.

Used on its side, the pastel makes a broad area of solid color.

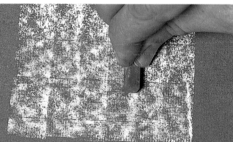

The side of the pastel can also be used to lightly glaze one color over the other.

1. The density of the hatched lines dictates the density and depth of the colors.

2. Crossing one set of lines with another further increases the density of the color and tone.

Hatching and crosshatching

Hatching is a traditional linear technique used to build up tone and solid color. Series of lines are made more or less parallel to each other, the distance between each line dictating the apparent density of color. Crosshatching takes the technique a step further by hatching lines across each other at an angle, increasing the density, and thus the depth of color and tone. In hatching there is very little actual blending of colors—it is the different colors' proximity to each other that results in them mixing optically. Hatching need not look mechanical: lines can be scribbled rapidly and at any angle. The important thing is to keep an open feel to the network of lines, allowing the underlying work to show through.

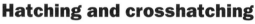

Blending

The powdery quality of pastel makes it possible to blend two or more colors together easily, thus creating other colors. The blending action can also be used to soften and blur edges, modify tone, model form, and to create a range of soft textures and effects. Blending should not be over-used, however, or the work will take on a "soft-focus" look, and will lack bite or depth of color. Blending can be done with a finger, brush, rag, or a blending stump—or anything that mixes and consolidates the pigment powder (see page 35). When using pastels prior to blending, take care not to build up too thick a layer, and do not press the pastel down into the paper texture by applying it with too much pressure; ingrained pastel is difficult to manipulate. It is also important to blend colors before fixing them.

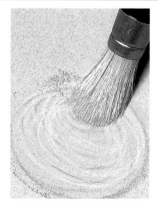

Blending can be done using a stiff bristle brush.

The finger is an ideal tool for blending.

The finger can also be used to vary the tone density.

Scumbling

Scumbling is the term used to describe the modifying of the tone or color of a toned sheet of paper or area of color, using pastel applied in an irregular fashion. This is done by lightly working over the support using the side of the pastel. Traditionally, the term was applied only to light tones applied over dark, but these days it describes the general method, regardless of the colors or tones used. The technique creates subtle areas of broken color and surface texture, and is often used to add subtle interest to otherwise flat, featureless passages of work. Fixing the work between layers enables several layers of different colors to be laid one over the other without disturbing those beneath. The support texture plays an important role in scumbling—the rougher the surface, the greater the degree of scumbling possible.

Fixing

Fixative should not be seen solely as a means of protecting the work upon completion. Used thoughtfully, it enables the artist to work the pastel in several layers without disturbing or mixing with previous layers, helping to keep colors clean and clear. The action of making corrections either with an eraser or by scraping away pastel with a blade can result in the support becoming smooth; a light spray of fixative over the corrected area leaves a slightly rough layer of resin particles, giving enough tooth to pick up further pastel work and disguise the corrected area. Fixative will change the color of lighter areas of pastel, knocking the tone back a little; some pastel artists use little or no fixative for this reason. This tonal shift can also be seen as beneficial, in that the artist can extend his or her palette of colors simply by fixing certain areas and not others.

The spray from fixative contained in a can is very fine.

Using a diffuser results in a spray that is slightly thicker.

The application of fixative will darken the tone of a lighter pastel color.

Pastels and painting mediums

Pastels consist of little more than colored pigments—the same as are used in the manufacture of paint—and as such have the potential to be mixed with oil, acrylic, or watercolor painting mediums. Care needs to be taken not to mix oil-based and water-based mediums, however, and the stability of the support needs to be considered, but the combination has great possibilities. Try working into a pastel painting using water and gum arabic, or with any of the alkyd or acrylic mediums available. Whichever medium you choose, remember that the characteristics of the pastel will change to resemble those created by the chosen painting medium.

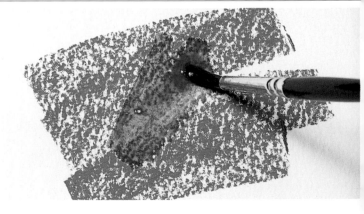

Accessories

FIXATIVE Because the pigment dust sits on the support surface, pastel paintings are extremely delicate, and the image is easily damaged or smudged. In order to prevent this from happening, pastel paintings can be protected by being framed immediately, or by fixing. Fixative is made from resin particles suspended in a spirit solvent, and is applied by spraying onto the work. The colorless spirit evaporates, leaving the resin particles behind to bind the pigment dust to the support. Fixative is available in aerosol cans, bottles that send out a spray using a pump action, or bottles that require the use of a diffuser. Some of the best-known brands of fixative available include those made by Winsor & Newton, Daler-Rowney, Grumbacher, Sennelier, Lascaux, and Talens.

BLENDERS Pastel blenders come in a variety of shapes, sizes, and materials. Traditional blenders are made from soft-paper felt that can be sharpened to a point and cleaned by rubbing on medium or fine-grit sandpaper. Other paper blenders are made of a similar soft-paper felt rolled and pointed at one end. These paper blenders are also known as tortillion, torchons, or stumps. Also available are blenders made from a sponge-like material mounted on a short wooden handle, and brush blenders that resemble very stumpy stencil brushes and come in a range of sizes and degrees of hardness to suit a variety of supports. Sponges and brush blenders can be cleaned using soap and water.

A small piece of pastel is inserted into a holder.

Plastic pastel holder

Metal pastel holder

PASTEL HOLDERS Metal and plastic pastel holders are made to accept regular-sized hard and soft pastels. The pastel is clipped inside the hollow body of the holder, allowing small stumps of pastel to be used with some control. The holders also help workers keep their hands clean.

Liquid fixative

Perfix Colourless Fixative

Spray fixative

Fixative diffuser

Paper pastel blenders

Sponges and brush blenders

Putty eraser

Single-edged blades

ERASERS Traditional latex and plastic erasers are of limited use when working with pastel. The action of the eraser smudges and pushes the pigment deep into the tooth of the support, making it even more difficult to remove. Kneadable putty erasers can be effective, but only if the pastel work is light. Pastel can be more easily removed by using a relatively stiff brush, or by flicking the area with a dry linen or chamois cloth. Traditionally, a bird's wing or several feathers tied together in the shape of a wing were used to brush away pastel. These feather cleaners can still be found (or it is an easy task to make your own). Single-edged razor blades can also be used for scraping off pastel dust in order to make a correction, or to expose underlying colors.

A single-edged razor blade can be used to scrape off pastel.

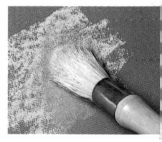
Pastel can be removed using a stiff brush.

STORAGE BOXES AND TRAYS It is essential to keep your pastels from breaking or being damaged when not in use. You will also find that working with pastels is much easier if they are kept clean, and in some kind of order. If you have bought a modest-sized set, chances are that the pastels within are contained in a tray-shaped box. Empty pastel boxes can be bought as well, ranging from those that hold just a few pastels to those with several drawers or trays that can hold up to several hundred. Whichever type of storage box or tray you choose, always buy one larger than you anticipate filling, as with time you will inevitably collect far more than you have room to store. You can also make your own storage tray; simply line a shallow metal or wooden box with corrugated paper.

Makeshift pastel tray

Oil pastels and paint sticks

Oil pastels are a relatively new innovation. Although they superficially resemble the wax crayons so familiar to children, they are far more sophisticated, and the better brands contain more pigment and are more flexible than wax crayons. They are an exciting material that demands a broad approach, and there are many techniques with which to use them. They can be used to produce images that range from expressionistic to photographic in quality.

Oil paint sticks are a far more recent innovation, first appearing during the 1970s. They have only become widely used within the last decade or so, and this increase in popularity has gone hand in hand with an increase in quality. The sticks deliver oil color to the support in much the same way as pastel, and without the need for a brush or palette knife—although both of these tools can be employed if required.

Composition

Oil pastels are made using pigments mixed with an oil-soluble wax and a non-drying binder; these hold the pastels together. After manufacture, oil pastels are enclosed in a wrapper, which not only provides support, but also helps keep the user's hands clean. The manufacturer's details and the color are included on the

USING WHITE SPIRIT OR TURPENTINE

Oil pastels are soluble in white spirit or turpentine, and thus these diluents can be used to create a number of effects, such as blending colors, or thinning the paint for a wash-like effect. Care should be taken not to overwork oil pastels with white spirit, however, as they can easily become thin and muddied. A single deft stroke with a saturated tissue or brush is all that is required.

Oil pastels

Characteristics: Depending on the characteristics of the pigments used, oil pastels can be opaque, semi-transparent, or transparent. Many oil pastels contain no oxidants. Although this helps to keep the colors pure and prevents yellowing, it also means that they never dry out completely. Sennelier makes a specially formulated oil pastel fixative to alleviate this problem.

Advantages: A strong color range is available. As well, they crumble and smudge less than dry pastels, and require no fixative.

Disadvantages: They can be difficult to use on a small scale, and require practice to achieve good results. They are also harder to blend than dry pastels.

Cost: Similar to that of soft pastels.

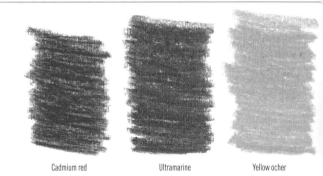

| Cadmium red | Ultramarine | Yellow ocher |

Cadmium red is an example of an opaque oil pastel color, while ultramarine is semi-transparent, and yellow ocher is transparent.

SHARPENING

The relative stiffness of oil pastels make them easy to sharpen using a sharp utility knife, or by rubbing on an abrasive surface. The shaped end of a paint stick can be preserved by constantly turning the stick.

Oil pastel boxed sets

Oil pastels

Manufacturer's color chart

wrapper. While dry pastels are known for their rich texture and subtle colors, oil pastels make thicker strokes, and the colors are more intense. Oil pastels are also harder than dry pastels, and thus crumble less, but they are more difficult to blend. They also smudge less than dry pastels, and require little or no fixative.

Paint sticks are made using fine-quality pigments blended with drying oils and specially blended waxes that enable them to be held in a stick form. The stick develops a thin film over its surface, which should be removed from the end before starting work; the film will re-form over the paint surface if left unused. Paint sticks come wrapped in paper or thin card, upon which the manufacturer's details and the color are written.

Similarities and differences

Both oil pastels and paint sticks can be worked into using oil painting mediums and techniques. They are, however, fundamentally different in that oil pastels never harden completely, while paint sticks eventually dry completely to give a durable film. While oil pastels can be used by themselves on unprimed paper, paint sticks should only be used on supports that have been prepared and primed. Both media are often used together with traditional oil paint: oil pastels are perfect for drawing or sketching in a work prior to painting, and paint sticks can be seen as yet another way of applying oil paint.

THE EFFECTS OF HEAT ON OIL PASTELS

At room temperature, oil pastels maintain a certain hardness. As the temperature rises, however, their malleability increases; in fact, if your hands are hot while you are working, the pastel may well start to putty. The softer the pastel becomes, the harder it is to control, and the more color will be deposited on the drawing surface.

Paint sticks

Characteristics: Like oil paints, paint sticks are sold in series according to the cost of the pigments used, and are coded according to permanence (see page 134). Some paint sticks are thixotropic, with the color becoming thin and creamy when rubbed onto the support with pressure and speed. Paint stick sizes vary according to brand, but can be generally categorized as small, medium, and large.

Advantages: Working with sticks encourages a direct approach, and brushes and palettes are not needed.

Disadvantages: Due to the wax content, paint sticks should not be used for extensive underpainting prior to using traditional oils. As well, they can only be used on surfaces that have been prepared and primed.

Cost: Comparable to similar sizes and colors in traditional tube oil paints.

The stick develops a thin film over its surface, which needs to be removed before use.

Paint sticks are available in a variety of sizes.

Paint stick boxed set

Color range and characteristics

As with dry pastels, the names given by manufacturers to the hues of oil pastels and paint sticks can be wildly different. The names used in the list below are common to most of the ranges. By mixing these colors with mediums and solvents, it is possible to create a wide range of blends and tints, thus extending the palette.

Oil pastels

While the choice of oil pastel colors available has increased dramatically in recent years, their price has remained consistent across the range. Sennelier currently produces 78 traditional colors, together with 16 metallic and fluorescent colors; Inscribe offers 72 colors; Conté, 48 colors; Caran d'Ache, 96 colors; Grumbacher, 48 colors; and Cray-pas, 84 colors. The Japanese-made Holbein range consists of 225 colors based on 45 different hues. The brands are all intermixable.

Paint sticks

Although smaller than that of traditional oil paints, the range of paint stick colors is fairly substantial. Winsor & Newton offers 34 colors and a colorless blender; Shiva offers 36 colors, three of which are iridescent; and Markel makes 60 colors, 14 of which are iridescent.

Basic palette

The colors shown here form the basic palette of most professional artists. A broad spectrum of hues can be mixed using these colors.

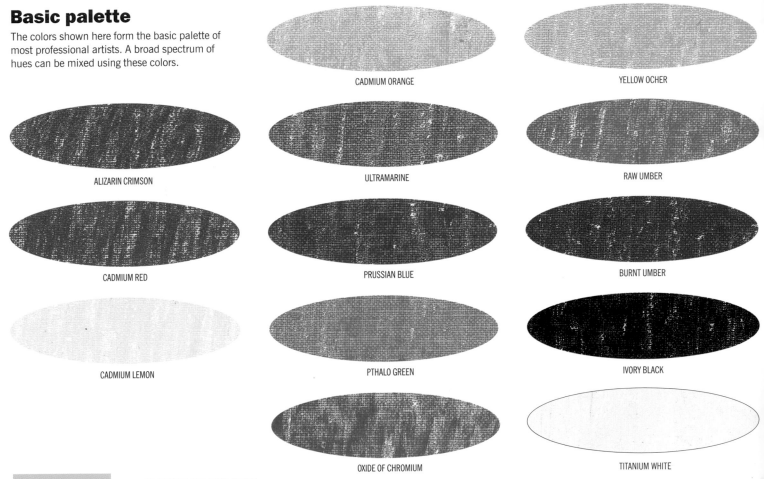

CADMIUM ORANGE

YELLOW OCHER

ALIZARIN CRIMSON

ULTRAMARINE

RAW UMBER

CADMIUM RED

PRUSSIAN BLUE

BURNT UMBER

CADMIUM LEMON

PTHALO GREEN

IVORY BLACK

OXIDE OF CHROMIUM

TITANIUM WHITE

Accessories

Oil pastels and paint sticks can be manipulated in much the same way as oil paint, and thus many of the mark-making tools used for oil painting can also be used on these media. Do not, however, be tempted to employ the same tools you use for dry soft pastel work—they will be ruined quickly by oil pastels and paint sticks.

Blending stick

BRUSHES As with oil paint, stiff brushes—either of natural bristle or synthetic fiber—can be used to manipulate and blend oil pastel colors together. The color left on the surface by oil pastels is thin and stiff, however, making moving and blending difficult. A brush dipped in a solvent such as turpentine or mineral spirits, will enable the pastel to move easily. Color from paint sticks is relatively loose, and can be spread easily by brush.

Color from oil pastels can be easily thinned using white spirit.

Round

Filbert

Flat

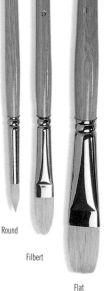

Colors can be blended together using a colorless blending stick.

BLENDING STICKS Many paint stick manufacturers also produce a blender stick or bar. This looks like any other paint stick, but is made from a combination of wax and oil; it contains no color pigment and resembles a milky, clear candle. Rubbing a blender bar over a work has the effect of smoothing out the color without making it lighter—the bar will thin the color, making it more transparent. The bars are manufactured specifically for use with paint sticks, but they can also be used with oil pastels.

PAINTING AND PALETTE KNIVES Painting and palette knives are invaluable for working with oil pastels and paint sticks, not only to manipulate and blend the paint, but also to scrape it off the surface when creating textural and sgraffito effects. Sgraffito effects, which are made by scratching through layers of color to reveal the underlying layers, can be done with any sharp object, including selected household and hardware tools (see page 41).

MEDIUMS, SOLVENTS, AND VARNISHES All oil-painting mediums and solvents, including texture gels, can be used with both oil pastels and paint sticks, and the use of these mediums and solvents will increase the material's potential greatly. For best results, experiment with whatever is available, but bear in mind that when using oil mediums and solvents with oil pastel, the work will need to be done on a properly primed and protected support.

Oil paint varnishes are not recommended for use, however, because they dissolve the wax content of the pastels and sticks. Special paint-stick varnishes are available, including an isolating varnish and a finishing varnish made by Winsor & Newton.

Specially formulated paint stick varnishes

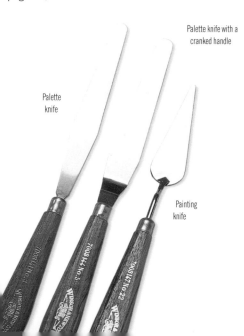
Palette knife with a cranked handle
Gel medium
Painting medium
Palette knife
Painting knife
Linseed oil
White spirit

Using oil pastels and paint sticks

Oil pastels and paint sticks are quite robust, and encourage a bold, direct approach. Generally speaking, they are not suitable for creating smaller-scale, detailed drawings; the sticks are simply too chunky. It is best to work on a large scale, using vigorous strokes.

Most of the techniques used for oil painting can also be used with both oil pastels and paint sticks; these techniques are explained in the section on oil painting (see pages 50–51). Several of the techniques that work especially well with oil pastels and paint sticks are shown here.

Can oil pastels and dry pastels be used together in the same work?
Yes, so long as the dry pastels have been applied and mixed using either oil-based mediums and solvents or acrylic mediums.

Can oil pastels be used on an unprimed surface?
Unlike oil paint, oil pastels can be used on any surface, as the constituents in oil pastels do not corrode paper or fabric. However, like oil paint, although oil pastel color may feel dry, it never really dries completely due to its antioxidant component.

CORE TECHNIQUES

Mark-making

Oil pastels can be used to create combinations of linear and side strokes in exactly the same way as soft pastels. Because of their solidity, paint sticks can retain a reasonable edge or a bullet-shaped point, thereby facilitating various linear strokes as well. Although paint sticks are difficult to use on their sides, they are usually thick enough for the color to be spread easily, enabling large areas to be covered with color quickly. Due to their thick consistency, both pastels and sticks can be worked easily in layers, and there is no need to wait for long periods of time until each layer is dry.

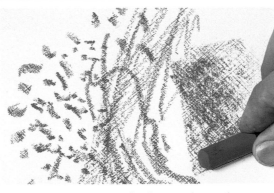

Oil pastels can be used to make fine linear strokes, or they can be used on their sides to block in solid areas of color.

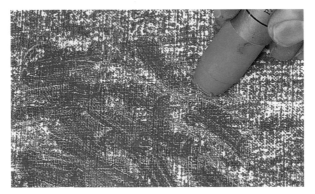

Paint sticks can be built up in layers, like traditional oil paint.

Scumbling

In this technique, one or more colors are applied over one another in light veils, so that each color partially covers the one below. Often used for skies, or to enliven backgrounds, the effect is much more exciting than that of flat, blended color. Scumbling can either be done with short, light side-strokes, or in a circular motion.

1. This technique is essentially free and broad, but it can also be controlled. It is used here to create a cloud effect.

2. Various light-toned oil pastel colors are scumbled over one another, using side-strokes following different directions.

Using mediums

The use of oil mediums and spirit solvents increases the potential of both oil pastels and paint sticks. These can be used either by dipping the pastel or stick into them, resulting in the color flowing more easily; by working into a painting with the mediums using a brush; or by spreading pure solvent or medium over the support and working into the wet surface with the stick or pastel. Experimentation will bring the most satisfactory results, but do not forget to observe the "fat over lean" rule (see page 50) when using mediums.

Using white spirit
1. Oil pastel glides onto a support that has been wetted with white spirit.

2. A second color is easily blended together with the first.

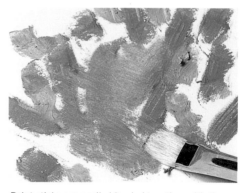

Oil pastels soften and blend together easily using solvents like mineral spirits or turpentine.

Paint stick color is thick, but it can be blended without solvents using a stiff bristle brush.

Paint sticks are easily blended together with the help of a dry brush.

Sgraffito

The consistency of oil pastels and paint sticks is perfect for making effects using sgraffito or scratching techniques. Color can be scraped off using palette or painting knives, or razor blades, to leave large areas of textured surface. Alternatively, a range of linear effects can be made by scraping and scratching through layers of paint, using any available object with a sharp edge or point. Another sgraffito alternative is to drag into the work using the hard point of a graphite stick or a colored pencil.

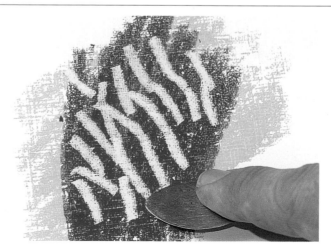

A rich tapestry of marks can be made by scratching through one layer of color to reveal the layer beneath.

Innovation

Matrix Paint Systems Inc. have introduced Genesis heat-fixable oils, which are specially formulated not to dry until exposed to temperatures around 120 °C (250 °F). The paint thus remains workable for a long time—work can be stopped and picked up again weeks later, with no difference in the paint's consistency. Seventy-eight colors are available, plus black and white, and come in 1 fl oz (35ml) jars. Glazing, thinning, and thickening mediums can be purchased as well, as can a heat gun and a small oven large enough to hold a 20 x 24 in (500 x 600mm) canvas.

Oils

Oil paints as we know them today have been around since the early Renaissance. Oil mediums had been available in Northern Europe for some time before that, but they were not widely used, as the lengthy time they took to dry was considered a major drawback. The popularity of oils increased considerably upon the discovery that their drying time could be sped up by the addition of metallic oxides during processing.

Changing methods

Oil paint was traditionally built up in a series of thin layers or glazes, with each new glaze consolidating and modifying the last. Pigments needed to be ground and colors prepared, making oil painting a slow process. When paint prepared by artists' colormen began to become available, the process was simplified. The increased portability of the new materials made it possible for work to be done on location. Brushwork became more expressive, with painters taking a more direct approach. Artists began producing work *alla prima*, an Italian phrase meaning "at the first," which describes a painting that has been completed during a single sitting. Such works are marked by a spontaneity and simplicity often lacking in multi-layered, glazed works.

Tubes

Characteristics: Oil paint was originally stored and supplied in skin bladders. These were later supplanted by metal and glass syringes, and then, finally, by collapsible tubes. Artists would buy these tubes empty, filling them with their choice of color. Today, oil paint is sold in a variety of tube sizes, ranging from smaller 0.75 fl oz (22ml) tubes to huge, fat 10 fl oz (300ml) ones. Some manufacturers even sell cans of oil paint, containing anywhere from 8.5 fl oz (250ml) up to 0.65 gal (2.5L) of paint.

Tube tops should be kept clean, to prevent the paint from drying out.

Advantages: Buying by tube will enable you to buy the exact amount of paint to suit your requirements. If working outdoors or on location, smaller tubes are ideal. If working in a studio and with large amounts of color, large tubes or tins are more economical.

Disadvantages: The tops of tubes can get thick with paint, making caps difficult to replace. The lids on cans of paint need to be secured tightly in order to prevent a skin from forming over the paint.

Cost: Cans and larger tubes are more expensive, but if a lot of paint is being used, they are far more economical than smaller-sized tubes.

Standard-sized tube colors

Tins of artists' colors

Tubes of artists' colors

Painting sets

Characteristics: Various sizes of painting sets are available. Besides containing a range of paints, many painting sets also contain mediums, thinners, palettes, and brushes. They are attractive to look at, and can be a good introduction to oil paint. Empty boxes are also available for filling with your own selection.

Advantages: Everything you need to get started is provided.

Disadvantages: The colors and materials included in the set may not be the ones you need.

Cost: Basic sets are comparable with buying individual tubes, while wooden presentation boxes can be very expensive.

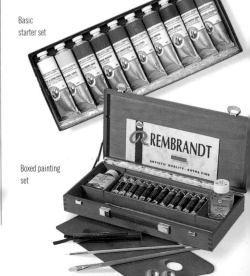

Basic starter set

Boxed painting set

Composition

Oil paint is made by mixing pigment with an oil medium or vehicle. The purpose of the medium is to bind and hold the pigment together to facilitate its workability, to secure it to the support, and to act as a protective film when dry. All manufacturers prepare their paint in this way. The constituency of the paint can vary slightly, depending on the pigments and the amount of binder used. Paint can be used by the artist straight from the tube, or it can be modified by the addition of oil mediums and thinners. Recent advances in the modification of oil mediums have resulted in the exciting new development of oil paint that can be mixed with both oil and water—a boon to those who are allergic to or irritated by oil solvents or thinners.

Artists' and students' quality

Artists' quality paints are made from finely ground pigments of the best quality, bound in the best oils. The colors are very strong, as they contain a substantial amount of pigment. Each color is priced separately, according to series; the cost reflects the cost of the pigments used to create the color. Depending on the manufacturer, a series can run 1, 2, 3, 4, 5, 6, or A, B, C, D, E, F— higher the number or letter, the higher the cost.

Students' quality paints are made from cheaper pigments—extenders are often added to bulk out the pigment content. They are very workable, and are inexpensive (all colors cost the same). The color range, however, is narrower than that of artists' quality paints.

PERMANENCE RATINGS

Like many other pigmented mediums, oil paints are given a star or letter rating (typically found either on the tube's label or in the manufacturer's catalog) which signifies the pigment's permanence: **** or AA = Permanent, *** or A = Normally Permanent, ** or B = Moderately Permanent, and * or C = Fugitive. (See page 134 for more detail.)

Alkyd oil paints

Characteristics: Made from a synthetic resin, alkyd oil paints have a similar consistency to traditional oil paints, and are used in the same way. They can be mixed with traditional oil paint and traditional oil paint mediums and thinners. The difference between these paints and traditional oils is the drying time— alkyd oil paints dry much faster, and each color dries at the same rate. The paint is extremely tough when dry. The range of colors is not as extensive as that of traditional oils. The Winsor & Newton Griffin range offers 42 colors, available in 0.67 fl oz (20ml) and 2 fl oz (60ml) tubes, with larger 4 fl oz (120ml) and 6.75 fl oz (200ml) tubes of Flake and Titanium White. The paints are arranged in three series/price bands.

Advantages: Due to their rapid drying time, these paints are ideal for thin layers and glazes. They are also useful for thick underpainting and impasto.

Disadvantages: They cannot be used over traditional oils, as the difference in drying times could cause stability problems.

Cost: Comparable with traditional oil paints of similar quality.

Alkyd oil paints

Water-mixable oil paints

Characteristics: Water-mixable oil paint is made using pigments bound together in a linseed or safflower oil vehicle that has been modified for solubility in water, as well as conventional oil thinners. The resulting paint can be used and mixed with conventional oil paints and mediums, or it can be used with its own range of water-mixable mediums. The mixing of conventional oil color and mediums into this type of paint leads to a progressive diminishing of its ability to be mixed with water.

Water-mixable oil paints can be used in the same way as traditional oil paints.

This paint was originally formulated by the American manufacturer Grumbacher in 1993. Known as "Max," the range is named after the company's founder, and consists of 60 colors, available in 1.25 fl oz (37ml) tubes, with Titanium White available in 5 fl oz (150ml) tubes. The price of the paint varies according to color.

Advantages: This type of paint can do everything conventional oil paint can do. As well, there is no need to use pungent solvents, to which many people are allergic.

Disadvantages: None.

Cost: Comparable with traditional oil paints of similar quality.

Water-mixable oil paint

Innovation

Grumbacher have recently introduced a follow-up range of water-mixable oils to the Max range, called "Max 2." When mixed with conventional oils in a ratio of 2 to 1, these oils can still be cleaned up using soap and water. Winsor & Newton have recently launched their own brand of water-mixable oils called "Artisan." This brand is available in 40 colors, and comes in 1.25 fl oz (37ml) tubes. Of these 40 colors, 31 are also available in 4 fl oz (120ml) tubes. The Artisan brand also has its own extensive range of mediums.

Innovations
• **IRIDESCENT WHITE** This new white color contains tiny particles of mica. When mixed with a transparent color, it becomes pearlescent.

• **SOFT MIXING WHITE** Formulated by Winsor & Newton, this new white is a soft, non-sticky blend of Titanium and Zinc White.

Color range and characteristics

The range of oil paint colors varies according to brand. All manufacturers carry the standard colors, as well as colors that closely resemble the standard ones which bear names specific to the brand. There are marginal differences between some colors that carry the standard names; this is due to the slightly different way that each manufacturer formulates the color. However, all colors and brands of oil paints are intermixable. The question of which colors and brands to choose is purely a matter of individual taste. In the artists' quality range, Winsor & Newton currently lists 113 colors; Schminke's Mussini consists of 118; Sennelier has 110; and Old Holland's

huge range has 168 colors. All paints are graded for permanence using specific codes (see page 134). Students' quality ranges usually consist of fewer colors than those of artists' quality.

Working with a basic palette

Oil colors are easy to mix together; only a few different colors are needed to create a wide range of color tints and tones. Given time, most artists arrive at a basic range of colors from which, through experience, they are able to mix most of the colors they need.

Working with a basic, limited palette is good practice,

Basic Palette

The eleven colors shown here form the basic palette of most professional artists. A broad spectrum of hues can be mixed using these colors.

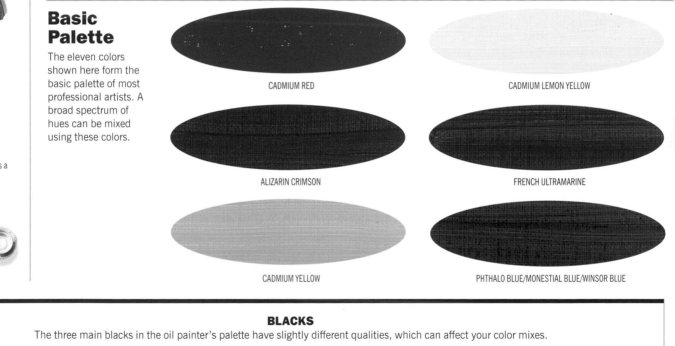

CADMIUM RED

CADMIUM LEMON YELLOW

ALIZARIN CRIMSON

FRENCH ULTRAMARINE

CADMIUM YELLOW

PHTHALO BLUE/MONESTIAL BLUE/WINSOR BLUE

BLACKS

The three main blacks in the oil painter's palette have slightly different qualities, which can affect your color mixes.

IVORY BLACK

MARS BLACK

LAMP BLACK

• **IVORY BLACK** The darkest—and most popular—of all of the blacks, this shade has a slight brown tinge. It is made from charred bones, and has good tinting strength. When mixed with yellow, an interesting range of dark greens is created.

• **MARS BLACK** A permanent black made from black iron oxide. It is dense and opaque, with a brown cast.

• **LAMP BLACK** Made from soot, this black has a high tinting strength. It dries very slowly, and thus should not be used for extensive underpainting.

Manufacturers' color charts

and will help consolidate your color-mixing capabilities. A typical palette usually includes a white, a cool and a warm range of the primary colors, a strong green, and some browns (these are difficult to mix cleanly). Black is sometimes included, but can also be easily mixed. Once you have created the colors you want, it is easy to forget how they were made the next time you want to use them. Creating and annotating rough color swatches will help you remember how your colors were obtained each time you paint.

Do I have to incorporate all of the colors shown below in my basic palette?

The colors shown below are only suggestions for a basic palette—this list is by no means absolute. However, experience has shown that these colors form a versatile, useful palette, and are capable of mixing together to create a wide range of colors. If you wish to add another color to the palette, by all means do so.

VARIATIONS IN TINT AND HUE

It should be noted that oil pigments can vary in tint and hue and in handling characteristics, depending on the manufacturer. This is especially so with the earth colors—umbers, ochers, and siennas—as they are natural pigments, and will thus vary according to source. For example, some burnt siennas have a yellowish tint, while others are more reddish.

PHTHALO GREEN /MONESTIAL GREEN/WINSOR GREEN

RAW SIENNA

BURNT UMBER

PAYNES GRAY

TITANIUM WHITE

- **CADMIUM RED** A strong, opaque, slow-drying red with good tinting strength. Mixes well with blues to create a range of browns, and with Cadmium Yellow to create a strong orange. The color is permanent.

- **ALIZARIN CRIMSON** A transparent, slow-drying red that has good tinting strength. There may be concern as to its permanence when used thinly. A good alternative is Permanent Rose, as this is lighter and completely lightfast. Both colors mix well with strong blues to create a range of purples and violets.

- **CADMIUM YELLOW** A permanent, slow-drying yellow with good tinting strength.

- **CADMIUM LEMON YELLOW** A permanent, slow-drying yellow that mixes well with blues to create a range of strong greens.

- **FRENCH ULTRAMARINE** A permanent, slow-drying blue with good tinting strength. Mixes well with alizarin colors.

- **PHTHALO BLUE/MONESTIAL BLUE/WINSOR BLUE** These are three different names for the same color, a strong, semi-transparent blue. It possesses an incredibly high tinting strength, and thus must be used carefully, or it may overpower other colors. Slow-drying and permanent.

- **PHTHALO GREEN/MONESTIAL GREEN/WINSOR GREEN** These are three different names for the same color. It has a very high tinting strength, and mixes well with yellows to create a range of vivid greens. Slow-drying and permanent.

- **RAW SIENNA** A transparent, quick-drying color that is permanent and inexpensive. Mix with Cadmium Yellow to create a bright ocher.

- **BURNT UMBER** A permanent, very quick-drying, semi-transparent color. When mixed with Phthalo Blue or Ultramarine, a near-black color is created.

- **PAYNES GRAY** A permanent gray. When mixed with Burnt Umber, a near-black color is created. Good for modifying other colors. A good base for a range of grays.

WHITES

There are several different types of white oil paints available, each with its own unique characteristics. Some have been specially formulated for a particular use.

- **TITANIUM WHITE** An inexpensive, pure white with excellent tinting strength. Mixes well with other colors. The pigment is carried in safflower oil, which makes it slow-drying.

- **UNDERPAINTING WHITE** This is very similar to Titanium White, but it is made using an alkyd resin or linseed oil rather than the slower-drying safflower oil. Like all alkyd-based paints, this color dries relatively quickly and is stable, even when used thickly.

- **FOUNDATION WHITE** This type of white uses a lead pigment and is ground in linseed oil. It is recommended for priming, and for works in which a good deal of white is to be used in layers. It is quite dry, containing very little oil, and is toxic.

- **FLAKE WHITE** This brilliant, lead-based white is very opaque and flexible. It is quick-drying, and will help accelerate the drying time of any color it is mixed with. The paint is toxic.

- **ZINC WHITE** This is a thin, semi-opaque white that is often used on works that involve a good deal of glazing.

- **CREMNITZ WHITE** A lead-based white with a stiff, stringy consistency. The paint is toxic.

THESE TWO PAGES
- THINNERS AND SOLVENTS
- ALKYD MEDIUMS
 AND GELS

Thinners, mediums, and varnishes

A certain degree of mystery and confusion surrounds thinners, mediums, and varnishes. This is not surprising, considering that, to a certain extent, they are interchangable. Put simply, both thinners and solvents dilute paint and thin it out. They can be used alone, or mixed with various oils and varnishes to create mediums. Mediums are used to alter the characteristics of paint, helping it to flow more smoothly, become more transparent, or dry more quickly. They must be used carefully, as the oils, waxes, and resins in their composition all dry at different speeds. Adding too much medium, or adding it at the wrong point in the painting process can result in the paint cracking. Varnish is made from natural or synthetic resin. When dry, it forms a tough protective coating on the surface of the finished painting. Varnish can also be mixed with a diluent to form a paint medium.

A large range

Most general art supply stores stock an extensive range of standard oil thinners, mediums, and varnishes, including many that have been specially prepared for specific uses. Pamphlets detailing composition and relevant technical information generally accompany most of these products.

FLAMMABILITY
Rags and papers that have been soaked in solvent can spontaneously combust when packed together in a confined space, so take care when disposing of these materials.

Innovation
Made from a blend of organic materials which have been specially formulated as non-flammable and non-toxic, a new product called Turpenoid Natural is now available. Compatible with both oil and alkyd paints, it is used in the same way as turpentine and white spirit, but it evaporates much more slowly than these traditional mediums. The medium has a light citrus scent.

Thinners and solvents

TURPENTINE Distilled from pine gum, turpentine is colorless, slow to evaporate, and has a strong smell. Its use will dull the paint slightly. Use good-quality turpentine for painting; cheaper-quality turpentine from hardware stores can be used for washing brushes and cleaning palettes.
Advantages: An effective solvent.
Disadvantages: Possesses a strong smell; can cause an allergic reaction.
Cost: Inexpensive.

MINERAL SPIRITS Mineral (white) spirits are a by-product of petroleum. They are relatively quick to evaporate, and do not deteriorate in storage.
Advantages: Not as strong as turpentine, nor do they have turpentine's distinctive smell.
Disadvantages: Can be an irritant.
Cost: Even less expensive than turpentine.

LOW-ODOR THINNERS Low-odor thinners evaporate slowly and do not deteriorate. Sansodor, made by Winsor & Newton, is one well-known brand.
Advantages: Pleasantly odorless.
Disadvantages: Slow-drying.
Cost: Expensive.

SPIKE OIL Made from the leaves and stems of the lavender plant.
Advantages: Has a wonderful smell, and is less likely to cause allergic reactions and irritations than turpentine.
Disadvantages: Slows down drying time, which can be problematic if the technique you are using involves the application of thin layers of paint.
Cost: Very expensive.

CITRUS SOLVENT Thicker than turpentine and mineral spirits, citrus solvent is strong and slow to evaporate.
Advantages: Less likely to cause allergic reactions.
Disadvantages: Slows down drying time.
Cost: More expensive than mineral spirits.

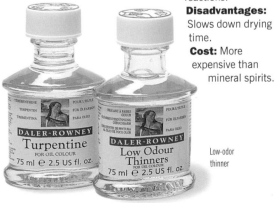

Turpenoid

White spirit

Spike oil

Turpentine

Low-odor thinner

Winsor & Newton, Daler-Rowney, Lukas, LeFranc & Bourgeois, Old Holland, Spectrum, Gamblin, and Grumbacher all produce a range of good-quality products.

Using thinners and solvents

Thinners and solvents should be used only a little at a time. As the thinner or solvent becomes dirty, it can be transferred to a larger jar. In time, the sediment will settle, allowing the cleaned thinner or solvent to be separated out. The thick, solid, dirty pigment sediment should then be disposed of at the dump, and the cleaned thinner or solvent can then be reused for cleaning brushes and palettes.

Are thinners and solvents toxic?

Turpentine is the most harmful of all thinners and solvents. It can irritate the skin and give the user a headache (white spirit can be used in its stead). That said, any type of diluent can be dangerous if not used with care. The fumes are rapidly absorbed through the lungs, and many thinners and solvents can be absorbed through the skin as well. When using thinners and solvents, always read the manufacturer's warning on the label, and follow instructions for use very carefully. As a general rule, you should avoid inhalation of all thinners and solvents, use them in a well-ventilated room, wear rubber gloves, and do not eat, drink, or smoke in the studio.

USING ALKYD MEDIUMS
The range of alkyd mediums and gels available has been designed for use with both oil and alkyd paints; they can also be used with water-mixable oils. By contrast, varnishes made with synthetic resins cannot be mixed with oil paint as a medium.

Alkyd mediums and gels

LIQUIN This medium was developed over 40 years ago by Winsor & Newton, and is popular and easy to use. It increases the flow of oil and alkyd colors.
Advantages: An excellent, quick-drying painting medium.
Disadvantages: Should not be used over work that has been painted using slow-drying oils.
Cost: Inexpensive.

WINGEL A gel medium manufactured by Winsor & Newton. When used straight from the tube, it mixes with the paint to produce a stiff paste that is ideal for creating expressive brush strokes. When worked with a palette knife, it loosens into a liquid that is suitable for glazing and fine line work.
Advantages: Increases paint flow and speeds up drying time.
Disadvantages: Should not be used over work that has been done with slow-drying oils.
Cost: Relatively inexpensive.

OLEOPASTO Another Winsor & Newton product, this stiff, translucent gel medium is designed for mixing with paint in order to thicken and extend it for texture and impasto work.
Advantages: An excellent impasto medium.
Disadvantages: None.
Cost: Can get expensive if a large amount is needed.

ALKYD FLOW MEDIUM A thin, free-flowing medium from Daler-Rowney, designed to increase the flow and transparency of oil colors.
Advantages: Very easy to use.
Disadvantages: Should not be used over work that has been done with slow-drying oils.
Cost: Relatively inexpensive.

ALKYD GEL MEDIUM Made by Daler-Rowney, this gel medium creates a tough glaze when dry, but has a minimal effect on the consistency of the paint.
Advantages: Easy to use.
Disadvantages: Should not be used over work that has been done with slow-drying oils.
Cost: Relatively inexpensive.

Alkyd glazing medium

Liquin

Alkyd gel medium

Oleopasto

Wingel

Alkyd flow medium

Innovations

- **WATER-MIXABLE OIL PAINTING MEDIUM:** This medium thins the constituency of water-mixable oil colors, improving their flow. It dries slowly and remains flexible, and can also be used as a retouching varnish on sunken colors.
- **WATER-MIXABLE FAST-DRYING MEDIUM:** Resistant to yellowing, this fast-drying medium improves flow and increases the gloss and transparency of colors.
- **WATER-MIXABLE LINSEED OIL:** Reduces and thins the consistency of paint. It also improves flow, gloss, and transparency.
- **WATER-MIXABLE STAND OIL:** Increases flow and transparency, and allows for smooth brushwork and fine detail.
- **WATER-MIXABLE IMPASTO MEDIUM:** This medium can be mixed with paint to create impasto and textural effects. It allows paintwork to be built up in several layers and speeds up drying time.

Mediums

COLD-PRESSED LINSEED OIL This oil is refined without the use of heat. Slightly yellow in color, it is used to reduce the consistency of paint, and to increase its gloss and transparency. It is also used to smooth out paint and reduce brushmarks.
Advantages: Improves the handling of paint.
Disadvantages: None.
Cost: Expensive.

REFINED LINSEED OIL Pale yellow in color, this oil is refined by steam-pressing, and then neutralized with an alkali solution. It increases the gloss and transparency of the paint in the same way as cold-pressed oil, but is less expensive.
Advantages: Improves the handling of paint.
Disadvantages: None.
Cost: Inexpensive.

BLEACHED LINSEED OIL Also known as sun-bleached linseed oil, this pale oil is looser than refined or cold-pressed oil. It is used to improve the flow of paint, and dries slightly faster than refined or cold-pressed oil.
Advantages: Increases the viscosity of the paint.
Disadvantages: None.
Cost: Slightly more expensive than refined linseed oil.

THICKENED LINSEED OIL Exposure to the air oxidizes the oil, leaving it thicker and more viscous than the other linseed oils. It still thins the paint, but brush and textural marks are retained. It is quick-drying, as it is already partly oxidized.
Advantages: Speeds up drying time.
Disadvantages: None.
Cost: Expensive.

STAND LINSEED OIL Stand linseed oil is made by heating the oil in order to thicken it. This type of oil is slow-drying, but produces a very tough paint film. It is often used in glazing medium recipes.
Advantages: Helps create an excellent, tough glazing medium.
Disadvantages: When mixed with certain solvents and left to stand for some time, it has a tendency to separate out.
Cost: Can be expensive.

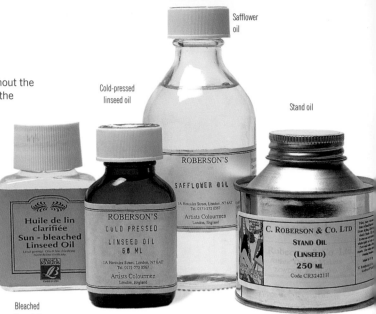

Safflower oil

Cold-pressed linseed oil

Stand oil

Bleached linseed oil

POPPY OIL Poppy oil is extracted from the seeds of the opium poppy. This type of oil is not as durable as linseed, but it is clear, and is less likely to yellow when mixed with white or pale colors.
Advantages: A clean, non-yellowing oil.
Disadvantages: Takes a long time to dry.
Cost: Inexpensive.

SAFFLOWER OIL A pale oil from India that slows down the drying time of paint. It is often used in the manufacture of white- and pale-colored paint.
Advantages: A clean, non-yellowing oil.
Disadvantages: Takes longer to dry than linseed oil.
Cost: Can be expensive.

Water-mixable oil painting medium

Water-mixable stand oil

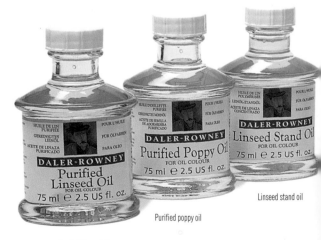

Water-mixable oil fast-drying medium

Purified linseed oil

Purified poppy oil

Linseed stand oil

Varnishes

DAMMAR VARNISH Dammar is made from a natural resin collected from conifers found in Malaysia and Indonesia. The resin crystals are dissolved in turpentine. This varnish is slightly yellow, and can seem a little cloudy, but it becomes clear when dry. If used thinly, the varnish dries to leave a hard, slightly glossy surface. A higher gloss can be achieved by giving the work a thicker coat.
Advantages: A quick-drying varnish.
Disadvantages: When applied under damp conditions, moisture can become trapped beneath the varnish and cause a bloom to develop.
Cost: Relatively inexpensive.

MASTIC VARNISH Mastic is a resin varnish that is slightly yellow and dries quickly to a high gloss. It has a golden hue.
Advantages: A quick-drying varnish.
Disadvantages: It becomes brittle with age. As well, it can be difficult to store, as it deteriorates when it comes into contact with the air.
Cost: Relatively inexpensive.

WAX VARNISH Made from beeswax mixed with mineral spirits, wax varnish is applied to the surface, then brushed out thinly using a stiff brush. Once dry, the waxed surface is buffed up using a lint-free rag. The more the surface is buffed, the higher the sheen.
Advantages: Simple to use and easy to remove.
Disadvantages: None.
Cost: Relatively inexpensive.

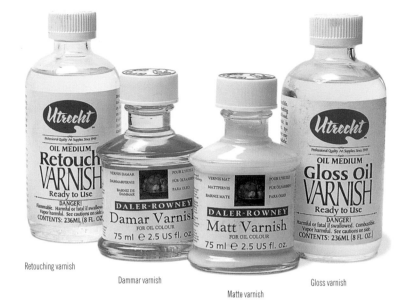

Retouching varnish

Dammar varnish

Matte varnish

Gloss varnish

GLOSS AND MATTE VARNISHES Made with ketone resin and mineral spirits, these varnishes can be used individually, or mixed together for a satin finish.
Advantages: Versatile, quick-drying, and straightforward to apply.
Disadvantages: Cannot be mixed with oil paint or used as a medium.
Cost: Inexpensive.

RETOUCHING VARNISH This type of varnish is used to brighten and rejuvenate sunken or dull areas of paint. Both Dammar and Mastic varnish can be used thinned for a similar effect.
Advantages: Revives sunken colors.
Disadvantages: None.
Cost: Can be expensive.

CRACKLE VARNISH A water-soluble varnish that will impart an aged look to a work. When painted over a traditional varnish, it will dry and crack to produce a "craquelure" effect.
Advantages: Achieves an old-master look.
Disadvantages: Of limited use.
Cost: Expensive.

Innovation
Utrecht has recently developed an all-purpose, universal matte oil varnish that can be used over oil, acrylic, and watercolor paints. Non-yellowing and transparent, this varnish can be used on virtually any surface, including canvas, board, and paper.

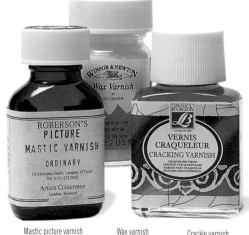

Mastic picture varnish Wax varnish Crackle varnish

Using oil paints

Oil painting can be whatever you want it to be—slow and considered, or quick and immediate. Time and countless practitioners have left a substantial legacy of applications and techniques. Paint can be applied thickly or thinly, quickly or slowly, and with practically any implement at hand. If the results are not to your liking, the entire work can be removed by scraping or wiping the paint away with knife or rag, or simply overpainted when dry. Oil paints have been unfairly stigmatized as a difficult medium; in fact, they are no more difficult than most other media—and considerably more straightforward than some, due to the ease with which corrections can be made.

Can I use more than one technique on the same painting?
You can use as many different techniques on the same painting as you wish. The important thing to remember is to always follow the fat-over-lean rule: begin by working with paint straight from the tube, or add a bit of thinner, then gradually increase the oil or medium content as the work progresses.

Are there some techniques that go particularly well with others?
Most artists learn which techniques to use together by way of trial and error. However, there are some techniques that are commonly known as working particularly well together, such as the application of glazing over textured impasto.

CORE TECHNIQUES

Fat-over-lean

Regardless of the style of painting or the techniques being used, you should always aim to work "fat-over-lean." Put simply, this means that the paint that is applied first should contain little or no added oil. Subsequent layers can contain increasing amounts of oil or medium, with the final layer containing the most. The reason why work proceeds in this way is simple. Lean paint, containing little oil, dries more quickly, and is also less flexible when dry. Paint with added oil dries more slowly, and is relatively supple. The aim is to build your work on a firm, stable foundation that will not shrink or move with time.

Underpainting

Underpainting is done using paint thinned with thinners and solvents, but containing no added oil medium. They are usually done to establish and position the elements within a painting, and to provide a tonal base upon which to work. Underpaintings can be made in full color, or, as is more often the case, in monochrome. A monochrome underpainting is known as a *grisaille,* and is usually made in shades of gray, brown, or dark green. This lays a tonal foundation for the work, establishing the lights and darks over which the paint is often worked in colored glazes. Liquin or another alkyd medium can be added to the paint to speed up the drying time.

Alla prima

Alla prima means "at the first" in Italian, and is used to describe a type of direct painting that aims for a completed work at a single session or sitting. Working in this way calls for decisiveness, spontaneity, and speed. Areas of paint are applied next to each other using simple, precise brushstrokes, and there are no modifications. Working in this way is both exacting and exciting.

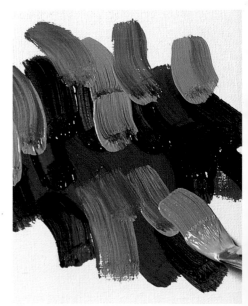

Impasto

Impasto means "dough" in Italian, and describes the technique of applying thick paint with a dough-like consistency. Impasto work can be done over a lean underpainting. The paint is applied thickly, using brushes and painting knives. In order to make the paint go further, it is often bulked out using extenders like Oleopasto, or inert materials like marble dust or fine sand. The addition of alkyd mediums helps the paint to dry thoroughly throughout, without forming a skin. Very thick impasto work can take years to dry.

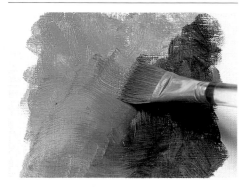

Glazing

Glazing is a traditional technique used to build up color by applying a series of thin, semi-transparent layers. Each glaze or layer of paint modifies the one beneath, altering the color and tone, and enabling the creation of complex color combinations that would be impossible to mix physically. The process is slow, as each layer must dry thoroughly in order not to be disturbed by the next. Using a quick-drying glazing medium can speed up the process. Glazes can be made over dry, thick, or impasto work. A glaze of a single color can be applied over the entire surface of a completed work for a sense of harmony.

Blending

The long drying time of oil paint makes it possible to manipulate it for a considerable amount of time. Blending two colors together does not present a problem, and can be achieved with simple, direct brushwork, using large bristle brushes. Alternatively, an imperceptible transition can be produced by repeated gentle smoothing and manipulation of the paint using a soft, flat brush or a fan blender.

Texture

Paint texture is created by applying the paint thickly with a brush or knife. Texture mediums, or inert materials like sand, sawdust, and marble dust, can also be added. Alternatively, texture can be produced by working into thin paint, by scratching back through layers, or by a combination of scumbled, scrubbed, expressive, and textural brushwork. This type of work can be tough on brushes, so use older ones—or any type of implement or tool that lends itself to making interesting textural marks.

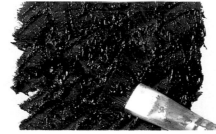

Building
The stippling or dabbing action of the brush fluffs up the paint, leaving a richly textured surface.

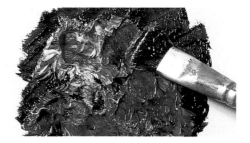

Adding colors
Another color added to the wet paint strengthens the textural feel.

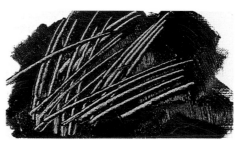

Sgrafitto
The point of a small painting knife cuts through the wet paint, revealing the support beneath.

Using a wedge
A wooden canvas corner wedge is used to make marks in the paint.

Innovation

Lescaux Aquacryl liquid acrylic paint is water-resistant in thin layers, but is resoluble when used thickly. As a result, both color mixes and dry painted areas can be altered by re-wetting.

Acrylics

Until the early part of the 20th century, oil paint had always been seen as the primary material for artistic expression. Over the years, countless practitioners contributed to existing techniques, modifying and adapting them to suit their method and style of working. After the advent of Impressionism, painting seemed to fragment, splitting into several different schools and directions. All were searching for a "new way," while using what was essentially an old material.

In the 1940s and 1950s, the new way finally materialized in the form of acrylic paints. Based on the tough synthetic acrylic resins that were used in the manufacturing industry, this type of paint had all of the advantages of the traditional media, with few of the drawbacks. Permanent, flexible and water-resistant, acrylic paints do not yellow, and show no signs of aging. Unlike oils, acrylics do not wrinkle, nor do they become brittle or crack. Acrylics also dry faster than oils, hardening quickly, while maintaining their flexibility and durability. Another advantage of acrylics is that, unlike oils, all colors dry at the same rate.

While some see the fast-drying capability of acrylic paint as an advantage, others see it as an undesirable characteristic. The rapid drying time means that it cannot

Tubes

Characteristics: Acrylic paint in a tube has a consistency similar to oil paint: smooth and buttery. Traditional metal and screw-top tubes are available—some brands also come in plastic tubes with large, easy-screw-top caps. The tubes range in size, from approximately 0.74 fl oz (22ml) to 8 fl oz (237ml). Internationally known brands include Liquitex, Winsor & Newton, Daler-Rowney, Lukas, Golden, Spectrum, and Rembrandt. Tube color brushes out well, and can be mixed with mediums or gels to extend or thicken the texture of the paint. Both traditional and interference colors are available.

Advantages: The availability of small tubes makes it possible to try out a wide range of colors without the expense of buying a large quantity of paint. As well, smaller tubes are easy and light to carry when working on location. Best used for work that requires full-bodied paint.

Caps must be kept clean, or they will not fit properly on the tube and the paint will dry out.

Disadvantages: Unless kept clean, tube caps can become clogged with dry paint, resulting in a poor fit and thus to paint drying out. As well, it can be wasteful if used to cover large areas due to its relative thickness.

Cost: Comparable to oil tubes of the same size and quality.

Interference tube color

Traditional tube color

Jar, tube, and bottle colors vary in their consistencies.

Jars, tubs, and bottles

Characteristics: Many manufacturers supply their paint in jars and tubs. Some come in plastic bottles, complete with a nozzle in the cap for squeezing out the paint. Jars and tubs range in size, from small 2 fl oz (59ml) jars containing concentrated color, to huge tubs containing 1.3 gal (5l) of paint.

Bottles

Tubs

Advantages: If working in a studio environment, large jars and tubs are more economical than small tubes. Jar and tub paint is best used for covering large areas with flat color, and for mixing with mediums for glazes.

Disadvantages: Care must be taken not to contaminate colors by dipping dirty brushes into the containers. They are not ideal for impasto or textural effects.

Cost: The initial outlay can be expensive, but can prove economical in the long term.

Jars

Easy-squeeze bottles with nozzles

be manipulated for long periods of time, as oil paint can, and it dries out quickly on the palette.

Composition

Acrylic paint is made by dispersing ground pigment into an acrylic vehicle, or binder. The binder consists of an emulsion of very fine resin particles suspended in water. The binder coats the pigment particles and, once the water has evaporated, holds them in place, creating a tough, yet flexible, permanent, water-resistant film that is resistant to oxidization and chemical decomposition. Polyvinyl acetate (PVA) paints are made in much the same way, but the pigments are suspended in a less-expensive—and lower quality—emulsion.

Artists' and students' quality

Artists' quality paint is made from the best pigments and acrylic resins. High-quality ranges include Utrecht, Liquitex Artists, Winsor & Newton Finity, Daler-Rowney Cryla, Golden Acrylics, and Lukas Cryl. Like oil paints, acrylic paints are sold in series: the higher the series number or letter, the higher the cost (see page 43 for more detail). They are also rated according to permanence (see page 134).

In students' quality paint, synthetic or organic pigments are used to lower the cost. High-quality ranges include Utrecht's regular pigment load, Liquitex Basics, Winsor & Newton Galeria, and Daler-Rowney System 3. The color range is smaller than that of artists' quality paints.

Innovation

Chroma color is a new type of water-based paint, originally developed for coloring cartoon cells. The colors are vibrant and strong. Made with acrylic resin, the paint can be used in a similar way to watercolor, gouache, ink, and, of course, acrylics. It is fast-drying, waterproof when dry, and can be massively diluted without losing its strength of color. It can be made thinner with water, and mixed with special Chroma mediums to retard drying time and add thickness, gloss, or transparency (use of non-Chroma mediums is not advised). It is available in 80 different hues, packaged in 1.5 fl oz (50ml) tubes and bottles.

Liquid acrylics

Characteristics: Liquid acrylic color resembles ink or liquid watercolor. It is available in bottles with standard screw tops, but more often the bottle top contains a dropper for transferring paint onto the palette. Liquid acrylics can be used in much the same way as ink and watercolor. Because they are made using an alkali resin, they can be softened and removed from pens and brushes with a preparatory alkali cleaning fluid.

Bottles of liquid acrylics often contain a dropper that is used for transferring the paint onto the palette.

Advantages: These are good for thin wash work—they work better than diluting thicker acrylics. Unlike liquid watercolor and some inks, liquid acrylics are lightfast.

Disadvantages: They are no substitute for watercolor, but are often mistakenly used as such.

Cost: Slightly more expensive than tube acrylics.

Painting sets

Characteristics: Several manufacturers offer introductory sets that include a range of pre-selected colors—and, occasionally, different acrylic mediums, brushes, and palettes—all contained in either simple packaging or a tailor-made wooden box. These sets can be an expensive way to sample the medium; a more economical introduction might be to purchase a few tubes and bottles separately.

Advantages: Sets that contain a good range of colors and both a gloss and matte medium can be an ideal introduction to acrylics.

Disadvantages: The choice of colors may not be to your liking.

Cost: Can be expensive, but if found on sale they can be good value for beginners.

Medium-viscosity acrylic colors

Liquid acrylic colors

Introductory painting set

Color range and characteristics

Acrylic paints are generally available in three different consistencies, each of which has a different range of colors. Acrylic tube paint, with its smooth, buttery consistency, has an extensive color range: Liquitex Artists' range includes 86 colors, Winsor & Newton Finity has 75, Daler-Rowney Cryla lists 51, and Lukas Cryl lists 39.

Tub color is manufactured to the same consistency as tube color, but is invariably thinner, more fluid, and more free-flowing. It is used for covering large areas with relatively flat paint. The color range is often as broad as that of tube color; Golden, for example, offers 84 heavy-body acrylic colors and 31 free-flowing ones.

The range of liquid acrylic colors, while not as wide as that of tube or tub colors, is more than sufficient for most purposes. The Magic Color range by Royal Sovereign has 44 colors, Daler-Rowney's FW acrylic ink runs to 30 colors, and Winsor & Newton has 36 colors in their Designers Liquid Acrylic range.

Fluorescent, metallic, and interference colors

Several manufacturers have extended their range of acrylic paint colors by including fluorescent, metallic, and interference colors.

FLUORESCENT, METALLIC, AND INTERFERENCE COLORS

An ever-growing range of shimmering colors is now available from several manufacturers. These colors can be used for both fine-art and decorative painting. The dyes in fluorescent colors are not stable, however, and thus they are not recommended for painting that is meant to be permanent.

Metallic colors

Fluorescent colors

Interference colors

Basic Palette

The colors shown here are included in the basic palette of most professional artists. A broad spectrum of hues can be mixed using these colors.

YELLOW OCHER

CADMIUM RED MEDIUM

ULTRAMARINE BLUE

PERMANENT ALIZARIN CRIMSON

PHTHALO BLUE

CADMIUM YELLOW LEMON

DIOXAZINE PURPLE

CADMIUM YELLOW DEEP

PHTHALO GREEN

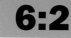

Fluorescent colors absorb invisible ultraviolet light, and reflect visible light of a longer wavelength. This makes the colors appear to glow.

Metallic colors contain tiny flakes of mica, or a synthetic substitute. The paint pigment coats the mica, which in turn reflects the light, creating a metallic glow.

Interference colors, also known as iridescent or pearlescent colors, also contain tiny flakes of mica, but these are coated with titanium oxide. The mica and titanium reflect light at two different wavelengths. These wavelengths interfere with each other, causing colors to shimmer—rather like the effect seen when oil is poured on water. This paint has a glittering appearance, which changes according to where the light hits it.

Working with a basic palette

As with other types of paint, working with a basic palette of acrylic colors is both challenging and fulfilling. Most of the color mixes you will need can be made using only a few colors. You can always extend your list of basics should a particular color or range of colors prove hard to mix, or if certain colors are being used frequently, or in large amounts. The goal is to begin with a good range of warm and cool primary colors, then add those intermediate colors that will provide a good base for mixing a range of browns, greens, and purples. As is the case with all matters involving color, the choice of which colors to include in your basic palette is, to some degree, subjective. Those listed below are merely suggestions.

PVA COLORS

Commonly considered the "poor relations" of traditional acrylic paints, PVA colors are typically made using polyvinyl acetate resins, and are a low-cost alternative to acrylics. Most PVA colors are lightfast, but some yellowing does occur. A plasticizer is usually added to the colors for increased flexibility. It is advisable to apply PVA paints on a rigid support, as they can become brittle and will "shatter" if knocked about.

CHROMIUM OXIDE GREEN

PAYNES GRAY

RAW UMBER

TITANIUM WHITE

BURNT SIENNA

Manufacturers' paint charts

- **CADMIUM RED MEDIUM** This warm orangey-red is strong and opaque, and has good tinting strength.

- **PERMANENT ALIZARIN CRIMSON** A cool red that is slightly transparent. Mixes well with Ultramarine. A good color for glazing.

- **CADMIUM YELLOW LEMON** A strong, cool, acid-lemon yellow that mixes well with cool blues. A good color for glazing.

- **CADMIUM YELLOW DEEP** A warm orangey-yellow with good tinting strength.

- **YELLOW OCHER** This color can be created by mixing, but because it is often used on its own, it is worth including.

- **ULTRAMARINE BLUE** A strong blue that can become dull when mixed with white, but mixes well with other colors.

- **PHTHALO BLUE** A strong, transparent blue. It must be used carefully, as it can overpower other colors. A good color for glazing.

- **DIOXAZINE PURPLE** A strong purple that mixes surprisingly well with other colors. A close purple can be mixed using Permanent Alizarin Crimson and Ultramarine.

- **PHTHALO GREEN** Makes an excellent base color for mixing a range of bright greens.

- **CHROMIUM OXIDE GREEN** An opaque, dull green that mixes well with other colors without overpowering them.

- **RAW UMBER** A cool, transparent brown, this color leans toward gray when mixed with blue and white.

- **BURNT SIENNA** A strong red-brown that subdues bright colors and gives a surprising range of colors when mixed.

- **PAYNES GRAY** Worth having in place of black. Mixes well with other colors.

- **TITANIUM WHITE** A strong, opaque white, it is the only white acrylic paint available.

MIXING BRANDS
Each manufacturer uses a slightly different formulation to create its paints and mediums, and thus may advise against the mixing of their brand with another. In reality, however, there is no great danger in doing so—artists mix brands all the time. If you are unsure about whether a particular mixture will work, mix a small amount and test the combination out.

Acrylic mediums and additives

There are no special rules governing the use of acrylic paints, mediums, and additives—all colors dry at the same rate, so there is no danger of cracking. Mediums should be added to paint a little at a time, and mixed in using a palette knife. Water can also be added to thin out the paint. Always mix colors before adding a medium. Each manufacturer has its own range of mediums and additives; as a general rule, these are intermixable with different paint brands. Below are some examples of standard mediums and additives.

Can oil paint mediums and thinners be used with acrylic paint?

Oil paint mediums and thinners should never be used with acrylic paint, nor should acrylic mediums and additives—or water, for that matter—be mixed into traditional oil paint. The two types of materials are simply not compatible. Acrylic paint can, however, be used for underpainting, and allowed to dry before oils are painted on top of it. As well, certain varnishes made from acrylic resins can be used to varnish oil paintings, but they cannot be used as mediums.

Varnishes

GLOSS VARNISH Both removable and non-removable versions are available. Removable varnish is soluble with mineral spirits or an acrylic varnish remover (see manufacturer's directions for use). Both types dry to a hard-gloss sheen that will remain flexible and will not yellow.
Advantages: Protects paint surfaces, and can enliven dull paintwork.
Disadvantages: A glossy surface can be distracting on a large work.
Cost: Relatively inexpensive.

MATTE VARNISH Both removable and non-removable versions are available. Removable varnish is soluble with mineral spirits or an acrylic varnish remover (see manufacturer's directions for use). It dries to a non-reflective finish, will remain flexible, and will not yellow. Gloss and matte varnishes of the same type can be mixed to give a satin finish.
Advantages: Protects paint surfaces, and can deaden excessively strident paintwork.
Disadvantages: Can make colors appear dull, and paintwork, flat.
Cost: Relatively inexpensive.

Permanent gloss varnish

Satin varnish

Matte permanent varnish

Soluble matte varnish

Gloss varnish

Pastes

TEXTURE PASTES As might be expected, texture pastes are used to create areas of texture. They can be applied to the surface of a work and painted over, or mixed with the paint and then applied. They are made to resemble sand, pumice, plaster, flint, stucco, lava, glass beads, opaque flakes, or blended fibers. Textured areas should be built up slowly and in layers; each layer must be allowed to dry before the next is applied. Liquitex, Winsor & Newton, Daler-Rowney, Ara, and Golden all produce a range of texture pastes.
Advantages: Makes a wide range of textural techniques possible.
Disadvantages: Can damage brushes if not rinsed out thoroughly.
Cost: Relatively expensive, as large quantities are typically needed.

MODELING PASTE Modeling paste is smooth and white. It can be mixed with color, or overpainted for a stronger color effect. When dry, the paste can be carved into and sanded. Generally used on a rigid support, the paste becomes more flexible when mixed with gel medium. When wet, objects can be impressed into it.
Advantages: The dried paste can be carved and shaped.
Disadvantages: Once applied, the paste must be allowed to dry slowly, or the paint will crack.
Cost: Relatively expensive, as large quantities are typically needed.

Texture paste

Modelling paste

Light modelling paste

Resin sand texture gel

Black lava texture gel

Natural sand texture gel

Glass bead texture gel

White opaque flakes texture gel

Blended fibers texture gel

Mediums

GLOSS MEDIUM When added to paint, gloss medium increases its depth of color, transparency, flow, and surface adhesion. Some brands can be used as a final varnish (see manufacturer's directions for use). Diluted with water and sprayed through an atomizer, gloss medium can be used to fix drawings, but the mixture should always be tested first.

Advantages: Imparts gloss and brightens the color of thin paint.
Disadvantages: None.
Cost: Relatively inexpensive.

MATTE MEDIUM This type of medium is used in the same way as gloss medium, but imparts a matte, non-reflective finish to dry paint. Some brands can also be used as a final varnish (see manufacturer's directions for use). Gloss and matte mediums can be mixed together to give varying degrees of gloss. Matte medium also makes a good clear-drying adhesive for collage work, and can be used to size canvas, board, and paper.

Matte mediums

Advantages: Gives a smooth, matte, modern feel to a work.
Disadvantages: Can make colors look dull.
Cost: Relatively inexpensive.

Gloss gel medium

GEL MEDIUM A thick, translucent paste that dries clear, gel medium is available in both matte and gloss finishes. When added to paint, it thickens and extends it for making impasto effects, leaving the color of the paint unaffected. The gel makes an excellent adhesive. When thinned with water, it can be used to size canvas or fabric.

Advantages: It adds body to paint, and can be mixed with substances such as sand or sawdust for interesting effects.
Disadvantages: Hardens quickly, so brushes must be rinsed out well after use.
Cost: Relatively inexpensive.

HEAVY GEL MEDIUM This thicker version of the standard gel medium also extends the volume of paint. It dries clear, so colors remain unaffected, and is also a strong adhesive.

Advantages: An excellent adhesive for collage work.
Disadvantages: Hardens quickly, so brushes must be rinsed out well after use.
Cost: Relatively inexpensive.

RETARDING MEDIUMS The rapid drying time of acrylic paint can be slowed by adding a retarding medium. This type of medium simply slows the evaporation of water from the paint, keeping it workable for longer.

Advantages: Keeps paint workable for longer.
Disadvantages: Using too much will result in the paint becoming sticky.
Cost: Relatively inexpensive.

FLOW-IMPROVING MEDIUMS These mediums ease the water tension and increase the absorption of thin paint into porous surfaces. This type of medium can be mixed with very thin paint when an airbrush or spray is being used, or it can be used to aid in the brushing out of thick tube color.

Advantages: Helps avoid the puddling of thin paint on fabric and well-sized paper.
Disadvantages: The addition of flow mediums can make masking and hard-edged work difficult.
Cost: Relatively inexpensive.

IRIDESCENT MEDIUMS These mediums contain tiny flakes of mica that alter the reflected wavelength of light. When they are mixed with paint, a metallic effect is created. The more medium that is mixed into the paint, the greater the effect. The medium is most effective when used with colors that are less opaque.

Advantages: Produces remarkable effects.
Disadvantages: Should be used with care, as the effects produced can overpower conventional paintwork.
Cost: Relatively inexpensive.

TINTING AN ACRYLIC MEDIUM
It can be necessary to tint an acrylic medium when using certain techniques, such as glazing or transparent impasto effects. Always add the color to the medium—not the other way around. Use a brush to add a tiny amount of color, then stir until the tone is consistent.

Jarpaque extender medium

Extender gel medium

Smooth texture medium | Marbling medium | Flow-aid | Flow enhancer | Gel retarder | Slow-dry medium | Gel medium | Gel thickener | Gloss heavy gel medium | Gloss blending and painting medium | Gloss medium and varnish | Pearlescent medium | Iridescent/pearlescent medium

Using acrylics

Acrylic paint can behave in similar ways to watercolor and oil paint. Accordingly, techniques from both disciplines can be used with acrylics. It is a mistake, however, to think of acrylic paint as a poor man's oil or watercolor. In fact, the advantages of acrylic paint as quick-drying, insoluble, and permanent when dry are only some of its many attractions. Its capacity to mix well with other dry art materials, the ease with which it takes on most surfaces, and its great adhesive qualities make it the perfect painting medium for mixed media work. Acrylic paint is, thus, an important medium in its own right. As such, it has developed its own range of techniques.

Can I use both acrylic and oil paint in the same work?
Oil paint can be used on top of acrylic paint. In fact, given the lengthy time that oil paint takes to dry, many artists do their preliminary work using acrylic paints, and then finish the painting using oil paints. However, while it is possible to use acrylic paint over dry oil paint, it is not generally advisable to do so, as the different drying characteristics of the two media may result in the paint cracking or peeling off.

CORE TECHNIQUES

Thin paint

When tube acrylic paint is thinned out, it becomes slightly more chalky than watercolor; the pigments seem to dry out, leaving a pleasant granular effect. Liquid acrylic color is best for thinning. The paint should be diluted using water, or a retarding or flow medium can be added. Resist the temptation to modify color mixes with white—use pure colors only, and choose less opaque colors.

Flat and graded acrylic paint washes are made in exactly the same way as watercolor washes. As with watercolour, the correct way to work acrylic paint is dark over light; that is, make light washes first, then modify them with overlaid darker washes. In this way, successive washes of transparent color can be built up to achieve the depth of tone required. Given that acrylic paint is stable once dry, there is no danger that overpainted washes will disturb or move previous washes. The paint is insoluble and permanent once dry, and no amount of re-wetting will move it. When the paint is thickened and a bit of white is added, acrylic paint will take on a gouache-like quality. Gloss or matte medium can then be added.

Thin wash
Dilution with water or flow medium gives a transparent wash.

Graded wash
Adding water to the mix after each stroke creates a graded wash.

Granulation
Thin acrylic washes granulate well due to the size of the pigment.

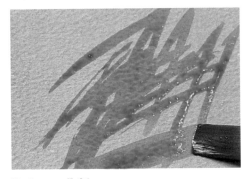

Dark over light
The application of dark paint over dry, light paint results in a watercolor-like effect.

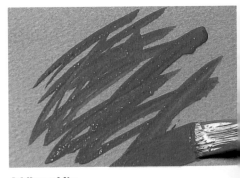

Adding white
The addition of white to the thin paint gives it a gouache-like quality.

Thick paint

Used straight from the tube, acrylic paint has a buttery consistency. It can be moved and manipulated easily by a brush or knife, and its character can be altered by the addition of various acrylic mediums. Paint of this consistency is perfect for *alla-prima* work, with even relatively thick paint drying within the hour. Gel medium can be added to preserve brush and textural marks. Blending, scumbling, and broken-color techniques all work well with paint of this consistency. For large areas of flat, solid color, consider using "flow formulae," or more fluid paint from jars, tubs, or bottles.

Alla prima
Acrylic paint of a buttery consistency is perfect for this spontaneous technique.

Blending
Acrylic paint must be blended quickly, before it dries.

Broken color
Areas of broken color can be built up easily, as the paint dries quickly.

Scumbling
In this technique, a layer of wet paint is brushed over an initial dry, textured layer.

Glazing

Acrylic paint is excellent for glazing techniques; its quick-drying capacity enables the completion of a painting in one sitting. Use of transparent colors and a gloss medium will further increase the colors' brilliance and transparency. Complex color transitions can be built up effectively and easily.

Staining

Acrylic paint contains no corrosive ingredients that might degrade paper or fabric, making it possible to work directly onto canvas, without any prior sizing or priming. Thin acrylic paint applied to unsized canvas will soak into it, staining the fabric fibers; this stained layer can be sized and then worked on in a conventional manner, or worked on without sizing. Always work dark over light, allowing each stain to dry before applying the next. Too many stained paint layers will dull the colors. Raw canvas repels paint, while a flow medium added to a thin color mix improves absorption. The support should be placed flat, or the thin paint will run. Once the paint has soaked into the fibers, it is impossible to remove, even when wet.

Impasto

For impasto work, use tube acrylic paint extended with a heavy gel medium, or with a texture medium or paste. Alternatively, you can create your own texture medium using additives like clean sand, sawdust, or marble dust. While extremely thick applications are possible, the thickness should be built up in layers, with each layer being allowed to dry before the next is applied. Paint can be applied with a brush or painting knife; additional textural effects can be made using anything which will make a mark—sponges, fabrics, crumpled tin foil, and bubble wrap will all create interesting effects. Or, work back into wet paint using a comb or a household tool.

Making texture
Add fine sand to the paint for a textured look.

Texture mediums
Prepared texture mediums can be added to the paint.

Tin foil
Crumpled tin foil pressed on paint gives a stucco effect.

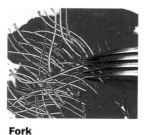

Fork
Any household implement can be utilized for an effect.

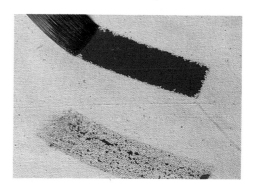

Watercolor and gouache

The delicate and transparent character of watercolor makes it unique amongst the media available to the artist. In pure watercolor, no white paint is used. Thin, transparent washes of color are painted onto a support that is usually white. As each wash of color dries, further washes can be added, modifying and qualifying those previously applied. A color is made lighter by the addition of more water, which thins the mixture, making it more transparent. When painted onto a white support, the increased transparency of the paint allows more light through. The light then reflects off the support and through the wash, thus making the color appear lighter.

Light to dark

Watercolor is very much a technique-led medium. Colors are usually painted light to dark; that is, lighter colors and tones are painted in first, followed by gradually darker and more intense colors, with the darkest colors being painted last of all. One reason for this order of application is that when a lighter wash is painted over a darker wash, the effect is minimal, while a range of effects can be created by applying a darker wash over a lighter one. Working light to dark also enables the artist to work broadly, as darker washes can be used to cover any lighter washed areas not needed in the final work.

Pans and half pans

Characteristics: Watercolor pans are usually rectangular, although some manufacturers, such as Pelikan in Germany and Grumbacher in the USA, market sets of paint that contain round cakes. Round Chinese pans are also available. Pans and half pans can be purchased in sets contained in wood, plastic, or black-enamel metal boxes. The lids of the plastic and metal boxes can be used as palettes for mixing colors (see page 120). Alternatively, empty boxes can be bought and filled with your own choice of colors. Major manufacturers of watercolor pans and half pans include Winsor & Newton, Daler-Rowney, Sennelier, Schmincke, Talens, Lukas, and Blockx.

Advantages: Pans are economical to use. They force you to mix paint in a slow and considered manner, because only a relatively small amount of paint can be taken by the brush from the pan to the palette. As well, boxes of pans are easily transportable; if the palette and paints are dried before the box is closed, they may even fit inside a jacket pocket.

Disadvantages: Large washes mixed using pan colors can take some time to mix, and they tend to use up a lot of color. As well, once the wrappers have been removed, it is easy to forget the names of the colors—making a note of each color's position in the paint box will solve this problem. While easy to use when slotted into a box, pans are messy and almost impossible to use when loose. Further, moving from one color to another during the process of mixing can result in dirty colors, so the pan will occasionally need to be wiped clean using a brush and clean water, or a paper towel.

Cost: This varies according to the brand, the cost of the pigment, and the grade of paint. While most colors are relatively inexpensive, some can be very expensive.

Paint boxes tend to get dirty, and need to be wiped clean periodically.

Watercolor is best painted dark over light.

Whole and half pans

Large Chinese watercolor pans

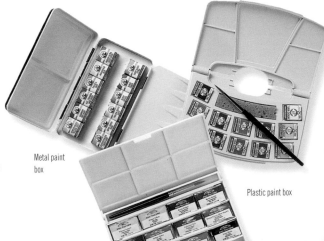

Metal paint box

Plastic paint box

A challenging material

The fluid nature of watercolor has given it a reputation as a frustrating, challenging art material. Washes continue to move and alter as they dry, adding an element of risk to any work undertaken. This unpredictability is, however, also part of the medium's attraction and charm. The best watercolor paintings have a sense of immediacy, and seem to have been executed effortlessly. But a great deal of planning—the positioning of highlights, for example—will have taken place before work has started.

Composition

Watercolor paint is made from finely ground, non-lead-based pigments mixed with a binder, usually gum arabic. A moisturizer such as glycerine, or sometimes honey, is added to prevent the gum from becoming brittle, and acts as a plasticizer. A wetting agent is also added, to encourage flow and absorption. A preservative like phenol or sodium orthophenylphenate is added as well. In less expensive paint ranges, a compound made from wheat starch known as dextrin may be mixed in, to improve the paint's texture.

Artists' and students' quality

As with other artists' quality painting mediums, artists' quality watercolor paints are made using very fine and often expensive pigments, mixed together with the very best materials. This grade of paint contains very little filler or extender, and mixes easily. Colors are extremely bright, transparent, and luminous, even when diluted.

CARE OF PANS

New pans can sometimes stick to the top of the box lid when it is opened, and then can scatter out of order. To prevent this from happening, remove all excess moisture from pans with a damp sponge after each painting session. Leave the colors and palette to dry off in a warm room before closing the lid, as if the paint absorbs the moisture, it will become sticky.

Tubes

Characteristics: Like pans, tubes of watercolor paint can be found in boxed sets of pre-selected colors, or bought separately. The same range of colors available in pans is generally available in tubes, with some manufacturers making tube colors only. Tube sizes vary greatly from brand to brand, but can be found in sizes as small as 0.17 fl oz (5ml) (manufacturers include Grumbacher and Winsor & Newton), or as large as 1.25 fl oz (37ml) (manufacturers include Da Vinci). Most brands offer a range of tube sizes that fall somewhere in between these two extremes.

Part of the appeal of tubes is that they can be carried loose in a bag.

Advantages: Tube color is far more economical if you are working on a large scale and require a large quantity of washes. Tubes are more convenient than pans, as they do not need to be contained within a box, and can be carried loose in a box or bag.

Disadvantages: Tube color can be wasteful, simply because it is easy to squeeze out too much paint. To avoid waste, mix the desired color by taking up a little bit of paint at a time onto a palette, mix it with the water, and then add paint by degrees, until the required color is obtained. Never squeeze paint directly into a pot that contains water, as not only will it be impossible to mix the paint thoroughly with the water—it will also be difficult to judge the color's strength. Tube lids must be kept clean and tight, otherwise the paint will become dry and hard. If this happens, the tube can be cut open, and the paint can be used like pan color.

Tubes which have become hard can be split open and used as pan color.

Cost: As with pans, the cost of tube color varies according to brand, the cost of the pigment, and the grade of paint.

Tube color

Boxed set

Innovation

D'Uva have recently introduced a watercolor paint that is erasable. Applicable with a brush or an airbrush, it behaves very much like traditional watercolor, but contains no gum binder, making it possible to erase dry washes with a kneaded eraser.

The watercolor is fixed by heating with a radiant heat source, such as a kitchen oven or a hair-dryer on a high setting. A special erasable watercolor solvent is also available for the creation of thinner washes. The paint is available in ten different colors, including black, with more to be released in the future.

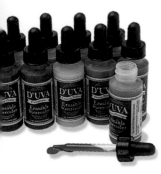

Each color is priced separately, according to series; the cost reflects the cost of the pigments used to create the color. Depending on the manufacturer, a series can run 1, 2, 3, 4, 5, 6, or A, B, C, D, E, F—higher the number or letter, the higher the cost. Utrecht, Winsor & Newton, and Daler-Rowney make high-quality paints of this grade. The paints are also graded for permanence (see page 64 for details).

As is the case with other students' quality media, students' quality watercolor paints are often less expensive than artists' quality paints, containing less pure pigment and more fillers and extenders, and all colors are sold at a uniform price. Many names of students' quality paint colors are followed by the word "hue," which denotes that cheaper pigments have been used. The selection of students' colors is usually smaller than those of artists' ranges. The same system of indicating permanence as for artists' ranges is used. Winsor & Newton Cotman and Daler-Rowney Georgian are two examples of good-quality students' ranges. Cheaper paints made in the Far East are generally of poorer quality, and are best avoided.

Gouache

An opaque, water-based medium, gouache paint is made in much the same way as transparent watercolor, but an inert white pigment is added, making the color dense and opaque. The brilliance of gouache color comes not from

Liquid watercolor

Characteristics: Liquid watercolor was originally formulated for illustrators and designers who required clean color of a standard strength. Unlike traditional pigment watercolor, liquid watercolors are invariably made from dyes. They are sold in glass bottles with screw-top lids, and contain a dropper to facilitate the removal of the liquid. They are available from several manufacturers, including Winsor & Newton, Daler-Rowney, and Dr PH Martin. The bottles can be bought as sets, or colors can be purchased individually.

Liquid watercolor

Liquid watercolor can be used in much the same way as traditional watercolor. It is not recommended for work that is intended to last, however, as the colors are invariably fugitive and will fade with time.

Liquid watercolor can be applied using a pen.

Advantages: Liquid watercolor works particularly well when put through a pen or airbrush. This is because the colors are made from dye rather than pigment, and thus do not clog. They can be mixed and diluted in the same way as traditional watercolor paint. When used neat from the bottle, they give a consistent depth of color.

Disadvantages: Only a limited range of colors is available, all of which are fugitive and will fade with time. The colors are very bright and will stain, making corrections or techniques that require color to be washed off difficult.

Cost: The colors all cost the same, and are relatively inexpensive.

Water-soluble pigment sticks

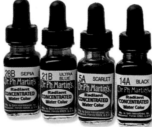

Water-soluble sticks can be softened by heating.

Characteristics: These pigment sticks are used in the same way as pastels or crayons, but can be worked into and blended using watercolor mediums and water. The sticks can also be scraped into or manipulated using a heat source, in much the same way as encaustic (see page 100). In addition to traditional supports, these sticks can be used on metal, plastic, and glass surfaces. Faber Castell produces the Albrecht Durer Aquarelle Stick, which is available in 60 colors. Caran D'Ache markets water-soluble crayons, which are available in 84 colors. Bright, smooth, and easy to use, they can be used dry, or mixed with water and watercolor mediums.

Pigment stick marks can blended using water.

Advantages: In essence two materials in one, these sticks make an excellent and adaptable sketching medium.

Disadvantages: None.

Cost: Relatively inexpensive.

Water-soluble pigment sticks

the white support, but from the reflective qualities of the added white pigment.

Many of the gouache application techniques are very similar to—if not the same as—those of watercolor, as are the equipment and supports used. Unlike watercolor, however, lighter gouache colors can be painted over darker ones. As well, gouache can easily be re-wet and re-manipulated after it has dried. This characteristic is, however, a mixed blessing: it makes corrections and alterations remarkably straightforward, but it also means that washes or layers of paint can disturb and mix with previously painted areas. Gouache worked in layers thus requires a direct and confident approach, to keep colors crisp and clean.

Composition

Like watercolor, gouache is made using pigment, binder, and preservatives. The pigment is coarser than that used in watercolor, and larger amounts are used, creating an opaque effect. In cheaper-quality gouache, an inert white pigment such as precipitated chalk or blanc-fixe is used to impart opacity. Despite their opacity, gouache colors can be used thinly, in transparent or semi-transparent washes. When used in this way, they look similar to watercolor, but are slightly less brilliant.

Artists' and students' quality

Only a single grade of gouache is available, the quality of which varies according to brand.

Gouache tubes and jars

Characteristics: Gouache is available in both tubes and jars, and there is little difference between the two. They can be bought separately, or tubes can be purchased in what are usually called studio or designer sets. The range of colors within these sets can vary, from just a few colors to a much wider range—Winsor & Newton's studio set, for example, has 93 colors, together with several tubes of black and white. A range of gouache colors is made by several manufacturers, including Daler-Rowney, Pebeo, and Schmincke. Lukas offers a limited range of colors in 2 fl oz (55ml) tubes and 6 fl oz (200ml) jars.

Dry gouache can be re-wet and further manipulated.

Advantages: In many respects, gouache is easier to use than transparent watercolor. The colors are pure and bright, and the paint has a greater physicality and covering power—and it can be used on a dark ground. When dry, gouache paint can be reused simply by re-wetting. Tubes are easily transportable.

Disadvantages: Overworking will result in muddy and confused colors, as new layers or washes of paint dissolve and pick up previously applied layers. This problem can be overcome by the use of direct and confident brushstrokes.

Cost: Although costs vary depending on the brand, gouache is usually significantly less expensive than transparent watercolor.

Rough over-working can result in muddy, dull color.

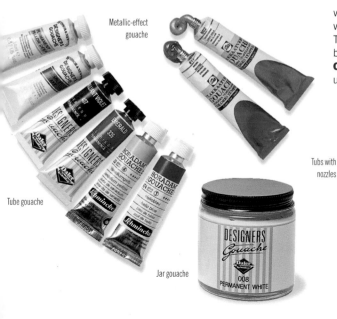

Metallic-effect gouache

Tube gouache

Jar gouache

Tubs with nozzles

Gouache can be painted light over dark.

Color range and characteristics

While paint colors from different manufacturers may share the same name, they may not be absolutely the same color. Some colors are made with pigments that can only be formulated in one way, using a particular set of chemical components; these colors will be basically the same, regardless of manufacturer. Other colors, however, can be made from several different pigments, each possessing a variety of different chemical components. This should rarely, if ever, cause a problem—if anything, it gives the artist a greater choice. However, if you have gotten used to using the Winsor & Newton Paynes Gray, and then decide to switch to Schmincke's Paynes Gray,

you could be in for a surprise. As might be expected, the Paynes Grays made by other large manufacturers such as Daler-Rowney, Talens, and Grumbacher will also differ slightly from one another.

Watercolor colors

The range of watercolor colors available depends on the manufacturer. Currently, the Winsor & Newton artists' range consists of 82 colors; Daler-Rowney offers 64; Sennelier, 80; and Da Vinci, 28; the Schmincke range is huge, consisting of 118 colors. Each manufacturer's range covers all of the standard colors, and consists as

Manufacturers' color charts

Basic palette

The colors shown here are a good selection for a basic palette for both watercolor and gouache. They have been chosen based on their degree of permanence, as well as for their general uses. A broad spectrum of hues can be mixed using these colors.

COLOR CHARTS AND PERMANENCE RATINGS

Watercolor paint charts are available from many paint manufacturers. These charts, along with the paint's label, will usually include such information as the color name, pigments used, formulation, degree of lightfastness, and price bracket, all often accompanied by a health label. The paint is also given a star or letter rating (typically found either on the tube's label or in the manufacturer's catalog) which signifies the pigment's permanence: **** or AA = Permanent, *** or A = Normally Permanent, ** or B = Moderately Permanent, and * or C = Fugitive. The ASTM (American Society of Testing and Materials) has also formulated a uniform code for lightfastness: ASTM I = excellent lightfastness, ASTM II = very good lightfastness, and ASTM III = not sufficiently lightfast. Inclusion of the ASTM code is purely optional; some manufacturers choose to include it, while others do not.

CADMIUM RED

CERULEAN BLUE

ALIZARIN CRIMSON

VIRIDIAN

CADMIUM YELLOW

RAW SIENNA

CADMIUM LEMON YELLOW

BURNT UMBER

FRENCH ULTRAMARINE

PAYNES GRAY

well of colors that are peculiar to the brand, such as Winsor Blue by Winsor & Newton, Mountain Blue by Schmincke, and Blockx Red by Blockx.

Gouache colors

The range of colors available in gouache is generally quite large: Winsor & Newton offers 117 colors; Daler-Rowney, 90; Lukas, 53; and Talens, 65.

Working with a Basic Palette

It is both unnecessary and impractical—not to mention financially crippling—to purchase a full range of watercolor or gouache colors. Most, if not all, artists work with a basic, limited palette of colors, the choice of which

has usually been arrived at through experience. As with other painting mediums, subject matter and technique will be determining factors, but ultimately the basic palette chosen by most artists consists of a careful selection of those colors that the artist has determined can be used to mix all of the desired colors.

Working with a basic, limited palette can be educational on the subject of color theory, as the artist is forced to search for and experiment with mixes in order to reproduce the desired colors. You will be surprised as to how many colors can be mixed using so few; a palette consisting of Cadmium Lemon Yellow, Ultramarine, and Permanent Rose, for instance, can be mixed together to create a substantial color range.

SAME NAME, DIFFERENT COMPONENTS

Different manufacturers may use the same name to describe a particular color, yet within each brand color, the pigments may vary. For example, Winsor & Newton's Paynes Gray is comprised of PB15 (Pigment Blue 15), PBk6 (Pigment Black 6), and PV19 (Pigment Violet 19). Schmincke, however, lists its Paynes Gray's pigments as PB29 (Pigment Blue 29), PR101 (Pigment Red 101), and PBk7 (Pigment Black 7). Two slightly different colors result, yet both have the same color name.

WINSOR & NEWTON

SCHMINCKE

TESTING COLORS

When mixing colors, it can be difficult to tell whether the right color has been achieved by looking at it on the palette. The color can be better assessed on a paper that is the same color as the ground you intend to use. Remember, the paint will look less intense when dry.

- **CADMIUM RED** A strong, intense orange-red with a high tinting strength, it can be mixed to make a substantial range of orange and browns.

- **ALIZARIN CRIMSON** Despite its low permanency rating, this color is a good choice for a cool red. It is a transparent color that mixes well with Ultramarine, and it has good tinting strength. An often used alternative is Permanent or Quinacridone Rose, a cooler, more transparent and permanent color.

- **CADMIUM YELLOW** A rich, semi-opaque, bright, clear yellow that mixes well with Cadmium Red to create a clean Cadmium Orange.

- **CADMIUM LEMON YELLOW** A semi-transparent, cool yellow, this color mixes well with Ultramarine, Viridian, and Paynes Gray for a range of greens.

- **FRENCH ULTRAMARINE** A rich, transparent, warm blue that mixes well with Alizarin Crimson for a range of purples and violets.

- **CERULEAN BLUE** A semi-opaque, permanent color that is excellent for skies. Its one drawback is that it can become lost within other mixes, so mix it carefully.

- **VIRIDIAN** Transparent, with a cool, bluish-green hue, this is a good base color for a range of greens. An alternative choice would be Phthalo Green, a newer green that is brighter and stronger than the more traditional Viridian. (Phthalo Green is also known as Monestial Green and Winsor Green, depending on the brand).

- **RAW SIENNA** When mixed with Cadmium Yellow, this transparent color takes on a deep golden-yellow hue. It also makes an interesting range of greens and grays when mixed with Ultramarine.

- **BURNT UMBER** A warm, rich brown that mixes well with other colors. When mixed with Ultramarine or Paynes Gray, a near-black color is produced.

- **PAYNES GRAY** A useful addition to the palette, this color mixes and modifies other colors well. It is also excellent for darkening colors without making them appear dull.

USING CHINESE WHITE

Chinese White is a zinc oxide pigment. When added to transparent watercolor paints, it makes them become opaque or semi-opaque. The resulting paint consistency is termed "body color," and is similar to a thin gouache.

Mixing Chinese White into a paint will immediately alter the paint's characteristics. Colors are lightened by the addition of the light paint—they are not, however, made more transparent. Included in many paint sets, Chinese White can be useful for making small corrections, or adding highlights. It should be used carefully, however; if used in the wrong way or overdone, it can spoil the subtle harmony of a work.

CHINESE WHITE

Innovation

From Winsor & Newton, this new medium prolongs the drying time of watercolor, allowing more time for blending. It can be used in several ways: by adding it to the mixing water; by applying it selectively, on certain areas of the work only; or it can be applied directly to the support before painting. While washes done with this blending medium have a tendency to "bead" as the paint continues to be manipulated, it will eventually brush out flat.

Many mediums can be used with both watercolor and gouache, while others are specifically labelled for use with either one or the other.

Gouache gloss varnish

Gouache/watercolor protective spray

Watercolor mediums and additives

A wide range of effects and techniques can be created by simply mixing clean water with good-quality watercolor paint. There are also several watercolor additives and mediums available, which can be used to good effect with gouache as well. Natural items can also be used to create effects: rock salt makes unique patterns, for example, and bleach can be used to lift out color. Alcohol can be added to paint to speed up its drying time.

Which mediums and additives do I really need?

In truth, there is no real need to use mediums or additives with watercolor paint. Mixed with water alone, watercolor is capable of producing some remarkable effects. It can actually be beneficial for beginners to use watercolor on its own, without any mediums or additives, as this will encourage familiarity and comfort with the paint. Mediums and additives do, however, simplify a number of techniques, and can add an extra dimension to a work.

Additives

OX GALL LIQUID This wetting agent is made from the gall bladders of cattle. It is added to the water used for mixing, and has the effect of lessening its surface tension, thus improving the flow of washes. This is especially important when working on heavily sized, smooth paper, which repels watercolor washes and causes them to puddle. Alternatively, the paper can be given a wash of diluted ox gall and allowed to dry before starting work.

Advantages: Increases the flow of washes and reduces surface tension.

Disadvantages: Over-use can result in brush marks drying with a soft-edge quality. As well, washes can lack brilliance.

Cost: Relatively inexpensive.

AQUAPASTO AND WATERCOLOR IMPASTO GEL Made by Winsor & Newton, Aquapasto has been around for years, and is used to add body to watercolor and gouache. Watercolor impasto gel from Daler-Rowney is a more recent product, and works in the same way. The clear medium is simply added to the paint, and the resulting mixture is painted on as normal, using either a stiff brush or painting knife.

Advantages: Adds dimension and texture to the otherwise flat medium of watercolor.

Disadvantages: Care should be taken not to contaminate watercolor pans with gel, as it can be difficult to

remove once dry. It is advisable not to use either substance with your best sable brushes, and to wash those brushes you do use well after use.

Cost: Relatively inexpensive.

LIFTING PREPARATION Lifting preparation enables dry washes to be re-wet and removed. The preparation is applied to the paper like a primer, and is allowed to dry before starting work. Once dry, work proceeds as normal.

Advantages: Ideal for working back into a painting, removing crisp, fine lines, creating atmospheric and weather effects, and for highlights and corrections.

Disadvantages: The medium can transform into a gel in cold weather. Placing the bottle in warm water will turn the gel back into a liquid.

Cost: Relatively inexpensive.

Lifting preparation

Aquapasto

Watercolor impasto gel

Mediums

GUM ARABIC Gum arabic is one of the major constituents of watercolor paint. It not only helps bind the pigment, but also contributes to the transparency and depth of the color. Gum arabic can be added to paint in two ways: a few drops can be placed in the general mixing water, or it can be added to specific washes or mixes only. Adding gum arabic will make your colors more transparent, give them greater depth, and imbue them with a slight gloss. More importantly, it will increase the solubility of the dry paint, making corrections and effects possible by re-wetting.

Advantages: Makes a number of textural effects possible, and makes corrections easier.

Disadvantages: Over-use can result in paint drying with a gloss finish; heavy use can cause the paint to crack and chip when applied too thickly.

Cost: Inexpensive, particularly when used sparingly.

WATERCOLOUR MEDIUM This medium behaves like—and has similar qualities to—gum arabic, but it also improves the flow of washes. It can be added to the mixing water, or used selectively on individual washes.

Advantages: Increases the brilliance and transparency of colors.

Disadvantages: Over-use can result in areas of work drying to an unsightly gloss finish.

Cost: Relatively inexpensive.

IRIDESCENT MEDIUM This medium adds a pearlescent, glittery effect to watercolor. It can be added when the wash or color is being mixed, or applied over the paint once it is dry. It is shown off to best effect when mixed with transparent colors and applied over a dark background.

Advantages: Particularly useful for design and decorative work.

Disadvantages: Care should be taken not to contaminate paints with the medium, or it may show up in parts of the work in which it is not required.

Cost: Relatively inexpensive.

TEXTURE MEDIUM Texture medium contains small particles suspended in a gel. It can be mixed with wet paint and then applied, or it can be brushed directly onto paper and then worked over with color. With patience, multiple layers can be built up to create pronounced textural effects.

Advantages: Increases the capability of the watercolor medium, and creates interesting effects.

Disadvantages: Brushes can be ruined if not cleaned thoroughly—it is best to use cheap, synthetic ones just in case.

Cost: Relatively inexpensive.

GRANULATION MEDIUM Granulation is a traditional watercolor technique that occurs when certain relatively coarse blue and earth pigments separate out from a wash and settle into the texture of the support, giving a granular, textured effect. Granulation medium causes the effect to happen, regardless of the colors used. The medium is added directly to the paint. By varying the paint, medium, and water ratios, different degrees of granulation can be achieved.

Advantages: The technique gives added drama and interest to paintwork—especially to skies and landscapes.

Disadvantages: As with any technique, care should be taken not to overdo it.

Cost: Relatively inexpensive.

PERMANENT MASKING MEDIUM This medium can be used in two ways: it can be applied undiluted onto the support; once dry, the medium is invisible, but it will isolate the masked area and repel any washes painted over it. Alternatively, the medium can be mixed with paint. When dry, it will resist any further washes that are made over it.

Advantages: The masking solution does not have to be removed, and thus allows for the creation of complex layers of masking.

Disadvantages: Once an area as been treated and masked, it is impossible to remove or alter the masking.

Cost: Relatively inexpensive.

LIQUID FRISKET Traditional liquid frisket, also known as masking fluid, is neither an additive nor a medium. It is a liquid latex solution that is painted onto the support. Once dry, it isolates the area from any unwanted washes painted over it. Once the wash is dry, the masking fluid is removed by gentle rubbing. It is available as a yellow or colorless liquid.

Advantages: Can be applied in any number of ways, and the fluid color makes it is easy to see masked areas.

Disadvantages: Care needs to be taken when removing the dry fluid from the support in order not to tear delicate surface papers. As well, brushes can be ruined if not cleaned thoroughly—use cheap, synthetic ones just in case.

Cost: Relatively inexpensive.

Innovation

Winsor & Newton have just developed a liquid frisket product that is applied in the same way as traditional liquid frisket, but dries clear and does not need to be removed. This product can also be mixed with paint and then applied, creating a colored area that will resist any further washes of paint.

Watercolor medium

Texture medium

Permanent masking medium

Gum arabic

Masking fluid

Iridescent medium

Granulation medium

Using watercolor and gouache

Mastering technique is of particular importance when using watercolor. Many of the core techniques are surprisingly easy, and require only a little practice. Others are a bit more difficult, but once you have mastered a few, it will then become easier to expand your repertoire.

Watercolor is simple and clean to use, so long as you have plenty of space to work in and all of the necessary materials at hand. It does have an unpredictable element to it, however; watercolor paint can dry quickly, collect in puddles, or run. While frustrating, these characteristics can also be seen as an advantageous, in that they can lead to the creation of exciting, beautiful effects.

Gouache

In some ways, using gouache is similar to using oil or acrylic paint. It can be used thick or thin, and it always remains soluble in water, even when dry. A sure, direct approach is necessary when laying a color over a dry, previously painted one, as the colors can become contaminated with each other. Further, some gouache colors contain strong dyes that can bleed through overlying layers of paint. This can be alleviated by painting a coat of bleed-proof white between the layers. Another unique characteristic of gouache is that colors look much lighter when they dry; this change can be compensated for by mixing colors slightly darker.

CORE TECHNIQUES

Washes

The one technique that is central to watercolor painting is the wash. This technique involves painting an area with diluted paint, usually utilizing a brush. A wash can be very small or very large. It can provide a continuous, flat tone over the whole area of the paper, or graded tonally, from light to dark or dark to light. Washes can also be further modified by the addition of more water.

Graded wash
A variation on the flat wash, the graded wash is applied in exactly the same way, but after each horizontal stroke, more water is added to the mix, making it slightly lighter. If you wish for the wash to run light to dark, add more paint instead of more water.

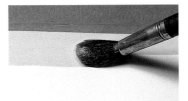

Applying a flat wash
1. Begin by making sure that you have mixed a sufficient amount of paint. Rest your support at a slight 20-degree angle. Load a large wash brush with paint and make a steady horizontal stroke across the paper. Due to the angle of the board, the paint will puddle slightly along the bottom of the stroke. Load the brush with paint and make a second horizontal stroke that slightly overlaps the first.

2. The excess paint will collect at the bottom of the second stroke, as is evident here. Simply continue making brush strokes in this way, until the desired area is covered. Any excess paint that collects along the bottom of the last stroke can be removed with a clean, damp brush.

Variegated wash
Similar to the graded wash, the variegated wash is a wash that changes color. Begin by making a standard wash. At the point where the color transition is to take place, carry on the wash with the second color, using a clean brush. This effect can be unpredictable, and should be carried out using a direct approach, with little or no hesitation.

Wet-on-dry

When wet paint is worked over a dry area, it is known as working wet-on-dry. Wet-on-dry work is characterized by crisp brushstrokes that hold their shape and color. This technique allows complex wash layers and color combinations to be built up. It is worked light to dark when using transparent watercolor, but can be worked dark to light if opaque, light gouache colors are being used.

Wet-on-wet

Wet paint applied over or into an area that is already wet with paint or water is known as working wet-on-wet. Depending on how wet the base layer is, the technique results in colors flowing and blending together, often creating beautiful color combinations. Working into very wet areas will produce unpredictable results; more control can be exercised if the base layer is only damp. The resulting images are ethereal.

Masking

Masking is a technique used to keep an area free of paint, either in order to preserve the white of the support or an underlying color, or in order to create a texture. Liquid frisket can be applied by brush, pen, or finger. Once dry, the masked area can be painted over. Once the paint is dry, the latex masking material is removed by rubbing gently with a finger. Masking can also be carried out using cut or torn masking tape, paper, or fabric.

Using masking tape
1. Masking tape sticks easily to most paper surfaces, and is quick and easy to use.

2. The tape should be pulled away from the support carefully, as some papers can tear. The tape can also be torn purposefully, to create an irregular line.

Using masking fluid
1. Neat masking fluid is brushed on here, but it can also be applied using a pen or a finger.

2. The dry fluid repels the liquid paint, protecting the area beneath. Once the paint is dry, the rubber masking solution is removed by gently rubbing with a finger.

Using torn paper
1. Torn paper gives a different edge quality than masking tape or fluid. Make sure that it is flat, and will not move, before you paint along its edge.

2. Once the paint has been applied, remove the paper carefully. Take care not to move it over the support surface, or the paint will smear.

Resist techniques

Resist techniques rely on the incompatibility of oil and water. Using a clear wax candle to draw onto the support, invisible marks are made that repel water and show up when a colored wash is painted over them. Colored wax crayons can be used in the same way, as can clean mineral spirits or turpentine; these should be painted over while they are still damp.

Using a candle
1. A clean, clear wax candle is used to draw a design onto the support surface.

2. When paint is applied, the design is revealed where the wax has repelled the thin wash.

Using crayons
1. Wax crayons can be used in a similar way using a desired color.

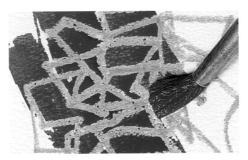

2. The design made by the crayon repels the paint in the same way as with the wax candle.

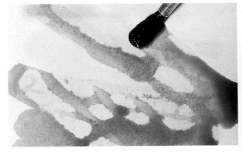

Using solvents
Clear white spirit or turpentine can be used in a similar way to repel the paint.

Sgraffito

The word sgraffito is derived from the Italian word *graffiare*, meaning to scratch. Once dry, paint can be scratched into using any sharp implement, including a craft knife, razor blade, or sandpaper. The technique can be used to create texture and highlights, as well as to erase mistakes and make corrections. On less absorbent surfaces, thick gouache—or watercolor thickened with gum arabic or texture paste—can be worked into when wet, using a comb, painting knife, a piece of wood, or a stiff bristle brush.

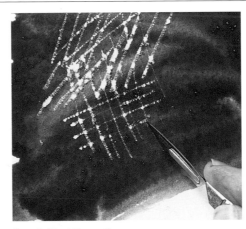

Scratching through
Any sharp implement can be used to scratch through the dry paint to reveal the support.

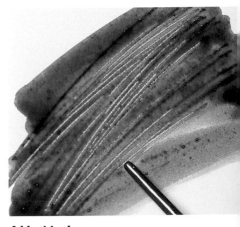

A blunt tool
Wet paint can also be worked through using a blunt tool, like the end of a wooden paintbrush.

Dry brush

In this technique, excess paint is removed from the brush, either by squeezing gently between the fingers, or by touching the brush on a sheet of paper towel. The brush is then dragged over the paper surface, and the paint is pulled from the brush by the texture of the paper. A variety of brushes can be used, but stiffer bristle brushes are best. The technique is slow-going, and thus takes a little patience. As well as working with precise brush marks, paint can be scumbled onto the surface with a scrubbing action—but beware, this method will be hard on your brush.

1. Dabbing the paint-filled brush onto a paper towel removes the correct amount of paint.

2. The damp bristles are splayed between the fingers here, giving the stroke an open feel.

Gouache

All of the techniques that can be used with watercolor can also be used with thin gouache, as can all of the watercolor mediums. Unlike watercolor, however, gouache can also be used thick, and will dry leaving an opaque, matte finish. When gouache is used thick, many of the same techniques as are used with acrylic paint are possible. It is necessary, however, to remember that gouache remains soluble when dry, and thus a color brushed over a previously applied dry color will pick up the new color and contaminate it, unless the brush stroke is quick and clean.

Using thin gouache
The paint is mixed with clean water, and applied in the same way as watercolor.

Using thick gouache
Mixing the paint with less water results in a thicker paint that will dry opaque and matte.

Color shift
If you make a brush stroke next to or over a dry area of paint of the same color, you will notice that the wet paint appears to be lighter in color. Do not panic if this happens—it is simply a result of the wet paint reflecting more light than the dry paint, as dry paint absorbs light.

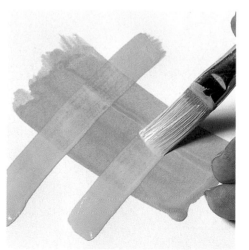

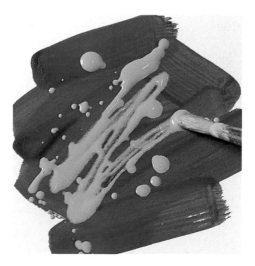

Using light paint over dark
One advantage that gouache has over watercolor is that the opaque characteristic of the thick paint allows for light colors to be placed over darker ones. Care must be taken, however, not to disturb the dry underlayer, or it may pick up and mix with the new color.

TERMINOLOGY
Throughout this chapter, when we speak about tempera, we are referring to the medium in its original sense: that of pigment mixed with egg and distilled water. Be aware, however, that some modern manufacturers—particularly those in mainland Europe and the USA—market their paints under the name "tempera" when they are in fact gouaches or body colors. When ordering or purchasing tempera paint, therefore, it is wise to specify "egg tempera."

HEALTH AND SAFETY
When using dry pigment, even if the pigment is known as non-toxic, always wear a proper mask with the correct filters fitted—masks with a soft material pad held over the mouth with clips and elastics are not suitable. Do not smoke, eat, or drink while working, and wash hands well after use.

Tempera

Tempera is the word given to the technique whereby pigment is prepared for painting, or "tempered," by mixing with egg yolk and distilled water. As the mixture dries, the water evaporates, leaving a thin, hard layer of color that is durable, but not very flexible.

Until the discovery of oil paint, all easel painting was done using tempera on wooden panels. As oil paint gained popularity, tempera was relegated to use for underpainting—the works were then glazed over in oil color. Because tempera needs to be applied to a solid support, this practice gradually died out as canvas became the most popular support.

A rewarding medium

Despite its lack of flexibility, tempera work does have a solidity and depth that can seem lacking in oil or acrylic works. This is due in part to the relatively transparent nature of the medium itself, that enables layers to be built upon each other without sacrificing the quality of the lower layers.

A few manufacturers produce ready-made tempera colors (some of these are listed below, under "Tubes"). However, because the color range of ready-made tempera tends to be limited, most artists prefer to make their own.

Tubes

Characteristics: Several manufacturers produce ready-made tempera paints. These come in tubes, and are used mixed with water. Daler-Rowney makes a range of 27 colors, available in three series in 0.75 fl oz (22ml) tubes; Old Holland makes 32 highly concentrated and permanent colors in six series; Sennelier makes 29 colors in five series, available in 0.65 fl oz (18ml) tubes. Depending on the manufacturer, series run 1, 2, 3, 4, 5, and 6, or A, B, C, D, E, and F; the higher the number or letter, the higher the cost.
Advantages: A convenient way to use this medium. Quicker than making your own paint.
Disadvantages: The range of colors is limited. Also, tube tempera can dry more slowly than homemade paint.
Cost: The higher-series paints can be very expensive.

The series is shown on the tube label

Tube egg tempera

Manufacturer's paint chart

Homemade tempera paint

Characteristics: Available from larger art stores, pigment is generally purchased by weight, in 1.7 oz (50g), 3.5 oz (100g), 8 oz (250g), 1 lb (500g), and 2.5 lb (1kg) measurements. Because the weight depends on the material from which the pigment is made, the volume varies from pigment to pigment.
Advantages: Mixing your own paints gives you complete control over your colors.
Disadvantages: Making tempera paint is a time-consuming process.
Cost: Pigment costs can vary.

Ingredients for homemade egg tempera paint

Making tempera paint

Tempera is produced by mixing finely ground pigment with an emulsion. The traditional emulsion is made by mixing together the yolk of an egg with distilled water. Purists maintain that egg yolk provides the only true tempera emulsion, but many artists have deviated from this original recipe, modifying the egg emulsion using linseed oil and varnish. These additions make the substance more workable, facilitating particular manipulations, and make the paint slower-drying, and therefore workable for longer.

Can any pigment colors be mixed with egg emulsion?
Any pigment colors can be mixed with egg emulsion to form tempera paint, but generally speaking, the more opaque pigments—such as the cadmiums—and the artificial pigments work particularly well. Since they are used thinly and are contained within the egg emulsion, these pigments will actually appear semi-opaque or semi-transparent. Such colors will give the painting body, while allowing it to retain its translucency.

EMULSION RECIPES

Every artist who works with tempera has a favorite emulsion recipe that complements their way of working. Two basic, well-tested recipes are given below.

Egg yolk and linseed oil
3 parts egg yolk
3 parts distilled water
1 part linseed oil

Add the linseed oil to the egg yolk a drop at a time, using an eye dropper, and stirring all the time. Once mixed, add the distilled water in the same way, stirring gently until it is thoroughly mixed through.

Egg yolk, stand oil, and Dammar varnish
3 parts egg yolk
3 parts distilled water
1 part Dammar varnish
1 part stand oil

Add the stand oil to the egg yolk a drop at a time, using an eye dropper. Once mixed, add the Dammar varnish and the distilled water and stir until mixed through. To test the emulsion, brush some onto a sheet of glass. If the strip pulls away in one piece when dry, the consistency is correct; if it crumbles, more yolk needs to be added to the mix. When dry, this emulsion creates a smooth, hard surface that can be buffed up to a slight sheen using a soft cloth.

Preparing emulsion

The emulsion should be prepared using only fresh hen eggs, as fresh egg emulsion stays workable for a longer period of time. The color of the yolk does not matter; it will have no impact on the color of the paint. It is important not to contaminate your emulsion, so try hard to keep your tools scrupulously clean, and use glass or ceramic containers, as these can be washed clean easily.

Unlike other painting media, homemade tempera cannot be saved for another day. Thus, the amount of eggs needed depends on the amount of paint intended to be used in a single painting session. Generally speaking, one egg is usually enough for a day's work.

1. Break the eggshell and pour the contents into your clean hand.

2. To separate the yolk from the white, roll the egg from hand to hand, allowing the white to drain away between your fingers.

3. To dry the yolk and remove all traces of the white, roll it around in the palm of your hand. Alternatively, roll it carefully onto a paper towel.

WORKING WITH A BASIC PALETTE

Because tempera is a such a fast-drying medium, only a small amount of paint should be mixed on the palette at one time. The paint dries too quickly to be mixed on the support. The colors below form a basic tempera palette.

BASIC TUBE PALETTE

ALIZARIN CRIMSON
CADMIUM RED DEEP
CADMIUM YELLOW DEEP
CADMIUM YELLOW PALE
FRENCH ULTRAMARINE
CERULEAN BLUE
VIRIDIAN
CADMIUM GREEN
YELLOW OCHER
RAW UMBER
BURNT UMBER
IVORY BLACK
TITANIUM WHITE

BASIC DRY PIGMENT PALETTE

ALIZARIN CRIMSON
CADMIUM RED DEEP
CADMIUM YELLOW DEEP
LEMON YELLOW HUE
ULTRAMARINE BLUE
CERULEAN BLUE
VIRIDIAN
TERRE VERTE
YELLOW OCHER
RAW UMBER
BURNT UMBER
IVORY BLACK
TITANIUM WHITE

4. Once the yolk is dry, hold it by the sac and puncture it with a scalpel, allowing the liquid yolk to drain into a glass jar or dish. Discard the empty sac.

5. Mix the yolk with a little distilled water, using a plastic palette knife or a glass rod. Do not use metal tools, as these will contaminate the emulsion.

6. To make the emulsion more fluid and workable, it can be modified by the addition of oils and varnish (see recipes, page 73).

Preparing pigment

Pigment is usually sold in a form that is already finely ground, and can be mixed straight into the emulsion. Some artists prefer to grind the pigment further, however, using a little distilled water to work the pigment into a creamy paste. This paste is then added to the emulsion a little at a time. Working on the relatively small scale that is typical of working with tempera, you will use very little pigment paste—an amount that will fill a 2 fl oz (60ml) jar should suffice for several paintings.

Another way to mix the pigment with the emulsion is to place the pigment in a small, screw-top jar, and then add the distilled water. Once the top is firmly secured, the jar can be shaken, thereby mixing the pigment with the water; this is then mixed with the emulsion a little at a time.

Certain colors should always be mixed directly on the palette. These include Ultramarine, which has a tendency to set hard when left as a paste, and white. Colors such as Alizarin Crimson and Prussian Blue will only last as a paste if a bit of alcohol is added to them.

The amount of pigment that should be added to the emulsion depends on the color of the pigment you are using—some colors are more intense, and require less pigment to be added. Too much pigment added to the emulsion will result in the negation of the stickiness of the emulsion, however, so be careful not to add too much. Experimentation is the best way to learn the proper balance.

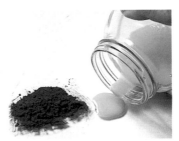

1. Most pigment is available pre-ground. However, it may benefit from extra grinding. This is done here using a glass muller on a thick glass mixing palette.

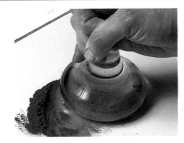

2. The emulsion-to-pigment ratio depends on the particular pigment used. Experimentation is the best way to learn the proper balance.

3. Mix the emulsion and pigment together well on a clean surface, using a palette knife.

Using tempera

Applying tempera has always been a slow process. It is the best example of an art material where the medium dictates the techniques that can be used. The quick speed at which tempera dries has a considerable bearing on the amount of paint that can be used at any one time, and precludes working on a large scale. As well, because of this quick-drying characteristic, tempera should not be painted on in a single thick layer. Rather, the paint must be built up in layers, to enable it to consolidate and set properly.

Thin tempera washes can be glazed over one another, but the bulk of tempera work involves the building up of a network or web of small, hatched marks that are used to model form and tone.

Choosing the support

Tempera can be painted on the same supports as are used for oils and acrylics—canvas panels, or even paper—but the traditional surface is an inflexible board. Whatever the support, the surface should be primed beforehand with two or more coats of white gesso applied in layers, sanding each coat before applying the next.

CORE TECHNIQUES

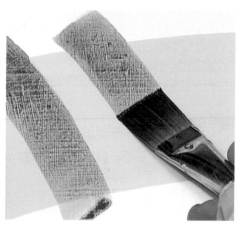

Glazing

Tempera can be used in thin, semi-transparent glazes in a similar way to watercolor. The glazes can be washed on loosely and used to quickly block in a work, or they can be used in a controlled way, to actually build up painted areas. As with oil painting, tempera is best used by working any thin wash areas first before building up the painted image using thicker mixes (see the "fat over lean" rule, page 50). If the work is being made on a white gessoed ground, a thin glaze of color will soften the starkness of the ground.

Brushwork

Tempera brushwork usually consists of a series of short hatched and crosshatched lines. These are built up to create a web of tiny marks that are often indiscernible from a distance. Due to this conformity of the brushwork, and the slightly chalky characteristics of the paint, tempera paintings can look flat, lacking any real depth both in tone and strength of color. This trait of the material needs to be worked against constantly. When successful, however, tempera paintings can possess the depth and intensity of oils, and the inner light and subtlety found in the very best watercolor work.

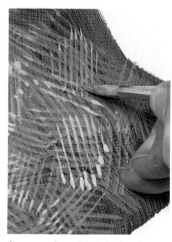

A weave of small hatched and crosshatched lines is the traditional way to build up tempera paintwork.

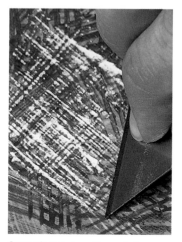

Corrections are easily made by scraping back the dry paintwork using a utility knife or a razor blade.

ACCESSORIES

Many of the accessories used with other painting media can be used for tempera painting as well. Because tempera is such a quick-drying medium, however, a special effort must be made to keep tools clean. Some artists prefer to use separate brushes and knives for tempera.

- **BRUSHES** Many of the brushes used for other painting media can be used for tempera work, but the softer sable and synthetic brushes used for watercolor work are perhaps the best choice. The important thing is to not allow the paint to dry on the bristles, as this will ruin the brush.
- **PALETTE KNIVES** Steel palette knives can be used to clean up after work, but when mixing paint and emulsions, plastic mixing knives should be used. These are available in most art stores.
- **PALETTES** Use a glass or ceramic palette, as these are easy to clean. Disposable paper palettes of the type used for oil and acrylic painting can also be used.
- **GRINDING APPARATUS** If you intend to grind your own pigment, you will need a glass muller and slab. These can be found at good art stores and at printmaking supply stores.
- **MASKS** When working with dusty materials or potentially dangerous vapors, a protective mask should be worn. The best masks have replaceable cartridge filters that are specifically made for work where dust or vapor is encountered.

Printmaking

The wide range of materials and techniques associated with printmaking make it a particularly flexible medium, offering the artist many possibilities for experimentation and expression. The medium accommodates beginners and more advanced artists alike, as satisfying results can be achieved both quickly and simply.

At the most basic level, all printmaking involves two surfaces: one bearing the image, and the other accepting the impressed image. With the exception of monoprints (see page 78), which are unique works of art, printmaking enables the artist to reproduce the same image many times over. The intention should be to make each print as similar as possible, discarding those that do not match the final artist's proof. Artist's proofs are taken at various stages during the preparation of the block, plate, or screen, allowing the artist to assess the progress of the print. These are labelled A/P, or Artist's Proof. The last proof should show the print in its final state and quality prior to the creation of the final edition.

Editions

The artist then decides on how many prints he or she wishes to make; this series of prints is known as the

Printmaking techniques

Printmaking is an extremely versatile form of artistic medium, incorporating a wide range of techniques and materials. Below are some inspirational examples of prints that have been made using some of the most popular printmaking techniques in use today.

Monoprints

This type of printmaking is particularly well-suited to beginners, as no presses or special equipment are needed. In this process, a one-off impression is made by applying ink to a surface and then transferring it onto paper. The texture and appearance of the resulting image is very different than those which are drawn or painted directly on paper.

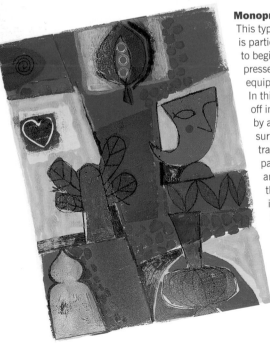

Relief prints

In this printmaking technique, a flat surface such as wood or lino block is used as the printing surface. A design is created, and those aspects of the design that are not meant to print are cut away, discarding the negative portion of the image, and leaving the image to be printed in raised relief. The raised image is then inked, typically using a roller, and then transferred to the paper.

edition. Within the edition, each print will be signed and numbered. For example, a print numbered 1/100 shows it to be the first print in an edition of 100, while 20/100 shows the print to be the twentieth in an edition of 100. Once the desired number of prints have been made, the plate, block, or screen is either destroyed or marked in such a way that makes it impossible to take any more prints which look the same as the edition. Limiting the edition in this way serves two purposes: first, numbering the prints limits the legitimate number of prints taken, thus safeguarding the prints' value; second, it preserves the integrity of the edition, as the printing process can lead, after a time, to the deterioration of the printing plate or block surface, which can result in inferior prints.

Must all of the prints in an edition look exactly the same?

If you decide to produce a limited edition of your print design, then all of the prints within the edition should look the same. There are other ways of varying your design, however. For instance, you may decide to print your design using different colors; this is known as a "suite." A variation of the suite is the "multiple," in which each print interacts with the others to create a larger work. Or, you might decide to produce a "monoprint," which, as the name suggests, is a one-off, unique work of art.

Intaglio

In intaglio printmaking processes, the image is obtained in the opposite way as in relief printing. Typically done on a metal plate, a design is cut or etched into the surface, and the sunken lines are then printed by pushing ink into them, followed by paper, to take up the inked marks. Thus, the original (uncut or unetched) surface becomes the "white" element of the print.

Lithography

Unlike relief and intaglio printing, in lithography, both the printing and non-printing areas are on the same plane. The image is drawn onto either a metal plate or a lithographic stone using greasy materials; the area not meant to be printed is treated with water-based materials. The greased portion of the image is then reproduced on paper using either direct pressure or an offset press.

Screenprinting

A very similar process to stencilling, screenprinting involves transferring ink through a screen of stretched, fine mesh by way of pressure. The design is made by blocking parts of the screen out, to stop the ink from coming through. The screen can be blocked out using either paper, stencil film, or liquid filler—or any combination of these materials.

Monoprints

The easiest form of printing—and the one that requires the least preparation and equipment—is monoprinting. As the name suggests, the technique results in a unique impression which differs in form as well as color from any other print. It is impossible to make another impression, let alone several prints that are identical, as trying to take multiple impressions results in each print becoming substantially lighter. It is, however, possible to work on the image between impressions, thus producing a series of similar prints.

Monoprinting is an excellent way to learn about and begin printmaking, because several of the techniques used are similar to those in other printmaking methods, and do not require special equipment or expensive presses—much of the necessary equipment can be found around the home and studio.

Unlike other printmaking techniques, monoprinting allows you to experiment each time you take a print. Creative enjoyment can be had by both the professional artist, working with technical help and sophisticated equipment, and the novice printmaker, using homemade equipment. The unpredictable quality of the medium is exciting, and constantly tests the artist's capabilities and competence.

Materials and equipment

PRINT SURFACES The surface upon which the print is made must be smooth, flat, and non-absorbent. Thick plate glass is ideal; sheets of picture or window glass can also be used, but take care not to apply undue pressure, or the glass may break. In order to prevent cuts, tape the edges with duct tape. Smooth, metal plates are another option, as is plastic or acrylic sheeting. If all else fails, try using Formica- or melamine-laminated hardboard (Masonite), or medium-density fiberboard (MDF). The advantage of using a clear, transparent surface is that a preparatory drawing or design can be placed beneath the printmaking surface and used as a guide.

INKS Any block-printing inks can be used. Printing inks are available in a range of basic colors, and can be either water- or oil-based; oil-based inks are slower drying than water-based ones. Oil paint can be used in place of printing inks, but take care not to over-thin the paint.

Brushes and papers

Prepare a "palette" of inks with separate rollers. Unless the print is going to be very simple, use oil-based inks, as water-based ones will dry very quickly.

Block-printing ink

PAPERS Most types of papers can be used for monoprinting. The one criterion is that the paper must be thin enough to carry the pressure applied to the back of the sheet when it is rubbed through to the inked plate surface.

ROLLERS Utilized in most printmaking techniques, a roller is a generally useful piece of equipment. Rollers are not essential for monoprinting, however; the printmaking surface can also be inked using a cloth or rag, and paint can be added using a brush. If a flat, relatively even tone is desired, however, it is best to use a roller.

Roller

CORE TECHNIQUES

Inking the plate or print surface

If you are using a see-through material as the print surface, place a drawing or painting beneath it to act as a guide. The ink or paint can be applied in a number of ways. Ink worked onto the plate using a roller will appear flat. A more complex surface can be developed using brushes and oil paint— use the paint straight from the tube and brush it out well, without over-thinning it. Different colored inks can be applied to different areas.

1. Place a drawing or design underneath the glass, to act as a guide.

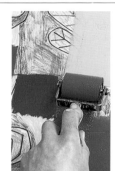

2. For areas of flat color, apply the inks with rollers. Several colors can be put down at a time.

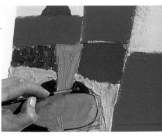

3. For a more painterly and textured surface, printing inks or oil paints can be applied using a brush.

Developing the print

Once the surface is inked, the design or drawing can be elaborated, either by working back into the image and erasing areas by wiping away ink or paint, or by drawing into the ink or paint using tools to manipulate the inked image.

1. Dabbing inked areas will create a mottled texture.

2. For linear patterns, make card "combs" and pull across sections of color.

3. Found objects, such as the end of a cardboard tube, can be used to "stamp" out shapes in inked areas.

Taking a print

When the image is ready, a print is taken by carefully placing a sheet of paper on top of the image. Once in position, the back of the paper is steadily rubbed using the hand or a rag pad. Try to apply even pressure, to ensure that equal amounts of ink are picked up and transferred to the paper across the entire print area.

1. To print without using a press, place the paper over the print and apply pressure with the hand or a rag pad, using circular movements. If a second impression is to be printed over the first image, tape down one end of the paper to ensure that the subsequent impression will print in register.

2. Check the progress of the print at any time by pulling back gently from a corner.

Line work

Line work can be made by drawing onto the back of the paper when it is positioned over the inked plate. Use the sharp end of a paint brush to draw, applying a fair degree of pressure. Use pencil if you need to see an image of what you are drawing. Remember that whatever you draw will be printed in reverse.

1. Roll out some ink very thinly. Carefully position the paper on top of it. Take care not to apply unwanted pressure, as this will make corresponding marks. Using a point—or if the progress of the drawing needs to be seen, a pencil—draw firmly on the back of the paper.

2. Starting at one corner, peel back the paper to reveal the transfer of the ink. The result should be a clear line with a pleasingly soft and slightly "fuzzy" quality.

Relief prints

A relief print is an image produced from the transfer of a raised inked surface to some other surface. It derives its name from the Italian word *rilievare*, which means "to raise." It is the oldest printmaking method, with prints made in China over 1400 years ago using techniques very similar to those employed today. Relief-printing methods include linocut, woodblock, and wood engraving (these are relatively sophisticated techniques), as well as collage printing.

With relief printing, an image is produced by inking and making an impression from a raised or relief image. This image is gouged and cut out of the surface of either a wooden block (woodcut) or a sheet of special printmaking linoleum (linocut). Wood engraving is a more sophisticated version of woodblock printing, and is done using fine, wooden blocks that have been sawn across the grain. Collage printing follows the same principles as other relief methods, with the positive or raised parts of the image (the part to be printed) emanating from a range of collaged materials.

One common aspect to all relief-printing techniques is that the parts that are cut away will not print. The end result thus depends entirely on the preparation done beforehand, and artist's cutting skills.

Materials and equipment

COLLAGE, LINO, AND WOODBLOCKS Collaged printing blocks can be made using a wide variety of materials, including corrugated card, relief-pattern wallpapers, seeds and pulses, string, and textured fabrics—in fact, anything at hand. The materials are glued onto a base board or solid support, as in traditional collage techniques (see pages 104-105).

The linoleum used for making linocut prints has a substantial burlap backing, and is available in several thicknesses. It can be bought as ready-cut blocks, or in rolls from which you can cut your own. Rolled lino should be warmed before unrolling to soften it; warming also makes cutting and gouging much easier.

Woodcuts can be made on plywood sheets, or any flat softwood. Special, side-grain woodblocks are available in printmaking supply stores. Wood engraving is a far more delicate process than woodcutting, and requires a hard, fine-grain wood. The block is cut from the end grain, which usually has a tight texture. Favorite woods include box, holly, maple, and fruit tree woods. Many woodblock suppliers provide a resurfacing service for used blocks.

Linoleum

Side-grain woodblocks

CUTTING TOOLS AND GOUGES Lino-cutting blades come in sets, and are made to fit into a handle. While these are fine for lino-cutting, however, they are of no use for woodcutting or wood engraving. Better-quality woodcut tools can be used for linocut as well; these are made from steel, and are fitted with a comfortable hardwood handle. If they are re-sharpened frequently and properly

Engraving tools

U-shaped gouges

V-shaped gouges

cared for, they can last a long time. A tap knife can also be used to cut lino, and craft and cutting knives can be used for fine line work in wood. Gouges, used for gouging out cuts in the wood or lino, are available either U- or V-shaped, and vary in size. Engraving in hardwood requires the use of stronger, solid-metal tools, also available in a range of shapes and sizes. A good-quality oilstone is also needed for sharpening cutting tools, and shaped oilstone slips are made for sharpening the inside edges of U- and V-shaped gouges.

Craft and cutting knives

Tap knife

INKS A relatively wide range of colored inks—both water-based and oil-based—is suitable for relief printing. Colors that cannot be purchased ready-made can be mixed on an inking slab. The viscosity of linseed oil-based inks can be altered by using a thinning oil, and the drying time can be accelerated using cobalt dryers.

Ink

ROLLERS Good-quality inking rollers are made from rubber or polyurethene. Rollers are made in a variety of widths, from 1-17 ½ in (25-450mm); the size you will need depends on the size of the woodblock or lino sheet.

PAPER There are many types of papers that are suitable for relief printing, and each has specific characteristics that can contribute to or detract from the quality of the finished print. A hard-surfaced paper, for example, can result in the ink drying with a gloss, while paper that is too soft can result in an indistinct image lacking in punch and definition.

CORE TECHNIQUES

Preparing lino and woodblock

Mark out your design using pencil, marker, or Indian ink. You can draw it directly on the lino or wood block, or trace a prepared design using tracing paper. Remember, the image will be reversed when it is printed.

Lino
1. Degrease the surface of the lino using methylated spirit (this is particularly important if using water-based printing ink).
2. A prepared drawing or design can be transferred onto the lino using tracing paper. If a bold result is required, the design can be strengthened using a marker. Fill in solid areas to give an accurate impression of the weight of the line.

Wood
1. Clean the surface of the wood using methylated spirit. Fine sandpaper can be used to bring out the grain pattern, or to remove loose fibers.
2. Either draw the image directly onto an inked block (the ink should be allowed to dry first), or transfer a prepared design using transfer paper.

Cutting

Simple woodcuts and linocuts are cut into along the lines of the design with a knife. The non-printing areas are then removed with a gouge tool, leaving the design in relief. Always cut along and away from the drawn lines—it is easy for the gouge to slip. Take a proof periodically to see how the work is progressing.

Lino
1. Use a V-shaped gouge for clean outlines, and to create detail such as hatching.
2. For a rough, slightly "crumbly" edge, use a U-shaped gouge (the type that is sold separately from the handle is particularly good for this effect, especially when blunt).
3. Use a wide gouge to clear all areas that will be "non-reading."
4. Rather than inking the block to take a proof, a useful shortcut is to make a rubbing using a wax crayon over thin paper. Any adjustments can then be made without having to clean off the printing ink first.

Wood
1. A knife can be used to cut outlines. This creates a boundary around the design prior to clearing the surrounding areas, and will prevent over-cutting.
2. Sizeable areas of unwanted wood should be cleared with a large gouge, cutting in the direction of the grain for greater ease.
3. A V-shaped gouge is useful for "drawing" deeper channels, and for creating uniform lines and clearing corners.

Printing

Prints from linocuts and woodblocks are made in exactly the same way: the surface is inked, and then the print is taken either by hand or by using a press.

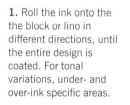

1. Roll the ink onto the the block or lino in different directions, until the entire design is coated. For tonal variations, under- and over-ink specific areas.

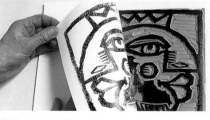

2. If printing without a press, pressure can be supplied by burnishing with a baren. Another popular tool is the back of a spoon; the hands are also effective burnishing tools.
3. When pulling a print, keep the paper still by placing one hand on top of it, then lifting up from one corner. Pull the print up gently, one half at a time.

MULTI-COLORED PRINTS

It is also possible to make multi-colored relief prints, either by using several wood blocks, or by using the reduction method. If using several blocks, trace the image onto each one. The number of blocks needed will depend on the number of colors being used: for example, four colors will require four blocks. Each block is designated a color, and all of the image is cut away except the part of the image that is to print the designated color. Each block is printed in turn, making sure that both the paper and the blocks are held in register. When using the reduction method, the block is cut and the first color is printed. More of the block is then cut away, and the second color is printed. The process is repeated for each color until the print is complete. This technique requires some lateral thought, as the artist must work out exactly what needs to be cut away at each stage of the process. Both techniques can be used with lino sheets as well.

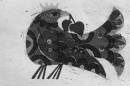

Intaglio

Intaglio printing, which derives its name from the Italian word *intaglione,* meaning to engrave or cut, refers to a range of techniques, all of which involve the incision of designs into metal plates. The ink is rubbed into and held in the engraved or etched furrows and depressions of the plate, the surface of which is wiped clean of ink (in the industrial process this is done by means of a scraper, while printmakers clean off the ink using a fine wiping canvas). Damp paper is then placed over the plate and passed through a press which has a flat metal bed. The press contains heavy metal rollers that apply pressure, forcing the damp paper into the inked grooves. The paper then takes up the ink, leaving an indented impression of the entire plate on the paper. The print is then peeled off of the press.

Types of intaglio

The design or drawing can be made on the metal plate using several methods. The drypoint method consists of scratching the design into a soft metal plate, usually copper, using a sharp pointed tool such as a steel needle or diamond point. Drypoint is very similar to pencil sketching—all that is really required is good draughtsmanship.

Materials and equipment

PRINTING PLATES Copper is the best metal for printing plates, but it is also the most expensive. It is soft enough to enable drypoint and engraving tools to bite easily, and acid eats into it evenly and cleanly. It is usable on both sides, but must be burnished and polished before use. Steel is harder than copper, and will give many prints before the image deteriorates. Zinc and aluminum are soft metals that are easier to use for drypoint, but zinc can oxidize and can make pale colors look dirty. Plates can be purchased in a range of sizes from good art stores or printmaking suppliers. They are often sold polished, and with an acid-resistant coating on the reverse side. Store plates with any plastic coating intact in a dry environment. Those plates that do not have any protective film should be greased and wrapped in grease-proof paper for storage.

ENGRAVING AND ETCHING TOOLS For drypoint, you will need a drypoint needle, a scraper to scrape away mistakes, and a burnisher to smooth over the corrected area. Engraving tools are made of solid sharpened steel. Tools for mezzotint, a form of engraving, consist of rockers made up of a series of teeth that bite into the metal plate; burnishers and scrapers are used to make corrections. Etching tools consist of etching points, which need only be sharp enough to cut through the ground to reveal the metal of the plate below. Again, scrapers and burnishers are used to facilitate corrections.

ETCHING GROUNDS, STOPPING-OUT VARNISH, AND AQUATINT The surface of the etching plate is covered and protected by a soft or hard ground. Basic ground ingredients are a mixture of beeswax, resin, and bitumen. Hard grounds are used when the design is to be drawn using an etching needle. Soft grounds create a softer line when "bitten" by the acid, and images can be made by impressing materials into it. Both types of grounds are melted onto the plate and spread with a roller. Drawings with a quality similar to soft pencil can be made by placing a sheet of paper onto the prepared plate and drawing onto it; when the paper is removed, the drawing is left showing in the ground.

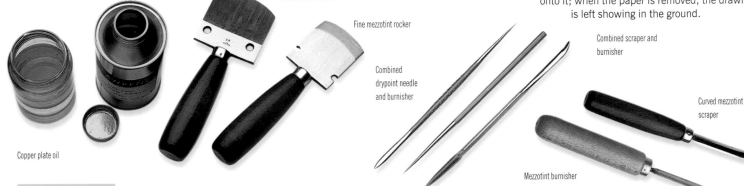

Zinc and copper plates

Copper plate oil

Coarse mezzotint rocker

Fine mezzotint rocker

Combined drypoint needle and burnisher

Combined scraper and burnisher

Curved mezzotint scraper

Mezzotint burnisher

Drypoint needle

Engraving is similar to drypoint, but the tool used is called a "burin." The burin actually cuts the metal, rather than simply making an impression upon it, as is the case with drypoint. In mezzotint engraving, the metal plate is pitted with tiny indentations made by a tool called a "rocker," roughening the entire surface. The image is then worked backward, from black to white, as sections of the plate are burnished. Etching is another form of engraving, but here the design is bitten into the plate by the action of acid. Those areas not to be printed are protected from the corrosive action of the acid by a "ground," made from a mixture of wax, resin, and bitumen, and coated onto the surface of the plate. The edges and back of the plate are protected from the acid with varnish.

Is it possible to recycle and reuse old metal plates?
It is indeed possible to recycle and reuse old metal plates. A damaged or worn plate can be ground down with block charcoal, using turpentine substitute as a lubricant, and then burnished and re-polished. If the damage is fairly deep, a snakestone can be used to grind the metal down. This latter process will dent the plate, but it can be hammered out carefully from the reverse side. The plate should be finished with metal polish, and then degreased.

SAFETY
Acid is extremely dangerous and corrosive. If brought into contact with skin, it will burn; if splashed in the eyes, it can blind; and if the fumes are breathed in, it can damage the lungs. Always wear protective clothing, work in a well-ventilated area, and store acids and acid-water mixes in clearly labelled glass jars. Always obtain expert advice on the correct acid mixtures for different metals.

Stopping-out varnish is an acid-resistant liquid that is applied to those areas of the exposed plate that are to be kept away from the acid. This should include the edges of the plate and, if not covered with a protective coating, the back of the plate.

Aquatint enables the printmaker to create areas of solid tone on an etching plate. It is made from resin dust, and is distributed over the plate surface by using an aquatint or dust box, or a type of shaker that sieves the dust onto the plate. The aquatint is then heated, melting the dust into tiny resin blobs that adhere to the surface of the plate, protecting the covered area from the action of the acid. The density of the aquatint, coupled with the action of the acid, gives varying tonal depth.

Stopping-out varnish

ACIDS Nitric acid is the strongest type of acid, and is used for etching copper, zinc, iron, and steel. Printmakers dilute acids to different strengths to suit the speed and degree of bite required. For biting copper, mixtures vary from 3:1 to 1:1 water to acid; for zinc, the solution is weaker, from around 5:1 water to acid. When used on copper, the exhausted solution turns blue. Always add the acid to the water, and not water to acid.

HOT PLATES A hot plate is used in etching for several operations, including preparing and inking the plate. The wax ground needs heat to melt it so that it can be distributed over the plate, usually by a roller, and the plate is heated while being inked. The heat thins the ink, allowing it to settle well into the lines and fissures on the plate. Thermostat-controlled hot plates are available, and come in a range of different sizes.

PRESSES Intaglio presses consist of a heavy, flat bed, traditionally made of metal, but increasingly made from hardwood bonded with a tough acrylic sheet. The bed is passed between two heavy rollers, and pressure is increased by lowering the upper roller by pressure-adjusting the screws. Felt blankets are placed over the plate and paper before they are passed through the press; these can be bought cut to the size of the press.

PAPER The paper used for intaglio printing is dampened beforehand by soaking in clean water, to give it flexibility. It is then drained, blotted, and interleaved with blotting paper to remove excess moisture. High-quality watercolor papers are often used for intaglio printing.

INKS Cans and tubes of oil-based inks are used for etching, and can be found in a range of colors. The inks are made using linseed oil, and are mixed and thinned using copper-plate oil, which is available in a range of viscosities.

Hand-operated press

Hard and soft ground

Tinned intaglio ink

CORE TECHNIQUES

Preparing the plate for etching

If the plate has hard, vertical edges, these can cut the paper under pressure. To avoid this, the edges are filed. The plate is then degreased, to ensure that the ground adheres properly. Smoking the ground darkens it, making it easier to see the etched lines. Soft grounds are not smoked.

Filing
File the edges of the plate to roughly a 45-degree angle.

Degreasing
The plate is degreased using a mixture of French chalk and ammonia; this is then rinsed off.

Smoking the ground
1. A hard ground is applied evenly over the front of the plate.

2. The plate is heated, and the ground is distributed over the surface with a hard roller.

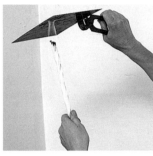

3. The plate is held upside down, and the flame is moved in a circular motion beneath the surface. Only the smoke—not the flame—should touch the ground.

Drawing on the plate

In intaglio, the pressure of the printing forces the paper into the intaglio to pick up an impression from the marks made—from fine lines to deep bites.

Drypoint
The design is scratched into the plate with a needle. This raises a burr on each side of the line, which holds the ink.

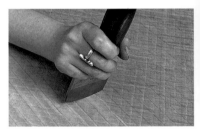

Mezzotinting
The plate surface is roughened using a rocker, and then worked back into using a scraper and burnisher.

Biting etching plates

The action of acid on metal is called the "bite." Estimating the speed and depth of the bite can only be assessed with practice. The longer the plate stays in the acid, the deeper the etched line will be, and the more ink it will hold.

1. Once ready, the plate is placed into the acid bath. Wear rubber gloves if there is any danger of your hands touching the acid.

2. A feather is used to wipe away the tiny bubbles that form where the metal is exposed; if left, they can cause an unevenly bitten line.

3. The plate is then removed from the acid, rinsed with cold water, and the ground is removed with an alcohol-based solvent.

Etching
The hard or soft ground is worked through to expose the metal of the plate.

Textural and tonal effects

There are a number of techniques that enable a variety of textures and tones to be made. These include aquatint, where tiny, melted blobs of resin act as an acid resist, and the sugar lift-technique, which involves painting the design with a sugar solution onto the plate.

Sugar lift

1. The design is painted on using sugar solution on a degreased plate. The sugar solution is typically one part sugar to four parts water and one part ink.

2. Allow the sugar painting to dry fully, then cover the entire plate with a thin coat of stopping-out varnish diluted with white spirit.

Aquatint

This process enables the creation of areas of solid tone, as well as gradations from white to black.

3. When the varnish has dried, immerse the plate in water. The sugar will begin to dissolve, and the varnish to lift; brush lightly to assist the process.

4. When the sugar coat has lifted, leaving the design exposed, place it in acid to bite as required. Bubbles will appear; these are caused by the fast action of the acid on the exposed metal.

Printing the plate

To ensure that the impression is taken squarely on the paper, you can lay a base sheet of paper on the bed of the press with the outline of the plate marked upon it. When the printing paper is placed on the plate, the edges can be aligned to this base sheet. Alternatively, stick masking tape guides on the press bed.

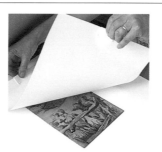

3. The plate is placed centrally onto the flat bed of the press, and a sheet of damp paper is placed on top of it.

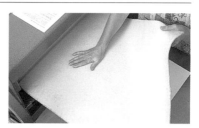

4. Felt blankets are then laid over the plate and paper (between 2-5 layers), with a lighter layer next to the plate and a heavier one next to the roller.

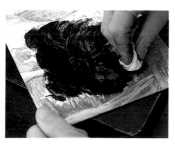

1. Once the ink is prepared, the etching plate is placed on the hot plate, and the ink is rubbed over the surface and into the etched lines using a pad of scrim.

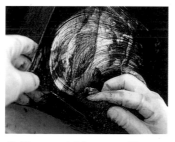

2. All excess ink is removed from the surface of the etching plate with a wiping canvas or the side of the hand. Do not dig the ink out of the deep intaglio.

5. The bed is put through the rollers. The blankets are then peeled back, followed by the sheet of paper, complete with the impression.

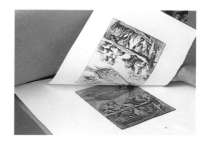

Lithography

The process of lithography is based on a simple chemical principle: the mutual antipathy of grease and water. The image is drawn onto a grease-sensitive, flush surface—a lithographic stone or a metal plate—using greasy materials, and the areas that will not print are treated with water-based materials, to keep them clear. When the printing ink is rolled on, it only adheres to the sensitized, greasy marks. The inked image can then be printed on paper either by direct contact, or by offsetting, which entails taking the ink up onto an intermediary surface, then laying it down on the paper. Much of the success of lithography depends on careful preparation.

Lithographic surfaces

Originally, lithographic images were prepared on large blocks of limestone, and printed by direct contact. Since the late 19th century, however, zinc and aluminum plates have been commonly used as replacements for stone. While stone printing differs chemically from plate printing, both processes depend on the use of greasy drawing materials.

An ideal introduction

In one respect, lithography is an ideal introduction to printmaking, as the image is created using standard

Materials and equipment

LITHOGRAPHIC INK AND CRAYONS Lithographic crayons look not unlike conté or carré pastels, and produce marks that are very similar. Round crayons are also available, as are large tablet crayons which are used for laying in large areas of tone. Crayons are sold in grades ranging from very soft to very hard. Lithographic ink is thick and waxy, and can be diluted with water. It can be painted on using a brush or pen, or applied using a sponge, rag, or a finger. Lithographic pencils and sticks can also be used. Lithographic crayon and ink manufacturers include Stones, W. M. Korn, and Charbonell. Lithocoal makes pastels and powders that can be used for washes.

PRINTING INK Lithographic printing inks are linseed oil-based, and are available in a range of colors. They are completely intermixable.

INKING ROLLERS Lithographic rollers are large, and look like rolling pins. The very best are made from leather, but excellent rubber rollers are also available. The size of the roller depends on the size of lithographic plate,

Lithographic crayons

Lithographic stick drawing ink

Lithographic pencil

Lithographic printing ink

Lithographic sticks

Lithographic liquid drawing ink

drawing and painting techniques, and put onto the surface in the same way as drawing or painting on paper—the marks made hold the ink for printing.

Monochrome and color lithography

Monochrome lithography is similar in tone and texture to crayon drawings, while color lithography involves the creation of various surface and textural effects by overprinting. Whatever color is used to ink and print the plate, the initial work is always done in black and white. And no matter what medium is used, it must be greasy. Black lithographic crayons, pencils, and ink are generally used to make the initial drawing. Once the plate has been processed, the image can then be inked up in any color.

Is it possible to mask off an area of the printing paper so that it remains white?

An area of the print can be masked off, and thus will remain white, by the simple application of gum or gum-etch solution applied with a soft brush. The gum will leave a slightly darkened mark on the lithographic stone or plate. Using this technique, a white border can be left around the print to act as a frame, or a particular shape may be printed white. Preparing an initial working drawing of your design will help you decide which parts of it you wish to mask off.

but in order to prevent overlap marks, use as large a roller as possible.

PAPERS Lithographs can be printed on either dry or damp paper. Dry paper requires a heavier printing pressure, and results in a print that looks slightly hard, with well-defined tones. Damp paper is softer, and needs less pressure to ensure good contact with the inked plate surface; prints made on damp paper have a more subtle, softer feel.

LITHOGRAPHIC PLATES Lithographic plates are made of zinc or aluminum. They are sold with a prepared grained surface, and can be found with fine, medium, and coarse finishes. The plates are made in a variety of thicknesses and dimensions, with the largest measuring up to several feet in width and length.

Zinc lithographic plate

Large inking roller

HAND-OPERATED LITHOGRAPHY PRESS

This table-top direct-method lithography press is made by Takach Press. The vast majority of presses today are designed specifically for printing metal plates, but some (such as the model shown) can be altered to accept litho stones as well. Direct method presses vary in design, but most are similar in principle: the bed of the press holds the plate or stone, which is then inked up by the artist. The selected proofing paper is placed on top of the inked image, and several sheets of soft paper are laid over it; this cushions the impression as the plate or stone passes through the press. A side lever lifts the bed of the press so that it comes in contact with the print, thus causing pressure on the plate or stone. The plate or stone is then drawn through the press by winding the handle.

Hand-operated lithography press

CORE TECHNIQUES

Preparing the plate

A few small variations are possible in the steps taken to prepare and process a lithographic plate. The steps shown here are a standard series of stages, and explain the basic principles, but methods and practices may vary slightly. Remember that the plate is sensitive to grease, and any fingerprints or hand impressions may show up in a finished work. To avoid this, use a piece of paper as a bridge upon which to rest your hand.

1. Sensitize a damp plate by sponging over a solution known as counter-etch, then then wash with cold water.

2. Once the plate is dry, prepare the edges by sponging on a border of gum arabic to delineate the working area.

3. Draw the design on the plate using a lithographic crayon, stick, or pencil. If using a drawing as a guide, use non-greasy transfer paper.

4. Apply the lithographic ink with a paintbrush, working as you would on paper. The ink can be used at full strength, or diluted with tap water.

5. Once the design is finished and completely dry, dust French chalk onto the plate, followed by powdered resin.

6. Apply liquid etch solution, covering the surface of the plate evenly and generously. This will help "fix" the drawn image on the plate. Wash off after a few minutes. Dry the plate using a hair-dryer.

7. Sponge a thin layer of gum arabic over the image, and allow to dry overnight.

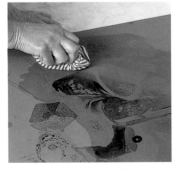

8. Wash out the image using mineral spirits—the gum will be unaffected by the solvent and will continue to protect the surface.

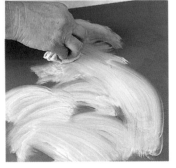

9. Rub in a thin layer of printing ink or asphaltum, to help reinforce the image and strengthen the texture.

10. Wipe the ink with mineral spirits, then wash the gum off. Roll up the damp plate with printing ink, gum it again, then let it stand.

Printing the plate

First, dampen the plate with a sponge; the greasy image will repel the water, which will settle onto the areas without an image. On a direct-method press, the paper is then placed over the plate and run through the press before being peeled back to reveal the image. The steps below illustrate the process when an offset press is used.

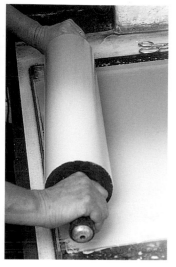

1. Transfer the ink from the inking slab onto a roller, then roll evenly over the image.

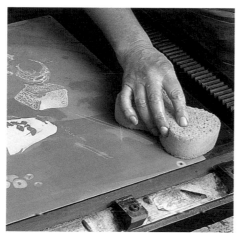

2. Using a wet sponge, remove the gum from the plate (as applied in step 10, left), then position the plate on the bed of the offset press.

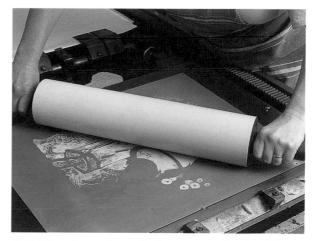

3. Roll the color evenly over the image area on the plate. Wipe with a damp sponge to remove any ink residue on the non-printing surface.

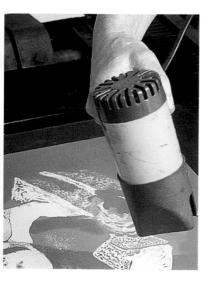

4. When enough ink has been applied to the image, wipe the plate with a sponge and water and dry using a hair-dryer.

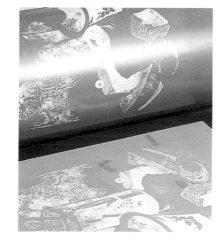

5. On an offset press, a rubber roller picks up the inked image. The paper upon which the image will be printed is positioned at the other end of the press.

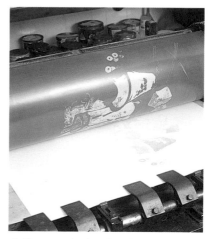

6. The paper is placed on the press bed, adjacent to the plate. The roller is taken over the plate and back, making contact with the paper, laying the image down.

Screenprinting

Screenprinting is the modern counterpart of stencilling, a popular form of decoration in the Middle Ages that was later used extensively in the manufacture of wallpaper. The technique is remarkably simple, and has changed little since the first patent for it was granted in the early 1900s; the technique of multi-color printing was developed a few years later.

Screenprinting differs from other printmaking techniques in that the impression is not taken from a plate or block, but is achieved by printing through an intermediary layer of fine fabric mesh. The ink is prevented from reaching certain areas of the paper by attaching a stencil made from either paper, stencil film, or liquid filler beneath the screen, thus blocking out certain desired areas of the mesh.

A colorful, versatile medium, screenprinting is capable of producing extremely charming images, and the use of multiple stencils allows for the production of highly sophisticated effects. The basic process of screenprinting is straightforward and relatively unsophisticated, and requires very little equipment to succeed. Besides being a popular fine art, it is also used for commercial purposes, particularly in the areas of graphic, ceramic, and textile design.

Materials and equipment

SCREEN A basic screen consists of a frame with a fine mesh fabric stretched over it. Frames can be bought with or without the mesh fabric already stretched. Screens are made from either hardwood or metal. The fabric used is high-quality polyester, and is available by the yard or meter and in different mesh sizes.

SQUEEGEE The squeegee fits inside the screen and pulls the ink across it, forcing it through the mesh onto the paper. It should be the same size or slightly smaller than the inside width measurement of the screen frame. Squeegees are made from wood or, less commonly, plastic or metal, with a stiff rubber blade secured to the bottom edge.

SCREEN FILLER AND STENCILS Simple stencils can be cut from tracing paper, but better results will come from using an adhesive stencil film. The film is available in rolls or sheets, and is colored but transparent. A design can be placed beneath the film to act as a cutting guide, and the film's transparency also allows it to be cut on a light-box. Stencil film does not feel sticky, because the adhesive is activated by wetting. Clear areas outside the stencil area that are not to be printed can be blocked out using a filler.

Excess ink can be squeezed from a squeegee into a tin, for later use.

PAPER Screenprinting can be carried out successfully on many different types of paper, and the characteristics of the paper will have a direct influence on the quality of the print. The use of lightly sized and unsized papers results in the print having a softer quality, while hard or heavily sized papers allow for transparent colors to be overlaid, giving a crisp image. Heavy paper or card can also be used.

INKS Water-based acrylic screenprinting inks are available in a range of intermixable colors from several manufacturers, including an excellent range from Speedball. Base extenders make the inks go further, and transparent base increases the transparency of the ink. Golden makes a silkscreen medium that can be mixed with any Golden acrylic paint, acting as a drying retarder and increasing the working time. Oil-based inks are also available, but are more difficult to clean up after use.

Acrylic paints

Screenprinting inks

Squeegee

Screen

CORE TECHNIQUES

Paper stencils

Simple stencils can be cut from paper. The advantage of using any type of hand-cut stencil is that the image that will print is prepared away from the screen, and thus any mistakes can be rectified by simply remaking the stencil. Tracing paper is ideal for making hand-cut paper stencils, because it can be seen through, and the design can thus be drawn directly onto the stencil paper prior to cutting. Remember that the stencil will represent the negative part of the image.

1. The design is traced onto the paper, and the sections that are to print are cut out using a scalpel, to create a stencil.

2. The paper stencil is placed onto the sheet of paper to be printed, and the two are positioned beneath the screen mesh.

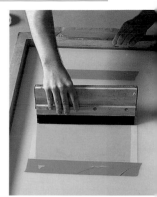

3. After stopping out the edges of the screen using tape (to ensure a clean line border), an even flow of ink is poured over the screen, and then pushed back using a squeegee, pressing the ink through the stencil.

Filler stencils

Liquid filler can be used to paint designs directly onto the screen. The painted image will represent the part of the image that is to remain unprinted. A working drawing can be placed beneath the screen to act as a guide while painting. Multi-colored images can be made using this method, as the stencil is modified or added to after each color has been printed.

1. Water-based liquid filler is brushed directly onto the screen, using a tracing below as a guide.

2. After stopping out the edges of the screen using tape (to ensure a clean line border), the ink is poured over the screen.

3. The ink is pushed back using a squeegee, pressing it through the stencil. Here, a second color, blue, is printed.

Stencil film

Stencil film is a gelatinous material affixed to a clear plastic backing sheet. A design can be cut into it using a sharp knife. When soaked with water, the material softens, and is pressed into the mesh. The backing is then removed.

1. Using a sharp knife, the top layer of the stencil film is cut into in accordance with the design.

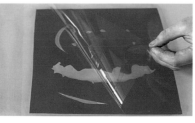

2. The stencil is positioned under the screen, and clean water is applied, to soften the material; the screen is then blotted with absorbent paper. When the screen is dry, any unwanted areas are blocked out using filler. When the screen is ready for printing, the clear plastic backing sheet is peeled away.

Tusche technique

This technique allows the artist to work with a positive image, as the marks made on the screen will actually print. The image is drawn onto the screen using greasy lithographic Tusche drawing ink or lithographic crayons.

1. Using greasy lithographic Tusche drawing ink or lithographic crayons, the image is drawn onto the screen.

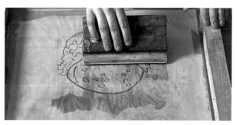

2. Once the design is dry, the entire surface of the screen is covered with a coat of gum arabic. When the gum arabic is dry, the greasy image is washed away using mineral spirits; the gum stencil is left covering the negative areas of the drawing. The ink will pass through the areas formerly covered by the greasy materials.

10:1

THESE TWO PAGES
• BRUSH AND SPRAY TYPES
• SPRAY GUNS
• COMPRESSORS
• PAINTS AND MEDIUMS

Airbrushing and spray painting

The use of the airbrush and spray gun as a means of rendering highly realistic natural, man-made, and fantasy or science-fiction subjects has become increasingly popular over the past four decades. In the 1960s, the airbrush was used extensively to create the dream-like imagery of that era. In the 1970s and 1980s, the trend toward photorealism and the removal of all marks of individuality from artworks resulted in the airbrush and spray gun finding a permanent place in many an artist's studio. Because high realism has remained a goal of many contemporary artists, the popularity of these techniques perseveres today.

Illusion and reality

The concept of fooling the eye is far from new, and to many artists, success in doing so has been something of a holy grail. The tradition of *trompe l'oeil* (tricking the eye) dates back to the ancient Greeks, and tales of artists tricking fellow artists and the public with these images are well documented. The ability of the airbrush to make unbroken, smooth transitions of tone and color that closely echo the effect of light on objects makes it the perfect tool for this type of work.

Airbrushing and spray painting techniques are used not only by fine artists to create paintings—they are also used

SAFETY PRECAUTIONS
It is dangerous to accumulate acrylic or pigment deposits in the lungs, so be sure to always wear protective clothing, a mask, and a respirator when using an airbrush or spray gun. Keep the protective gear on for a short time after you've finished painting, as the toxic materials can hang in the air.

MAINTENANCE
In order for spray guns and air brushes to operate at their best, it is essential that they be cleaned thoroughly and immediately after use, before any paint has a chance to dry. Moving parts in sprays and brushes are usually chrome- or nickel-plated, both of which provide excellent protection against chemical corrosion and sticking paint. All brushes and guns can be stripped down for cleaning, but before this is done, it is best to spray through with chemical solvent, airbrush cleaner, and water. Paint should then be cleaned from all external surfaces, the spray stripped down, and all of the individual parts cleaned.

Brush and spray types

The airbrush consists of a fountain-pen-like cylinder, usually made of brass and chrome. Inside the cylinder is a hollow tube which contains a long needle that fits tightly into the hollow nozzle or opening at one end of the brush. The nozzle has an open cap that can be adjusted or removed to alter the texture of the paint spray. The needle is moved in and out of the nozzle, effectively turning the spray off or on by a trigger mechanism mounted on top of the airbrush barrel and operated by the first finger. A reservoir holds the liquid paint, which is fed into the barrel of the brush and flows down to the nozzle around the operating needle. The paint reservoir can be on top of the airbrush barrel, in which case the paint is gravity-fed, or beneath the barrel, where the paint is suction-fed. An air hose connects to the bottom of the brush, delivering air under pressure to the nozzle. When the trigger is pressed, it atomizes the liquid paint and blows it out at the support. The airbrush nozzle diameter varies according to make and model: the smaller the diameter, the finer the spray width, making it possible to make a line as small as $1/75$ in (0.4mm) wide. Well-known airbrush manufacturers include Aerograph, Badger, Olympos, Thayer & Chandler, Vega, Iwata, and Paasche.

Spray guns

Spray guns operate in very much the same way as airbrushes; they usually have larger nozzles, however, making it possible to spray over much larger areas. Many guns also incorporate a flow control for altering the spray. The paint reservoir is larger than that in an airbrush, and is mounted on the top of the gun, gravity-feeding the paint to the nozzle, or below the gun, feeding the paint into the nozzle by suction. Spray guns invariably need a higher air pressure than airbrushes to work well, and they are not suitable for fine work on a horizontal surface—due to the position, angle, and size of the reservoir, the gun is best used with work that is held vertically. Spray guns are made by Olympos, Iwata, Clarke, and DeVilbiss, among others.

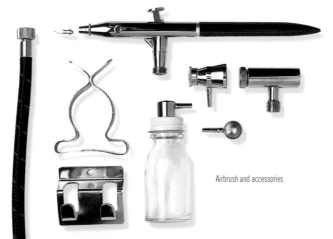

Airbrush and accessories

Spray gun

by illustrators for rendering complete illustrations, and, in limited application, to enhance detail, form, or contrast on hand-painted illustrations.

Characteristics of the medium

With conventional art materials, every tremor and tick made by the artist is seen in the marks made, yet this is not the case with airbrushing and spray painting. Unlike the application of all other drawing and painting materials, the airbrush and spray gun never actually make contact with the support. This factor can make airbrush and spray paint work made by one artist look very much like the work of another, at least to the uninformed. Indeed, the soft transition of color and tone

achieved with airbrushing simulates photography, leaving no painterly marks at all. However, there is no doubt that experimentation with different techniques can produce work that is both interesting and unique.

Auxiliary equipment

Masking materials Given the nature and techniques of spray painting, masking is absolutely vital. For fine work, a number of airbrush masks and templates are available. These are made from paint- and solvent-resistant plastics, and are thin and light, making them easy to handle and manipulate. Stencil masks are made in a variety of curves, angles, circles, and ellipses; templates for making specific effects, such as ocean waves, are also

Innovation

Dr. PH Martins has developed a range of non-clogging acrylic paints for airbrushing called Spectralite. The grain of the paint is ultra-fine, so it will not clog the nozzle. The paint is also water-resistant, fast-drying, and needs no diluting or mixing before use, nor are any fixatives or protective coatings required. The paint comes in dropper-capped containers, and is available in 48 standard and 16 metallic colors.

Compressors

Pressurized air is fed to the airbrush or spray gun under a consistent pressure by way of an air line connected to a compressor. The compressor works by pumping air into a tank and holding it there until the trigger on the gun or brush is activated, releasing it to atomize the paint in the nozzle. In order for the gun or brush to release an even flow of paint, the air needs to be stored and released under a consistent pressure. This is achieved by switching the compressor on and off to regulate the pressure of the air in the storage tank, thus keeping it at the same level. The air stored under pressure is measured in pounds per square inch, known as PSI. Different airbrushes and spray guns require different PSI counts to atomize the paint. While most compressors easily deliver sufficient pressure to operate smaller airbrushes, care needs to be taken when choosing a compressor for a large-capacity spray gun.

Paints and mediums

Watercolor, gouache, acrylic, and even oil paint can be sprayed, as can ink, although shellac-based inks are best avoided. All media need to be suitably thinned, either with water or a suitable solvent. It is possible to use liquid watercolor that is manufactured using dyes instead of pigments, but remember that these are fugitive, and can fade with time. Liquid watercolor is made by several manufacturers, including Luma, with a range of 86 colors available in 1 fl oz (29.5ml) and 2 fl oz (59ml) bottles, and Dr. PH Martin, with a range of 24 lightfast colors. Liquid acrylics have the advantage of being lightfast and permanent; they are available from several manufacturers in a relatively wide range of colors, and thin out easily with water. Ranges are made by Royal Sovereign Magic Color, with 44 colors; Daler-Rowney, with 30 colors; and Winsor & Newton Designers, with 36 colors.

Liquid watercolor

SPECIFIC RANGES There are ranges of liquid acrylic colors that are made specifically for use with airbrushes and spray guns. These include the Golden range, available in 34 colors, and Dr. PH Martin Spectralite acrylics (see Innovation, right); Dr PH Martin also makes Ready-Tex Textile colors, suitable for this purpose as well. Createx makes a good range of 32 standard colors, and a variety of fluorescent, pearlescent, and iridescent colors, as well as colors specifically formulated for use on plastic and metal surfaces. Holbein makes 50 colors in their Aeroflash range, and Deka makes a range of water-based enamel paints that are specially thinned for use with an airbrush.

Createx offers an extensive range of mediums. These include extenders, opaque mediums, catalysts that improve wash-fastness on fabrics, retarders to extend drying times, and flexible varnishes. Several brands of cleaning solvent are also available.

Airbrush propellent

Compressor

Airbrush medium

Airbrush color

available. Masks and stencils can be made using acetate, Mylar, or Melinex sheet. These materials are best cut using a stencil burner or a heat knife, both of which can cut through plastic sheet smoothly and quickly, to create graceful curves and intricate shapes. Frisket or masking film is made from easy-cut vinyl; this layer is placed close to the support, to protect against under-spray. To facilitate this process, one side is sprayed with a low-tack adhesive. Masking film is available in a matte and gloss surface, and comes in sheets and rolls.

Respirators and masks When using airbrush or spray painting equipment, it is essential to use a mask that covers both the nose and mouth. The best type of masks accept a filter cartridge, which can filter out dust, paint mists, or vapors, depending on which materials are being used. Most masks are designed to accept either a single or double cartridge, and can be taken apart easily for cleaning and for the replacement of filter cartridges.

Jars and bottles A number of manufacturers produce special paint jars and bottles that are interchangeable with the reservoir jar that is supplied with many airbrushes. Keeping a supply of these containers on hand allows the artist to keep paint mixes and change colors easily, without the need to constantly clean equipment.

Cleaning materials Several manufacturers produce solvents and cleaning fluids for use with airbrushes and spray guns. These are sprayed through the brush between color changes, and are also used for soaking clogged parts overnight. Tools with different-sized cleaning rods and brushes are available as well for clogged nozzles, trigger seatings, and aircaps.

CORE TECHNIQUES

Airbrushing is an acquired skill, and requires practice, patience, and careful planning to produce successful work. An understanding and awareness of color, tone, light, and contrast, and good draughtsmanship skills are also necessary.

Masking

The most important airbrush and spraying techniques to master is the art of masking. Regardless of the masking materials used—frisket film, liquid frisket, cut card, acetate, or fabric— the purpose of masking is to keep the paint away from certain areas. Different methods and masking materials are invariably used together in the same work, because one method may be more suitable for one section of the work and produce a better result than another. Clever masking is an important part of the creative process.

Flat tone
1. Mask the area to be sprayed, then spray from top to bottom, for a flat tone.

2. Upon completion, carefully remove the masking material, taking care not to disturb the paint.

Found objects
Both natural and man-made objects can be used as masks for spraying.

Acetate
1. Color is sprayed along a sweeping curve cut from acetate.

2. The removal of the mask shows that where the acetate was laid flat, the color has a firm edge.

Torn edge
1. A piece of card is torn in half randomly.

2. The mask is laid flat on the artwork and the torn edge is sprayed over, creating a ragged line.

Freehand spraying

Freehand spraying requires some practice. Smooth starting and stopping, the distance of the airbrush or spray gun from the support, and the speed with which a pass is made will all affect the spread of the color. Unlike spraying onto a masked area, freehand spraying creates a soft edge, as the paint spreads freely. This technique is typically used to develop form and detail within masked areas.

1. A wave effect has been created by spraying lightly in a horizontal direction.

2. The depth of color is gradually built up evenly, from top to bottom.

3. The finished work shows how the interwoven lines have created a complex tonal effect.

Corrections

The question of which correction technique to use depends on the type of support you are working upon. In general, it is easier to make corrections on less absorbent surfaces. Watercolor can be removed from small areas, while colors that have bled beneath masks can be scratched gently away using a sharp scalpel or craft knife blade. Alternatively, white paint can be used to spray away mistakes; once dry, the white-painted area is reworked as normal. Paasche market an air-eraser set that acts like a mini-sand blaster, and is capable of very accurate work.

Removing color bleed
Here, the color has bled underneath the mask. To remove it, the work is placed on a smooth surface and, when dry, the paint is carefully scratched off using a sharp craft knife.

Over-spraying with white
1. A smooth gradation of color running from maximum strength at the top to a softer strength at the bottom was intended, but a small error has been made in the lighter area.

2. To correct the error, opaque white is sprayed across the width of the area containing the irregularity, graduating from bottom to the middle of the section, to maintain the original gradation.

3. After the white area has dried, the area is resprayed with the original color. When the mask is removed, a clean area of gradated color can be seen.

Lifting watercolor
Small watercolor-based areas of work can be corrected by lifting the paint off with a cotton bud. This method is best restricted to smooth support surfaces.

Innovation

While many existing encaustic formulas call for the use of Dammar varnish, the wax paints made by Enkaustikos! are solvent-free, containing Singapore Dammar resin that has been heat-filtered without the use of solvents of any kind. Enkaustikos! also makes a product called Slick Wax, which can be used instead of mineral spirits and turpentine to remove wax paint from brushes.

A classic encaustic medium can be made by blending either carnauba or Dammar resin with beeswax while heated to about 170°F (75°C).

Encaustic

The word *encaustic* is derived from the Greek word *enkaustikos*, which means "to process with heat." The technique was popular in both ancient Greece and ancient Egypt. Proof of the durability of the technique can be seen in the magnificent series of portraits found in Egypt today known as the Fayum portraits. These pictures were made over a period of about 300 years, and were intended as funerary decoration, to cover the mummy or embalmed body of the owner. The encaustic technique sunk into obscurity around the 8th or 9th century AD. Thereafter, fresco, tempera, and oil paints all took turns at taking center stage.

First revivals

Attempts to revive the encaustic technique were made by several Renaissance artists, including Leonardo da Vinci, but none of these succeeded. Later, many artists of stature, including Vincent van Gogh, experimented with wax mixed into their oil-painting mediums. One of the few major artists of modern times to utilize the technique is Jasper Johns, the American pop artist. Johns made many encaustic pictures, including a representation of the American flag. More recently, encaustic has been experiencing a revival, due in part to the sophistication of modern equipment—it is easy to heat the wax using

Encaustic waxes

Pure, refined beeswax is the best wax to use for encaustic work. Pale in color, it can be bought either natural or bleached; the color has little effect on even very pale pigment colors. The wax has a relatively low melting point—around 145°F (63°C)—and is sold by weight, in sheets or pellets. Beeswax is a relatively soft wax when cool, and can be made harder by adding a little carnauba wax, a natural leaf wax taken from the Brazilian carnauba palm. Carnauba has a higher melting point than beeswax—around 185°F (85°C). It is also darker than beeswax, and is available in various grades and colors. Because it is brittle, carnauba is not suitable for use by itself. The addition of around 15 percent carnauba wax will have little effect on the color, but it will raise the melting point of the wax mix.

OTHER ADDITIVES AND MEDIUMS With encaustic, heat is actually used as a solvent. The wax is solid when at normal ambient temperature, but when heat is added, the molecules relax into a liquid. This journey through the heat zone, from one quality of wax to another, is what makes wax such a unique medium. Many artists also modify the wax mixture using turpentine, varnish, or oils such as linseed. These affect the workability and drying time of the wax, and provide an opportunity for experimentation.

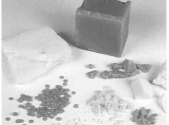

Wax and mediums in both natural and finished forms.

Wax sticks

Encaustic wax sticks are made from pigment that has been mixed with wax, and then allowed to solidify into sticks; blocks and slabs can also be made. Darker colors tend to have a thicker consistency, while lighter colors are often more liquid. The stick, or part of it, can be melted into a metal dish and used as traditional encaustic paint. Alternatively, it can be melted directly onto a hot painting iron, or used as a crayon and melted using a hot-air gun. Once the work is finished, it can be buffed with a soft cloth. Arts Encaustic, Enkaustikos!, and R&F Paints each offer several ranges of basic colors, including a pastel range and a metallic range. All colors are intermixable.

Wax can be melted onto a hot painting iron.

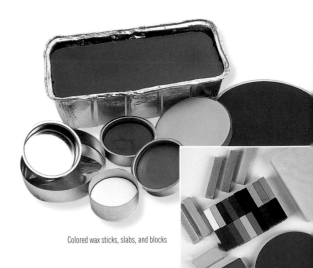

Colored wax sticks, slabs, and blocks

electric hot plates, and the availability of wax sticks removes the need to mix pigments and wax. These new developments have resulted in a growing awareness of the unique creative possibilities of encaustic.

A unique medium

Encaustic is a unique medium in many ways. In normal circumstances, encaustic work is very durable, and has a relatively hard surface. It is impervious to atmospheric changes in dampness, because it will not expand or shrink (although the support may). It will, however, soften with heat, and the work can crack when cold. Encaustic work has a slight sheen that can be buffed with a soft cloth. The surface can be damaged by scuffing and

abrasion, and so it requires careful treatment. Although the wax material adheres to most surfaces, a rigid support is best with a lean ground. While the majority of pigments and paint products are non-toxic, most carry cautionary labelling and hazard warnings.

Color range and characteristics

Traditional encaustic work is done using paint made from pigment mixed with hot wax. The pigments are the same as those used for making other painting materials, including oil, tempera, and pastels. They can be obtained from good art stores, and are sold by weight. It is easy to inhale dry powder from the pigments, some of which are toxic, so always check the label for safety instructions.

BASIC PALETTE
A range of basic pigment colors might include Cadmium Red, Alizarin Crimson, Cadmium Yellow, Cadmium Lemon, Cerulean Blue, Ultramarine, Viridian Green, Raw Umber, and Burnt Umber. These can be added to when and if necessary. Good, clear greens, browns, and purples can often prove difficult to mix, and thus additional colors from these pigment groups might prove valuable.

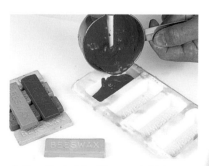

Encaustic paint pigments

Mixing encaustic paint

There is some debate about which type of beeswax to use to when mixing encaustic paints. Many artists prefer beeswax that has been cleaned of its impurities, either by bleaching or refining. There are no hard and fast rules about proportions of the wax and pigment mixture, except that there must be enough wax to coat the pigment particles. The more pigment that is added, the more opaque the paint will be.

1. Place beeswax pellets into a container. A stainless steel measuring cup is ideal for this purpose.

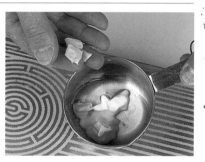

2. Add about 15 percent carnauba wax (or lumps of Dammar resin, if you prefer).

3. Melt the two ingredients together over low heat (do not use an open flame). A domestic hot plate is excellent for this purpose. Stir the liquid thoroughly, to blend the waxes.

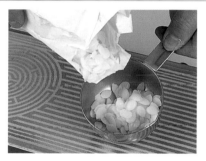

4. Add small amounts of pigment to the mixture, stirring it in thoroughly. Only a small amount of pigment is required to create translucent color.

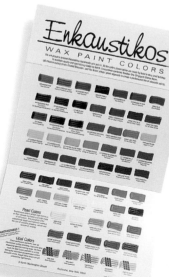

5. Pour the hot liquid wax paint into a heat-resistant mold. When cold, the wax pieces can be de-molded, and will be ready for use.

Manufacturer's paint chart

Using encaustic wax

One of the attractions of encaustic work is that it consists of a blend of very old techniques and processes, yet it is able to incorporate some of the most modern developments in other media and disciplines. Encaustic painting offers many of the same qualities as oil and acrylic painting: the layering of colors, glazing, sgraffito, and the creation of heavy impasto textures are just some of the techniques possible to achieve with this medium. Once you become practiced in the basic techniques described here, it can become second nature to look for other ways of extending the medium. And as you grow more familiar with the unique versatility of encaustic paint, you can even begin to develop your own techniques.

Which techniques work best for encaustic wax painting?

The best techniques for encaustic wax painting is really a subjective choice. Most contemporary encaustic artists have arrived at the decision as to which techniques they prefer by trial and error. Some artists, for example, may not want their wax paintings to crack, while for others, cracks in the painting are integral to its appearance. Experimentation is the best way to help you decide which techniques you prefer, and will help you discover how to achieve them.

What kind of supports are suitable for encaustic wax painting?

Many different types of supports can be used for encaustic wax painting; the determining factor is that the wax paint must not flake off after the painting cools. Rigid, flat supports should be used for thicker applications, or the wax will crack.

CORE TECHNIQUES

Modifying wax

Beeswax can easily be modified into a paste. Place some beeswax in a jar, or a container that can be closed, and add a small amount of white spirit or turpentine. Close the jar or container and put it aside, shaking it every few days until the wax has absorbed the liquid and become softened. The more solvent that is added, the softer the paste will be. If mixed in directly with pigment, it can be used as a cold paste wax paint.

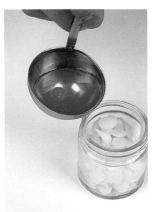

1. Place beeswax pellets in a container that can be sealed. Add about 10 percent white spirit or turpentine.

2. Seal the lid and shake the container. Repeat this action every few days, until all of the solvent has been absorbed.

3. The beeswax will eventually soften into a buttery paste.

Glazing

As with traditional paint, it is possible to glaze using encaustic. The wax is prepared as usual, but very little pigment—often just a few grains—is added. The thin mix is then painted over thicker work, and this layer modifies the underlying color in much the same way as with other painting media. Clear wax can also be used; this will have the effect of deadening and muting more strident colors. The natural color of the wax, which can be anything from clear to misty yellow, should also be considered.

Brushing

With this technique, hot, colored wax is applied to the support using quick, short brush strokes. Keep your hot plate and container of hot wax close at hand, because once removed from the heat source, the wax will harden quickly. Layer upon layer of colors can be built up in this way. Brush marks can be softened, and the wax manipulated by using a hot-air gun or a heat lamp.

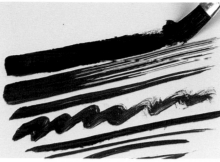

Using a natural hair brush, marks are made with hot liquid wax paint applied onto a cold surface.

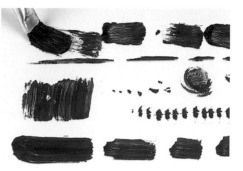

As soon as the brush leaves the wax pot, the paint starts to cool and congeal.

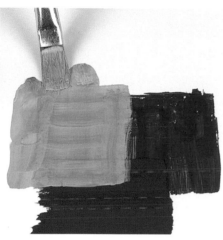

Opaque colors can be created using strongly pigmented waxes.

Two different colors can be applied with a single stroke.

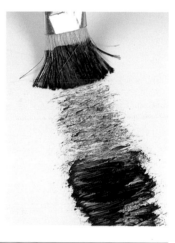

Hot wax flows easily from a hot brush, but as it cools down, the wax loses its liquidity and becomes a solid mass on the end of the brush.

Sgraffito

When dry, the nature of wax makes it perfect for scraping and scratching into using any sharp implement. Thin, flat blades can be used to scrape back layers, revealing those beneath. Round, sharp instruments will produce a range of linear marks, while palette and painting knives can be used to apply the paint after the wax has been softened with a hot-air gun or a heat lamp.

The paint can be scraped right back to the original surface.

The top layer of wax color can be removed, revealing an underlying color.

Heavier impasto forms can result in carved effects and interesting textures.

Using an iron

A flat iron is sometimes used with encaustic. With practice, it can produce a surprisingly large range of marks and effects. For example, wax can be smeared onto the hot iron surface and then smoothed across the support, leaving behind a thin glaze of wax. Alternatively, the iron can be stippled onto the surface to create different textures, while the edge and point can be used to create a range of linear marks.

An iron can be used much like a large heated palette knife.

An iron or hot plate can be used to heat the surface of the painting from underneath.

Using a stylus

A heated stylus, with its range of interchangeable heads, makes fine line work and a degree of detail possible—but a good deal of practice is necessary in order to learn how to use it properly. Wax that already sits on the support can be softened and re-manipulated, or the tools can be used to apply wax straight from the hot plate.

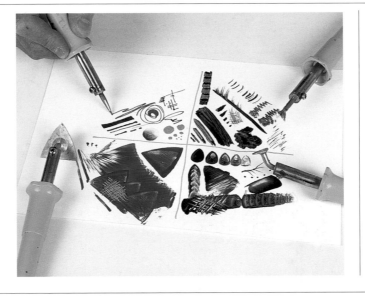

Heat gun

A heat gun softens and liquifies the hard wax, making it possible to manipulate and push it around the support. The gun should be used with some care, as it can soften and spoil work that is not meant to be changed. The gun is also a valuable tool for softening and blending dry brushwork, which, due to the nature of the medium, can appear hard and less than subtle.

Cleaning brushes

Always use natural fiber brushes with encaustics, as synthetic brushes may melt. Before cleaning, the brushes should be kept warm on a hot plate, so that they will be receptive to the liquid wax paint that is necessary for cleaning.

1. Ensure that the brush fibers are thoroughly heated and supple by resting them on a hot plate.

2. Add some clean, thin wax—an old candle is ideal for this purpose. Work the wax into the brush hairs.

3. Wipe the brush hairs using a tissue. Repeat step 2, then wipe once again. Keep adding thin wax and wiping until the brush is clean.

Tools and equipment

Although encaustic tools and equipment are available at many larger art stores, they are not easily found elsewhere. Fortunately, much of the equipment needed can be made by utilizing equipment originally intended for other uses. As well, information and supplies are now available worldwide via Web sites.

HOT PLATE A heat source is required if traditional techniques are being used. A small cooking hot plate, preferably with a flat plate element, is ideal; this should have a control to adjust the heat (a low, controllable temperature is needed). Domestic food warming trays work just as well. Enkaustikos! and R&F Paints, among others, make hot plates specifically for encaustic work.

Scribing, scraping, and carving tools

Natural hair fiber brushes

Palette knives and flexible blades

Domestic hot plate

BRUSHES AND KNIVES Traditional bristle brushes are used to make short, quick strokes of hot wax. The wax will harden on the brush as soon as it cools, and thus brushes must be kept warm while not in use (rest the head on a hot plate). To clean brushes, wipe excess wax from the bristles with a tissue, then work candle wax into the brush hairs (see Cleaning Brushes, left). There is no need to clean encaustic brushes perfectly. If possible, keep a set of brushes for encaustic work only. Steel painting and palette knives are excellent for manipulating paint, and are easily heated and cleaned.

Temperature-controlled wax pot

SPECIALIZED ENCAUSTIC TOOLS Several tools are made specially for the encaustic artist. The first is a small iron, similar to a travel iron, that is thermostatically controlled. Wax can be applied onto the iron, which is then pulled or pushed across the support, depositing a trail of wax paint. A wide variety of marks can be made, depending on how the iron is held. An electric stylus tool, which resembles an electric soldering iron, is also available. A range of interchangeable tips fits into the end; some are shaped like mini-irons, and some are pointed; others, made from copper wire, resemble small brushes. Cool, hard encaustic work can be worked back into using scraping or scribing tools.

MIXING TRAYS AND CONTAINERS Metal containers are necessary for holding melted wax and wax pigment mixes over a heat source. Metal cans are ideal for this, and can be found in many sizes. Tin cake trays with a series of several depressions stamped into the surface also make perfect palettes (look for those with flat bottoms). A sheet of metal—an etching plate would do—placed onto the hot plate can be used to mix small amounts of wax colors together in much the same way as traditional paint.

Mixing tray and containers

Low-heat painting irons

Metal brushes and stylus attachments

Hot-air gun

HOT-AIR GUNS Hot-air guns made for encaustic work are available, but hair-dryers set on high are just as effective. The hot air from the guns melts the wax, blending the colors together and softening edges.

WAGNER

Electric stylus pen

ACCESSORIES
Cutting equipment and adhesives are covered in the section on auxiliary equipment (see page 131), and the many supports you can use can be found on pages 106–115. You may also find the items listed below useful if you intend to work extensively with collage:

• **A PAIR OF FORCEPS or TWEEZERS** is invaluable for picking up and positioning small pieces of paper, especially if your hands become dirty or sticky with paint or glue.

• **ROLLERS** of the type used in printmaking (see pages 76-91) are used to flatten out and secure glued pieces of collaged paper and fabric to the support—they allow for a heavy, steady pressure that gets rid of air bubbles and wrinkles.

• **A SHEET OF PLATE GLASS** or **CLEAR ACRYLIC** can be placed over the work while it is drying. Weights can be added to keep the work flat. The ability to see the work through the clear material will allow you to make sure that the collaged pieces remain in position.

Collage

Almost immediately after the invention of paper, artists and calligraphers began using collaged images to embellish their works. With the advent of printed material on a mass scale, the Victorians developed a passion for creating decorative objects by covering various items with printed ephemera, a technique known as decoupage. Designs and patterns cut from paper and natural objects have also long been used to decorate various household items and ornaments.

The word collage is derived from the French word *coller*, and means "to paste" or "to stick on." Its beginnings as a means of artistic expression were modest, starting with simple newsprint, but soon more sophisticated patterns began to emerge, such as the printed representations of actual surfaces, like wood.

A new art form

The principle behind collage as an art form seems remarkably simple now, but in an age when painting was struggling to escape from a deep-rooted classical tradition, it was extremely radical. As the art form developed further, such materials as soft fabrics, wallpaper, wood veneer, corrugated cardboard, bottle labels—even theater programs—became popular items

Paper and card

Characteristics: The variety of textures found in watercolor papers makes them a good choice for collage work—especially the highly textured Indian Khadi papers. Papers made in Japan and Thailand are beautiful additions as well; they are often delicate and soft, and many have vegetable material in the form of leaves and flowers added. Tissue paper glued with acrylic matte medium can be built up in several layers to give a range of tones, while colored Ingres and Canson papers can be used plain, or colored further with paints or pastels. Colored corrugated card and paper can be bought or recycled from packing cases, as can bubble wrap and brown wrapping paper. Kitchen foil, colored cellophane, acetate, tracing paper, and cheap sugar paper also offer a wealth of possibilities.

Advantages: Both paper and card can be easily obtained in a number of colors and textures.

Disadvantages: The paper may become discolored or stained by some types of glue.

Cost: Prices range from inexpensive to expensive, depending on the ingredients and materials the paper is made from.

Fabric

Characteristics: Linen canvas, cotton duck fabric, inexpensive cotton scrim, and cheesecloth are all wonderful for collage, either in their natural states, or tinted with paint or ink. Many fabric shops sell offcuts of all kinds of material. Different thicknesses of felt can also be found in a range of colors. Wool, string, colored nylon, and garden twine have potential as well—even old clothes and old carpet-sample books can be used if your imagination and inventiveness are up to the task.

Advantages: Fabric and materials have a distinctly different look to them.

Disadvantages: Heavy fabrics will need to be fixed securely to the support. As well, it can be difficult to attach other materials onto coarse fabric.

Cost: Varies according to the particular material.

for collage. Today, practically any conceivable item is acceptable for use in a collaged work.

Collage materials

The sources of collage materials are virtually endless—from heavier objects, such as porcelain and wood, to light materials, such as paper and gauzy fabrics—almost anything can be used. Suitable materials for collage can really be found anywhere, and collage artists never tire of collecting materials for inclusion in their work. Many artists like to use household items that have been discarded or thrown away. These items cost nothing, and the fact that they are being recycled adds to the satisfaction of completing a successful piece of work.

Most local councils and authorities run recycling schemes for household garbage and sort out paper, card, fabric, and lumber, among countless other materials, all of which can be taken away and reused at no charge. You can also recycle your own work—a previously made unsuccessful drawing or painting torn or cut up can prove inspiration material for a collaged work.

Collage can also serve as a means by which an artist can capture and preserve meaningful events in his or her life; the use of family polaroids or snapshots—or photocopies, if the originals are to be saved—can contribute to the formation of a documentary-style piece of work.

Lumber

Characteristics: Sheet timber like hardboard (Masonite), thin plywood, medium-density fiberboard (MDF), and wood veneer are all easily cut to shape, or can be broken to give a jagged edge quality. Wooden moldings and hardwood beading can also be put to creative use, as can readily available softwood. Most lumber yards and commercial lumber stores have an offcut bin, and it is well worth looking here, as the prices are usually very low. Balsa wood, available from hobby stores, is also useful, in that it is easily worked and extremely light.

Advantages: A substantial and long-lasting material. Available in a range of colors and surfaces.

Disadvantages: Can be awkward to attach to a support, and may make the work heavy.

Cost: Depends on the particular material, but timber can be expensive.

Found materials

Characteristics: When it comes to found materials, the sky is the limit. The materials listed here are only suggestions: wallpaper and wallpaper-sample books, cardboard boxes, printed packaging, diagrams, plans, Christmas and birthday cards, postcards, and paper bags are all usable, and can be found around the home. Further afield, you can collect shells, stones, driftwood, and feathers, and do not overlook dried flowers, leaves, and grasses. Save broken china, toys, and circuit boards. Use up extra cork or vinyl floor tiles or offcuts of linoleum, wire mesh and chicken wire, and be sure to save old magazines and newspapers.

Advantages: A constant, inspirational supply of materials is available. The thrill of discovery also adds to the fun of using found materials.

Disadvantages: None.

Cost: None.

Photographs and photocopies

Family photographs, holiday snapshots, and party Polaroids can all be cut up and used for collage. Or, if you prefer to save the originals, make photocopies (these can be enlarged or reduced), or make prints after scanning the image into a computer. A computer can be used to digitally alter images. You can also photocopy objects and parts of the body. Copied images can be pasted directly onto the support, or printed onto heat-transfer paper and transferred to fabric. Use a fax machine to make copies of text and photographs—the imperfect quality of fax and photocopies simply adds a different look to the image.

Advantages: A wide range of images and texts can be used. These materials can add a personal element to the work.

Disadvantages: Certain computer programs can be time-consuming to learn and expensive to purchase. As well, the longevity of the images on paper is less than ideal.

Cost: Inexpensive.

Making collage

The materials and elements of a collaged work can be repositioned any number of times before being securely affixed to the support. Choose your support carefully, as it must be heavy enough for any weighty or thick materials. Once the materials have been arranged to your satisfaction, they will need to be removed and then secured to the support in the correct order. The proper position of each piece can be remembered by making a sketch, or taking a Polaroid photograph.

Collage composition can be developed from precise shapes, or from more amorphous ones; the materials can be left smooth, or crumpled and creased for a highly textured look. For protection, finish the work with a gloss or matte varnish.

What is the best way to affix collage materials to the support?
Acrylic gloss, matte, and gel mediums, with their adhesive properties and transparency, are ideal for binding most collaged items to a support. Another popular technique is to press the items into wet acrylic paint or modelling paste.

Can I use PVA woodworking adhesive to secure paper and card to a support?
All PVA adhesives can be used to adhere paper and card to a support. Care should be taken when using PVA adhesive on thin papers, however, as the adhesive can discolor with age.

CORE TECHNIQUES

Decollage

The opposite technique to collage is decollage, or the removal of previously glued materials. This is done in such a way so that traces of the removed material are left behind.

Frottage

With this technique, an image is taken from a textured surface by rubbing through with thin paper using a soft graphite stick, conté pencil, or pastel.

Dechirage

Dechirage describes the tearing of paper or card for effect. Different papers tear in assorted ways, giving a range of torn edge qualities.

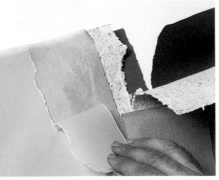

Grattage

This technique is similar to sgraffito. A sharp tool is used to scratch or pick through a layer of paper or card, exposing the layer beneath.

Cutting

A cut edge has a clean and crisp quality that is precise and well-defined. Cutting thin paper and fabric collage materials is usually done using scissors or a sharp utility or craft knife. For accurate cutting, be sure to replace scalpel and craft knife blades frequently; using a self-healing cutting board helps the blade to stay sharp longer. More intricate and complex shapes can be cut using a fine scalpel or small nail scissors. Larger shears are best for large, graceful curves and straight lines. For thicker papers and cards, use heavy-duty cutting tools.

Utility knife
For thick paper and card, it is best to use a heavy utility knife.

Craft knife
A sharp craft knife is best used for finer cutting work.

Large scissors
A large pair of scissors can be used to make sweeping curves.

Small scissors
To cut small, intricate shapes, use small scissors.

Gluing

Always position the materials correctly first before applying the adhesive. Unless you have a good memory, make a rough diagram or take a Polaroid photograph showing the position of the pieces before you attempt any changes. A dry-glue stick is helpful for keeping pieces in position prior to final fixing. Alternatively, place a sheet of plate glass or clear acrylic over the work; this can also be used after the final fixing to hold the pieces in position, and weights can be added to apply pressure. Be sure to use a suitable adhesive for the materials used, read the instructions, and remember that some manufacturers advise allowing the adhesive to set for a few minutes before application. Some adhesives need to be applied to both of the surfaces to be joined. Acrylic medium or acrylic matte varnish can be used as a final protective film.

1. Prior to fixing, make sure that the pieces to be collaged are in their correct positions.

2. Apply the appropriate amount of adhesive evenly over the back of each piece to be collaged.

3. Place the piece in position, and apply a weight to keep it flat until it dries.

Tearing

Torn paper has a far more expressive edge quality than cut paper. Paper tears differently if it is torn across its length or its width; the side of the sheet that is torn can make a difference as well. Tear with the grain for a smooth edge, and against it for a rough edge. Complex shapes can be torn, but this can be difficult with smaller shapes. Straight lines can be torn against a ruler, while precise, wavy lines can be torn against a card template, or made freehand. Thicker papers and papers containing added vegetable matter or long cotton fibers leave a ragged, expressive edge when torn.

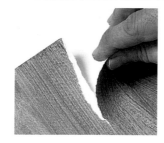

A smooth edge
Tear with the grain for a smooth torn edge.

Tearing with a ruler
To make a straight tear, use a ruler for guidance.

Tearing against a curve
Use a template made from thick card for a curved tear.

Innovation

Prepared Masonite panels are available uncradled or cradled, and can be primed to give a number of distinct surfaces. Ampersand makes a range of panels under a variety of names: Clayboard Original is a kaolin-clay-coated board that is ideal for tempera, ink, gouache, encaustic, and pencil; Textured Clayboard is recommended for watercolor and acrylics, and Gessoboard is great for oil and acrylics. There is also a board with a sandy, toothed surface that is perfect for pastels.

Pintura makes canvas-covered, compressed-wood panels in rectangular, round, and oval shapes. As well, Innerglow produces a range of panels constructed from wood layers that are primed and ready for use. Savoir-Faire makes archival-quality panels from birch and mahogany that require priming. Windberg and Red Dot panels are primed on both sides, and are suitable for all media.

Supports

Any surface upon which a work of art is made is referred to as the support. The list of supports used by artists over the years is long, from the cave walls used in the Stone Age to modern, lightweight, acrylic fibers. Today's artists are spoiled not only by choice but also by availability—a wide range of materials can easily be found and purchased, not just from the specialist manufacturer, but also from local art stores. As both professional and amateur artists become ever more adventurous and demanding, the list of materials used as supports grows increasingly larger. The main concern when choosing a surface upon which to work is one of permanence, and understandably so; it is not only the artists who want their work to last, but also those who may wish to buy their work—perhaps for a considerable sum of money.

Canvas and fabric

Canvas is the most widely used support for both oil and acrylic work. This is due in part to its lightness, which makes it easy to transport, and also makes it possible to work on a very large scale. Canvas is also particularly receptive to the stroke of a brush. Due to its nature, however, canvas requires slightly more preparation than

Linen canvas

Characteristics: Made from the flax plant, linen canvas is the best type of canvas available. It is strong and very difficult to tear or puncture, the thread gives an interesting weave, and it has a

wonderful color. Linen can have an extremely smooth woven texture, or it may be rough and irregular; the texture depends on the number of threads per square inch. The fabric can be single or double weave; heavyweight double weave is better for extra-large canvases.

Linen thread gives a unique weave.

Linen is available in rolls up to 3½ yd (3.17m) wide, and comes in smooth, medium, and rough surfaces; weights normally fall between 7 oz (200g) and 17 oz (482g). It can also be bought in ready-primed rolls. As well, art stores stock ready-stretched canvases in a limited range of sizes.

Advantages: The best canvas available, linen canvas is a pleasure to work on.
Disadvantages: The tension can slacken in damp weather.
Cost: Expensive, but worth it.

Cotton canvas

Characteristics: Cotton canvas, also known as cotton duck, is made from 100% cotton, and is a light cream color. It is available in rolls from 4 ft 6 in (1.37m) up to 4 yd (3.65m) wide, and in weights from 8 oz (225g) to 15 oz (425g), with a tight, regular weave. It stretches very easily and holds its tension well, being less prone to atmospheric changes than linen. The

heavier weights stretch much better and feel far more substantial than the lighter weights. This type of canvas is available in pre-primed rolls. As well, most art stores stock pre-stretched canvases in a limited range of sizes.

Cotton canvas thread gives a regular, predictable weave.

Advantages: Heavier weights are a very good alternative to linen.
Disadvantages: The weave appears somewhat mechanical.
Cost: Moderately expensive, but up to 75% less expensive than linen canvas.

Linen canvas

Cotton canvas

Can I reuse my supports?

The answer to this question depends on the type of support, and the materials that have been applied upon it. In general, however, it is usually possible to use the reverse side of the support. As well, a failed painting or drawing often makes an ideal foundation for a new work.

Is it better to use a linen canvas rather than a cotton canvas for a permanent painting?

Although linen is stronger, more stable, and less deformable than cotton, a good quality cotton canvas (12-15 oz) is a perfectly acceptable support for a permanent painting.

most other supports: it needs to be stretched and primed before use. Such preparation is especially important when using corrosive materials like oil paint, although some materials—acrylics, for example—can be applied directly to the fabric without any preparation. The most popular fibers for making canvas are cotton and linen.

Before buying a length of canvas, it is wise to first ascertain how the fabric will be divided up—this will depend upon the number of paintings you are going to make. The goal is to make as many paintings as possible with minimal canvas wastage. Be sure to allow a 2 in (50mm) overlap around each painting for attaching the canvas to the stretcher (see pages 116-117).

Hessian, muslin, calico, and scrim

Characteristics: None of these fabrics have sufficient strength or closeness of weave to be stretched, but they are ideal for marouflaging onto wooden panels to create inexpensive painting boards (see page 118). All have a pleasant texture and color. They are available in a range of weights and widths, and can be bought by the yard or meter. Look for these materials in an art store with a good canvas or fabric section, or any fabric store.

Advantages: All of these fabrics have pleasant textures.

Disadvantages: The thread of these fabrics can become brittle with time.

Cost: Very inexpensive.

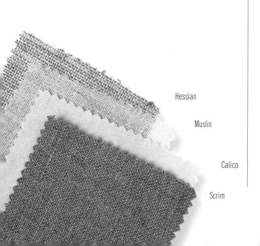

Hessian

Muslin

Calico

Scrim

Hardwood panels

Characteristics: Hardwood panels are traditionally made of hardwood from species like oak, birch, mahogany, walnut, cedar, and poplar. Softwoods are not suitable because they are prone to warping, and are extremely resinous. Hardwood can be found at lumber yards, but it must be seasoned and free of cracks, and will likely be expensive. Old pieces of wrecked furniture are a good alternative source of useable timber.

Advantages: Traditional and long-lasting.

Disadvantages: Difficult to find and prone to warping.

Cost: Expensive, but if reclaimed they cost next to nothing.

Oak hardwood panel

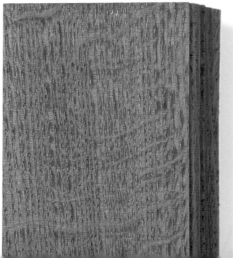

Hardboard

Characteristics: Hardboard or Masonite is popular among artists as an inexpensive painting surface. Tempered hardboard has a very hard surface, while untempered hardboard has a softer, slightly absorbent surface. Hardboard is available in a standard sheet size of 4 x 8 ft (1220 x 2400mm) and in $\frac{1}{16}$ and $\frac{1}{8}$ in (2 and 3mm) thicknesses. Even relatively small hardboard panels can bend easily. To prevent bending, boards of any size are best battened or held in a frame. Both sides of hardboard can be used; the reverse side resembles coarse jute sacking.

Advantages: An excellent surface to work on.

Disadvantages: Large panels can warp.

Cost: Inexpensive.

Hardboard front

Hardboard back

THESE TWO PAGES
- MEDIUM-DENSITY FIBERBOARD
- PLYWOOD
- BLOCKBOARD
- CANVAS PAPER AND BOARD
- CARTRIDGE PAPER
- BRISTOL BOARD

Boards and panels

For centuries, gessoed wooden panels were used as the support for work in tempera, which requires a rigid support. Although an excellent surface to work on if prepared correctly, wooden supports have some drawbacks: even moderate-sized pieces can be heavy; if not properly seasoned, the wood can split or warp; and panels made from traditional woods are difficult to find and expensive. However, man-made panels such as hardboard, medium-density fiberboard (MDF), plywood, and blockboard make excellent painting surfaces, and are readily available. They are also cheaper to buy and prepare than stretched canvas, relatively easy to transport and store, and durable.

Which support surfaces need protective preparation?

Only those surfaces which would be corroded by the action of oils and oil solvents need preparation. This is done by sizing or priming. Although other surfaces do not require preparation, it is important to remember that unprimed surfaces are very absorbent, a characteristic which will alter the flow and workability of the paint.

Can a wooden support be protected from warping?

Warping results when wood loses or absorbs moisture from the atmosphere, causing it to shrink or expand. This danger is lessened through seasoning, a process whereby wood is air- or kiln-dried, thus reducing the moisture in the wood to the same level as that in the air.

Medium-density fiberboard

Characteristics: The ubiquitous MDF has been used extensively by artists ever since it first appeared. Sheets are very smooth and stable, and will only deteriorate if allowed to become wet for a period of time. Boards are made in a standard 4 x 8 ft (1200 x 2400mm) sheet size and ¼, ⅜, ½, ¾ and 1 in (6, 9, 12, 18 and 25mm) thicknesses. Both sides look exactly the same. MDF is made using a carcinogenic urea-formaldehyde resin, so avoid breathing in its dust. A formaldehyde-free MDF has recently been introduced.

Advantages: An excellent, smooth surface. Available in a range of thicknesses.

Disadvantages: Large, thick sheets are extremely heavy.

Cost: Reasonably inexpensive.

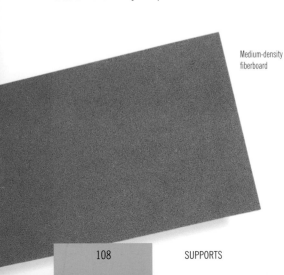

Medium-density fiberboard

Plywood

The thickness of a piece of plywood depends on its number of plies, or layers.

Characteristics: Plywood is made by bonding several thin, wooden veneers together under pressure. Each layer is known as a ply, and the sheets are usually between ⅛–¾ in (3–18mm) thick, with an odd number of veneers so that the grain on the outer veneers always runs in the same direction. The outer veneers are made of a hardwood, usually birch, mahogany, or poplar, with the grain running lengthways down the board. Boards are the standard sheet size of 4 x 8 ft (1200 x 2400mm). Plywood can warp, so larger panels will need to be encased within a wooden frame, or braced.

Advantages: A pleasant surface to work on. Available in a range of thicknesses.

Disadvantages: Can warp unless framed or braced.

Cost: Moderately expensive.

Plywood

Blockboard

Characteristics: Blockboard is made by sandwiching small blocks of wood between two softwood veneers. The grain of the wooden blocks is arranged to run in different directions; this makes the board relatively stable, and protects it from warping. Available in ½, ¾, and 1 in (12, 18, and 25mm) thicknesses, the boards measure a standard 4 x 8 ft (1200 x 2400mm). Thick boards can be very heavy, but seldom require battens.

Advantages: Stable, with a smooth surface.

Disadvantages: Thick boards are very heavy.

Cost: Moderately expensive.

Boards are easy to prepare once they have been cut to size, and the edges sanded to prevent splinters. Rigid wooden boards are traditionally prepared using gesso, which gives a beautifully smooth surface upon which to work. If the board is large and thin enough to possibly warp, it will need to be braced or cradled by fastening wooden battens to the back of the panel.

Paper and cardboard

With a little preparation—by priming with gesso or acrylic primer, or by stretching—both paper and card can be used as a suitable support for any medium. The characteristics of a sheet of paper can vary greatly: the manufacture of paper, although technically a straightforward process, allows for the texture, weight, color, size, absorbency, and material composition to be modified easily. This diversity provides the artist with an inspirational choice of beautiful surfaces to work on.

Given the range available, and the ever-increasing availability of unusual Eastern papers, give your choice of paper serious thought before you make a purchase. Nothing will have as direct an effect on your work as the surface upon which it is made. Most manufacturers produce pocket-sized sample pads which can be used to test the paper in order to ensure that it is the surface that you require. Some art stores sell damaged papers at a discount—another good source of inexpensive test paper.

Canvas paper and board

Characteristics: Most heavier-weight papers with a degree of texture can be used for acrylic painting—or, if suitably primed, oil painting—but paper with a canvas texture serves the purpose far better. Care must be taken if using acrylic paint on these papers, as several types are still primed using oil-based primer. These papers are sold as sheets, or in a variety of different-sized pads; Canson also sell their Figueras oil and acrylic papers in 33 ft (10m) rolls. Daler-Rowney makes acrylic paper that comes in a pad form.

Oil and acrylic papers are found in various surface textures.

Canvas boards have canvas or canvas paper laminated onto a cardboard backing. They are made in several sizes, and with different textures. Canvas paper and boards are made by several manufacturers, including Daler-Rowney, Canson, Winsor & Newton, Strathmore, Utrecht, Fredrix, and Fabriano.
Advantages: Stable and easy to use when working on location.
Disadvantages: Can easily be damaged.
Cost: Relatively inexpensive.

Oil canvas paper

Pad of acrylic canvas paper

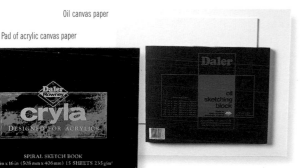

Cartridge paper

Characteristics: Cartridge paper is wove, and is usually machine-made. It is available in shades ranging from bright white to pale cream. The paper is uncoated and surface-sized. It has a slight tooth on one side, and is smoother on the reverse.

Cartridge paper is generally found in a range of weights, between 45–145 lb (90–315gsm), and is available as sheets, rolls, pads, and sketchbooks. It can be used with all types of art materials. The paper can be primed with acrylic primer and stretched if required, but its primary use is for drawing with dry media and ink. Popular brands include Daler-Rowney, Heritage, Atlantis, Collage, Strathmore, Lambeth, Fabriano, Basik, Utrecht, and Stockwell.
Advantages: It can be used with most art materials.
Disadvantages: Smoother sheets lack tooth, and are not ideal for dry, dusty materials like pastel or charcoal.
Cost: Relatively inexpensive.

Cartridge pads

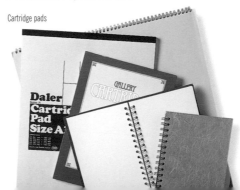

Bristol board

Bristol board is is a strong, machine-made paper with a heavily sized, compressed surface. It is an excellent support for graphite, colored pencil, marker, ink, watercolor, gouache, and airbrush. It is available in 1-, 2-, 3-, 4-, and 5-ply—this denotes the number of layers that have been laminated together to form the sheet, with 5 being both the thickest and heaviest. Popular brands include Fairfield Bristol, Mirage Bristol, Strathmore Bristol, Bienfang Bristol, Canson, and Aquabee.
Advantages: A stable, durable support that requires no preparation.
Disadvantages: None.
Cost: Sheets can be expensive, especially the 4- and 5-ply ones.

Bristol board

Watercolor paper

Watercolor paper can be either machine-made, mold-made, or hand-made. Machine-made papers are the most inexpensive but are less resistant to deterioration and may distort when wet. Mold-made papers are produced using cylinder-mold machines. The paper fibers are formed into sheets and randomly distributed, much like hand-made papers. This type of paper is very durable, and is resistant to distortion. The best watercolor papers are hand-made. These are usually 100% cotton, and are made by skilled craftspersons. They are durable, and have a pleasingly irregular texture.

Watercolor papers are wove, invariably acid-free, and white, although a few manufacturers offer various pale,

Is watercolor paper prone to yellowing or deterioration?

Papers that contain acid, such as newspaper, are prone to yellowing and deterioration. All good-quality watercolor papers are acid-free, however, and thus will not yellow or deteriorate with age. Some also contain calcium carbonate, to protect against atmospheric acids.

Can white watercolor paper be tinted by hand?

White watercolor paper can be tinted by hand, but the effect will be different than an internally pigmented sheet. A uniform watercolor wash can be applied over the sheet, or pigment powder can be rubbed into the paper fibers using cotton wool.

Art, illustration, and watercolor boards

Characteristics: Art and illustration boards are made from cardboard with a laminated surface. They are designed to be used with watercolor, pen, ink, airbrush, marker, and technical pen, and are available in a range of sizes up to double imperial (see page 114), with surface textures ranging from smooth to rough. Some boards are coated to give a non-bleed surface; these take a fine line that can be erased by stripping or scratching out with a blade.

Watercolor boards are laminated with watercolor paper in hot-pressed, cold-pressed, and rough surfaces. They are used in the same way as traditional watercolor paper. Manufacturers include Daler-Rowney, Canson, Winsor & Newton, Strathmore, Creative Mark, Bainbridge, Schoellerhammer, and Utrecht.

Advantages: These boards have a wide range of uses, and require no stretching.

Disadvantages: None.

Cost: Relatively inexpensive.

Art, illustration, and watercolor boards can be found in many different colors.

Watercolor boards

Watercolor papers

ROUGH PAPERS

Characteristics: Rough papers can be extremely difficult to work on. Used properly, however, the paper imparts a sparkle and life into the work that can be difficult to achieve with other papers. Rough papers are often internally sized only, making them reasonably absorbent. Like other absorbent papers, however, rough papers can be difficult to make corrections upon, because the paint settles and dries into the paper fiber. Rough watercolor paper can also be primed and worked on using acrylic and oil paints. Many rough papers are handmade, and these are quite beautiful to work on.

Advantages: When used properly, work done on rough paper has a sparkle that is difficult to achieve on other surfaces.

Disadvantages: It can be difficult to use properly, and requires a sure, bold style of working.

Cost: Reasonable, although handmade sheets can be very expensive.

Pads of watercolor paper

tinted colors. The "white" papers range from brilliant white to warm cream. Watercolor papers are either internally sized or surface-sized, and some papers are sized in both ways—the degree of sizing affects the absorbency of the paper, and the behavior of the paint on its surface. They come in three different textures: rough, cold-pressed (also known as NOT), and hot-pressed.

Papers are available in pads, sketchbooks, rolls, and as single sheets. Sheets are usually sold in the standard size of 22 x 30 in (559 x 762mm), but some brands are also sold in both larger and smaller sizes (see page 114 for available sizes). The papers are sold in degrees of thickness ranging from approximately 72 lb (150gsm) up to 400 lb (850gsm). Some of the most popular and

widely available papers include Arches, Fabriano, Bockingford, Waterford, Whatman, Two Rivers/Passion, Twinrocker, Lanaquarelle, Atlantis, Schut, Somerset, Schoellerhammer, Canson, Zerkall, and Strathmore.

Pastel papers

Some pastel artists like to work on boards, but most prefer to use the special papers that are available for pastel work. Pastel papers need a sufficiently textured or abrasive surface to hold several layers of dry pastel dust without becoming oversaturated. The surface should look relatively smooth, and not pitted and rough.

One especially popular type of paper used for pastel work is velour paper, also known as flock paper. This

COLD-PRESSED PAPER

Characteristics: Cold-pressed, also known as NOT (for "not hot-pressed") paper, has a slight texture or tooth, and is generally considered the easiest watercolor paper to use. The paper has enough texture to enable all of the watercolor textural techniques to work, but is smooth enough to allow for a degree of precision brushwork. It can be primed to accept oil paint, and many of the smoother papers make a good surface for drawing materials. Cold-pressed papers can be handmade, mold-made, or machine-made.
Advantages: An easy-to-use, versatile type of paper.
Disadvantages: Work can lack the "bite" of that done on rough paper.
Cost: Moderate.

HOT-PRESSED PAPER

Characteristics: Hot-pressed paper is very smooth, having been passed through polished-steel rollers to remove any remains of texture left behind by the papermaking process. These papers are usually heavily surface-sized, and paint can puddle and sit on the surface, taking a long time to dry and leaving water or drying marks. The paper is best suited to precise technical work rather than expressive work. The paper's qualities and hard-sized surface also make it a very good paper for drawing upon. Hot-pressed papers are usually machine-made, although mold-made and handmade papers can also be found.
Advantages: Excellent for precise work and drawing.
Disadvantages: Watercolor work can look tired and uninspired.
Cost: Moderate.

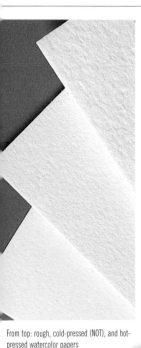

From top: rough, cold-pressed (NOT), and hot-pressed watercolor papers

Tinted watercolor papers

Pastel papers and boards

Characteristics: The long-established Ingres and Canson Mi-Teintes brands are some of the most popular pastel papers, but many others are available as well. Fabriano Tiziano offers 31 colors, Larroque Bergerac handmade comes in 7 colors, and Sabertooth multi-media pastel paper is available in 6 colors. Windberg pastel paper is primed with marble dust, and Wallis sanded pastel paper, available in rolls, also has a gritted surface (it is only available in white, but can be tinted with water-based paint). St Cuthberts Mill have just introduced Somerset for pastel, a range of thick pastel papers with a velvety surface.

Schminke's Sansfix pastel board comes in 6 surface colors. Sennelier makes a heavy board in 14 colors, and Frisk produces a range of boards in 14 colors. Another alternative for the pastel artist is Pumicif paper; also known as flour paper, this is a fine-grade sandpaper. Pastel papers are usually sold as individual sheets, or in packs that contain a range of colors.

Pastel board

Advantages: Pastel takes very well to the surface of these special papers and boards.
Disadvantages: None.
Cost: Moderately inexpensive to moderately expensive.

Velour paper

Pumicif paper

soft-surfaced, velvety paper gently strokes the pigment from the pastel, producing a matte finish that is almost more like a painting than a drawing. Velour paper is very responsive, but is difficult to make corrections upon, as the surface may spoil if overworked. Watercolor papers can also be excellent for pastel painting, as they can stand up to a lot of wear. A medium or rough surface paper is best—a hot-pressed paper will be too smooth.

Pastels are usually worked out of a colored or tinted ground. Most supports specifically designed for pastel work are already tinted; if white, they can be tinted by the application of watercolor or thin acrylic paint with a brush, sponge, or spray diffuser before the work is begun.

How is a pastel board prepared?

If you would like to try working on a pastel board instead of the usual pastel paper, a board can be prepared relatively quickly and easily. Mix some marble dust and pumice powder with some acrylic paint for color, and add a bit of matte medium. Brush the mixture onto the surface of the board. While still wet, dust more marble dust or pumice powder onto the board until it has the required tooth. Once dry, the board is ready to be worked upon.

Colored papers

Characteristics: Colored papers are used with drawing, ink, pastel, and water-based painting media, and for collage construction. Ranges include inexpensive sugar and tissue papers, and wove- and laid-surfaced papers; all come in several weights and sizes. Some well-known ranges include Daler-Rowney's Canford brand, available in 59 colors, and an Artmedia paper from Winsor & Newton that comes in 35 colors. Canson makes several ranges of colored paper, including Mi-Teintes, a high-quality vellum drawing paper available in a range of 50 colors, including white. Ingres paper is a type of laid drawing paper that comes in a range of colors; it is made by Canson, Fabriano, Arches, Hahnemühle, Zirkall, and Schut, among others. The slightly abrasive surface makes the paper ideal for pastel, charcoal, and chalk works.

Advantages: Working against a colored background gives work a sense of overall color harmony.

Disadvantages: The paper colors can be strident and overpowering.

Cost: Relatively inexpensive.

An extensive range of colored papers is available.

Japanese papers

Characteristics: Paper is made all over Japan, and each area of the country produces a paper with its own distinct characteristics. The fiber traditionally used to make the paper is called Bast, and is sourced from the Gampi, Kozo, and Mitsumata trees. Although thin, Bast is extremely strong. Bast can be expensive to harvest and prepare, which partially explains the generally high cost of Japanese papers. Papers are usually a natural white or buff color, but colored and decorative papers can also be found. Japanese papers are usually only lightly surface-sized, or completely unsized. They are typically lightweight, and can have a wove or laid surface. Available brands include Amime, Ban-shi, Gampi-shi, Gasen-shi, Hosho, Kozo-gami, Mitsumata-shi, Tengujo, and Torinoko.

Advantages: Delightful papers with distinct characteristics. Many Japanese papers are excellent for printmaking.

Disadvantages: These papers can be difficult to master, and are of limited use.

Cost: Relatively expensive.

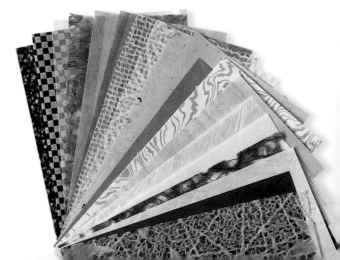

Paper weights and sizes

The weight of a sheet of paper describes its thickness. In manufacturers' catalogs, this is described in either pounds and grams—sometimes both measurement systems are used.

The weight in pounds (lb) or grams (gsm) describes the weight of a ream (500 sheets) of paper of any given size. For instance, an imperial sheet measuring 22 x 30 in (559 x 762mm) might be described as a 300 lb (600gsm) paper; however, if the same paper were available as a 40 x 60 in (1015 x 1525mm) sheet, it would be described as a 1114 lb paper, as a ream of paper this size would be heavier. The paper's weight would still be described as 600gsm, however, because the metric figure expresses the weight in grams per square meter,

PAPER WEIGHTS	
72 lb	150gsm
90 lb	180gsm
120 lb	240gsm
140 lb	285gsm
200 lb	410gsm
300 lb	600gsm
400 lb	850gsm

Nepalese, Bhutanese and Thai papers

Characteristics: Nepalese papers are made using two different techniques, one from India and the other from Japan. The Indian-style papers are natural in color and lightly textured; a range of colored laid papers is also available. The Japanese-style, or Washi papers are made using leaves, bark, and bamboo; these lightweight papers resemble brightly colored thick tissue. Bhutanese papers, called Tsasho and Resho, are made in different ways: Tsasho papers have a wove surface, while Resho papers are laid; although lightweight, both papers are surprisingly strong. Thai papers are made exclusively from mulberry bark. The sheets are thin and light (approximately 10–30 lb/20–60gsm), and show the pattern of the mold mesh on one side of the sheet. The sheets are a natural, pleasant cream color.
Advantages: A wonderful range of textures and colors.
Disadvantages: These papers can be very absorbent.
Cost: Inexpensive.

Indian papers

Characteristics: Long-fiber cotton rag papers, known generically as Khadi papers, are made all over India, with the bulk of artists' papers coming from southern India. These very strong papers are internally and externally sized, and accept most materials—including oil paint, if primed with gesso. The papers are available in weights ranging from 105–475 lb (210–1000gsm). The papers are made in a range of A sizes and imperial sizes, as well as a special size called Indian Atlas, which is a huge 40 x 54 in (1015 x 1370mm). Khadi papers are available in a range of strong colors.

Cotton rag and fiber papers use fiber obtained from a variety of sources, including jute sacking, sugar cane, banana, rice straw, tea, and pond algae. One beautiful paper made in northern India from hemp fiber gets its distinct laid surface pattern by having been formed on a screen made from grass. The paper has a natural, light-brown color, and is sized using wheat starch.
Advantages: These textured papers extend the range of working possibilities.
Disadvantages: The texture of these papers can be very pronounced, and can overpower the image.
Cost: Inexpensive.

Khadi Indian papers

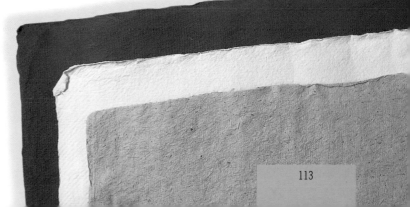

which is the same regardless of the size of the sheet (all sheets are the same thickness). This measurement is typically described as gsm, gm2, or g/m2.

Lighter papers (less than 140 lb/285gsm) have a tendency to buckle and wrinkle when washed over, and thus require wetting and stretching before use (see page 119). If the grade is extremely light, it is probably better suited to use with dry or drawing media. Heavier grades of paper generally do not require stretching before use, as their inherent stiffness will prevent buckling and wrinkling. They are also very receptive to paint. Some heavier papers can stand up to a remarkable amount of rough treatment.

IMPERIAL SIZES	
Imperial	22 x 30 in (559 x 762mm)
Half imperial	15 x 22 in (381 x 559mm)
Double imperial	30 x 44 in (762 x 1118mm)
A SIZES	
A1	23.39 x 33.11 in (594 x 841mm)
A2	16.54 x 23.39 in (420 x 594mm)
A3	11.69 x 16.54 in (297 x 420mm)
A4	8.27 x 11.69 in (210 x 297mm)

Printmaking papers

Characteristics: In theory, almost any paper can be printed upon, but in reality, different printmaking techniques demand papers with different characteristics and properties. With most printmaking techniques, the overall consideration is one of consistency; the printmaker must ensure, all things being equal, that every print in a single edition is identical. Many watercolor papers make excellent printmaking papers. There are also papers made specially for printmaking on the market. Well-known manufacturers include Somerset, Fabriano, Lana, Arches, BFK Rives, Inveresk, Hahnemühle, Zirkall, Strathmore, and Whatman. Japanese papers are highly recommended for relief printing techniques.

Printmaking papers are available in a variety of different textures.

Advantages: Choosing the right paper will ensure a good-quality print.
Disadvantages: Choosing the wrong paper may result in an inferior print.
Cost: Relatively inexpensive to moderately expensive.

Printmaking paper sample pad

Tracing paper

Characteristics: This familiar paper is used to transfer drawings from one surface to another. It is commonly used in collage work, and can also be used for dry media sketching, as well as to make initial sketches for works in pen and ink, watercolor, and acrylic. The paper cockles when wet. Tracing paper can be found in a limited range of weights, up to 55 lb (115gsm), and is available in sheets, pads, and rolls.
Advantages: Can be extremely useful for collage work.
Disadvantages: None.
Cost: Reasonably inexpensive.

Tracing paper

Layout and marker paper

Characteristics: Also known as detail paper, layout paper is a thin white paper used for roughing out ideas. Its thinness makes it possible to place one sheet over another, allowing an image on the lower sheet to show through. This enables a modified design or drawing to be made by closely following the first. The paper accepts traditional pencil, colored pencil, ink, and technical pen. A special

Marker paper (left) is specially coated to prevent ink from bleeding through, whereas layout paper (right) is not.

type of layout paper called marker paper is made specially for use with markers. Slightly more dense than traditional layout paper, marker paper is coated to prevent the ink from bleeding through. Both types of paper are available in several weights, and in a range of sizes. Rolls of layout paper are available in both black and white.
Advantages: Excellent for working out ideas.
Disadvantages: Useless for permanent work.
Cost: Relatively inexpensive.

Marker paper pad

Miscellaneous supports

SHEET METAL Metal is the only surface that is impervious to the corrosive action of the oils and solvents used in oil painting. The best surfaces for working on are copper, zinc, and aluminum; iron and steel are prone to corrosion, but proper preparation can overcome this problem. Before any work is done, the metal will need to be scrupulously degreased using solvents that do not react with the metal; keyed, by sanding the smooth surface; and primed, using a suitable primer. Plates of sheet metal are available from printmaking material suppliers.

Advantages: Properly prepared metal should last a very long time.

Disadvantages: Sheet metal is heavy and awkward to prepare and to use.

Cost: Moderately expensive.

ACETATE Acetate sheet is the type of film used in animation. It is readily available in a range of thicknesses, and is typically measured in microns. Available in sheets, pads, or rolls, acetate can be purchased either untreated, or treated to accept pencil, ink, watercolor, gouache, and acrylic. Work can be easily damaged by scratches and marks, but it will last if carefully protected. As an alternative, Melenex is an extremely clear film that is superior to acetate, and is often used by artists for cutting stencils.

Advantages: Good for collage, assemblage, and mixed-media work.

Disadvantages: Of limited general application.

Cost: Moderately expensive.

VELLUM AND PARCHMENT Vellum is made from the skins of calves, sheep, and goats, which are soaked in lime and scraped to remove the hair and fat. Once clean, the skin is stretched and dried over a frame. It is then scraped again, and smoothed and treated with pumice. Vellum can be fine or coarse, and can vary in color.

Parchment is made from the inner layer of sheepskin, and is prepared in a very similar way to vellum. It is slightly greasier than vellum, however, and has a harder surface. It is favored for calligraphy, painting, and pastel work. Both vellum and parchment are available from art stores and specialist paper stores.

Advantages: Both supports offer a unique surface.

Disadvantages: Both supports can be hard to find.

Cost: Expensive.

FOAMBOARD Available in black or white, foamboard is made by sandwiching polyurethane foam between two extremely light and rigid sheets of board. Care needs to be taken with edges and corners, as these are easily damaged. Some brands can be bent into shape by wetting; others have a self-adhesive surface. The boards are produced in a range of sizes, from 20 x 30 in (508 x 762mm) up to 40 x 60 in (1016 x 1524mm), and in ⅛, ³/₁₆, and ⅜ in (3, 5, and 10mm) thicknesses. Bienfang Foamboard is made using a clay-coated facing, and can be worked on with most media. When primed with acrylic gesso, standard-faced foamboard will accept all media.

Advantages: A lightweight material.

Disadvantages: Easily damaged if dropped or leaned upon.

Cost: Moderately expensive.

GRID OR GRAPH PAPER Grid or graph paper can be used to work out designs and drawings, especially those using any mathematical grid or progression, or for enlarging drawings using the grid technique. The papers are available in both imperial and metric rulings, and in weights up to 45 lb (90gsm). Sectional grids come as well in tracing paper format and in isometric rulings, designed to assist the drawing of three-dimensional objects. The papers are available as separate sheets, pads, and rolls.

Advantages: Can be useful and time-saving for specific tasks.

Disadvantages: Of limited use.

Cost: Relatively expensive.

Zinc

Copper sheet

Acetate

Foamboard

Foamboard is available in a range of different thicknesses.

Parchment and vellum are made from animal skins.

Parchment

Vellum

Graph paper

Preparing supports

Stretching Canvas

Stretching your own canvas is not just economical—it also allows you to prepare the canvas in accordance with your own specifications. Canvas is stretched over a frame made from mitered wooden stretcher bars. These bars are available from art stores in a range of lengths, widths, and profiles—only stretcher bars of the same width and profile will fit together. For a work under 24 x 24 in (600 x 600mm), use 1¾ x ⅝ in (45 x 16mm) stretcher bars. For larger works, use 2¼ x ¾ in (57 x 18mm) bars.

Stretcher pieces are usually classified as economical, mid-quality, or professional quality, and are made from various species of kiln-dried pine or tulip wood. The highest-quality stretchers are joined using a dovetail joint; others use a mortise and tenon. Many stretchers incorporate two slots into the corner joint to allow a triangular wooden wedge to be inserted; this can be used after priming to push the wood apart and apply lateral pressure to the canvas, stretching it taut.

Conventional stretcher frames can impose a strain on the canvas; the canvas is subjected to concentrated stress as it is turned around the edges of the stretcher. If this stress is prolonged, it can lead to the splitting of the canvas along the edge, and the tacking can become separated from the edge. This problem can be avoided to some extent by using thick staples positioned closely together rather than tacks, thereby distributing the stress evenly.

Constructing the stretcher

You will need four stretcher pieces (each pair should be of equal length), a wooden mallet, pinking shears, and a tape measure. Four-piece stretchers are easily assembled—just slot the bars together, making sure that all of the bevelled edges are at the front. Larger stretchers are assembled in the same way, but are also mortised to accept cross pieces. Some stretchers have slots in the corner joints for inserting wedges after priming. When the pieces are assembled, tap the corners with the mallet for a snug fit (do not use a hammer—this will dent the wood). The stretcher is now ready for the canvas.

Stretcher pieces, wedges, and canvas samples

Lay the stretcher on a flat surface and slot it together, keeping all of the bevelled edges on the same (front) side. Check that the stretcher is square by using a T-square, or by measuring diagonally corner to corner: if the measurements are the same, the frame is square.

Cutting the canvas
1. Cut the canvas so that it is about 2 in (50mm) larger than the stretcher frame—use pinking shears to prevent the edges from fraying.

Positioning the canvas
2. Place the stretcher on the canvas, making sure that the weave of the canvas is parallel with the stretcher's edges.

Attaching the canvas to the frame

Using a tack gun, place a staple through the canvas and into the wooden frame at the halfway point along one side. Do the same on the opposite frame edge, then secure the other two sides in the same way. Carry on out toward the corners, placing staples at about 2 in (50mm) intervals. Work on alternate edges, pulling the canvas just tight enough so that the weave of the fabric stays in line with the edges of the stretcher bars. Fold in the four corners and secure each with a single staple. On ready-primed canvas, use canvas pliers to grip the canvas tightly and pull it taut.

1. Pull the canvas overlap up the sides and over onto the back of the stretcher frame. Secure at even 2 in (50mm) intervals with staples.

2. Working one corner at a time, pull the corner of the canvas tightly across the back of the stretcher, toward the center.

3. Fold one of the canvas wings in and over.

4. Fold the second wing of canvas in and position it over the first wing.

5. Secure the fold to the stretcher frame using a single staple.

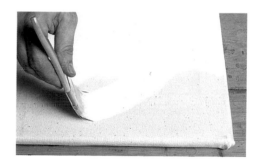

6. Once the canvas has been secured to the stretcher, it can be sized and primed.

7. If the canvas remains limp when dry, it can be made taut by forcing the stretcher bars apart using wooden wedges hammered into the slots at each corner.

PRIMING AND SIZING

If using an oil primer, the fabric will need to be sealed or sized with glue size, to prevent the oil from corroding the material. The most widely used glue size is rabbit skin glue; this is prepared by soaking glue granules in water, and then heating the mixture by placing the container in simmering water. The size is applied warm, and should be allowed to dry thoroughly before applying primer. After sizing, brush several coats of white oil primer onto the canvas; this will need a few weeks to dry. Alkyd primer can be used as an alternative to oil primer; suitable for both oil and acrylic paints, it can be worked on after just a few days.

Acrylic primer can be used to prime the canvas if you will be working with acrylics. With acrylic primer, there is no need to size the canvas. Simply work the primer into the raw canvas, giving the surface several thin coats, and allowing each coat to dry before applying the next. When the last coat is dry (this will take a few hours), the surface will be ready to be worked upon.

Marouflaging

Suitable thin fabrics like canvas, hessian, muslin, and calico can be marouflaged or glued to a board to give it a textured surface. Marouflaging is an extremely inexpensive and effective way of using up fabric and off-cuts from boards, and results in a support that is excellent for use on location.

1. Rub the board thoroughly with a damp cloth to remove any sawdust, then place it face down onto the fabric. Cut the fabric to size, leaving a 2 in (50mm) overlap on all four edges.

2. Turn the board face up and liberally paint the surface with a coat of warm glue size (if using oils) or acrylic matte medium.

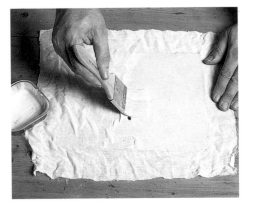

3. Place the fabric square onto the board and brush on more size or medium. Start from the middle and work out to the edges, applying enough pressure to make sure no air bubbles or thick pockets of glue or medium are left, until the fabric is completely flat.

4. When dry, turn the board over and place it on a block of wood. Apply acrylic matte medium around all four edges.

5. Fold the fabric over the sides and onto the back of the board. Smooth down using more acrylic matte medium.

6. It is possible to prepare several small boards by cutting up a larger board, marouflaging a large piece of fabric to it, and then sawing it into smaller pieces once dry.

Gesso priming

Gesso gives an inflexible, slightly absorbent surface. Traditional gesso is made by mixing whiting with warm glue size and white pigment. (Black gesso is also available; another alternative is to tint acrylic gesso with black acrylic paint.) Acrylic gesso has one clear advantage over traditional gesso: it is flexible, and so it can be used on stretched canvas. Smooth boards are usually given several thin coats of gesso, with each coat painted at a right angle to the previous coat. Each coat is allowed to dry, and then sanded using fine-grit sandpaper before the next coat is applied. The number of coats required depends on the degree of surface smoothness desired.

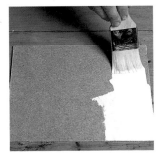

1. Using a soft bristle brush, apply a layer of gesso to the surface of the board.

2. When the gesso is dry, sand the surface to remove any brushmarks.

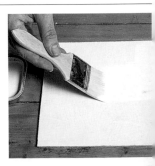

3. Repeat steps 1-2, using brush strokes painted at right angles to the previous ones. Always sand between coats.

Stretching paper

When wetted, paper fibers absorb moisture like a sponge and swell, causing the paper to buckle. When the fibers dry, they shrink again—but not always to the original size—and the buckling can persist. The application of watercolor or other wet media washes over such an uneven, "wavy" surface can be difficult. Stretching the paper before beginning work helps to solve this problem by ensuring that the sheet dries flat each time it is wetted. Any paper that is to receive wet paint can be stretched, although the technique is usually applied to watercolor papers. Heavier-weighted papers (above 300 lb/600gsm) can be used without stretching, as their inherent thickness prevents excessive buckling.

1. You will need a sheet of paper, a wooden board that is larger than the paper, adhesive paper tape, a sponge, a craft knife, and clean water. Prepare four strips of adhesive paper tape, cutting each strip approximately 2 in (50mm) larger than the paper.

2. Lay the sheet of paper centrally on the wooden board and wet it thoroughly, squeezing water from the sponge. Alternatively, the paper can be wetted by holding it under a running tap, or by dipping it into a water-filled tray or sink.

3. Wipe away any excess water with the sponge, taking care not to distress the paper surface.

4. Beginning on the longest side of the paper, wet a length of tape using the sponge, and lay it down along one edge, so that about one-third of the tape surface is covering the paper, with the rest on the board.

5. Smooth the tape down with the sponge. Apply the tape in the same way along the opposite edge, and then along the other two edges. It is important to work quickly, as once wet, the paper will begin to curl. Place the board and paper aside to dry for a few hours; when the paper is dry and flat, you can begin your work. A hair-dryer can be used to speed up the drying process, but keep the dryer moving so that the paper dries evenly, and do not hold it too close to the paper's surface. When dry, remove the paper from the board by cutting the adhesive tape where it joins the paper to the board using a sharp craft knife.

Alternative method

Staples can be used to secure medium and heavyweight papers. Wet the paper and position it on the board, as above. Secure the edges by placing staples about ½ in (13mm) in from each edge, and at ½–1 in (13–25mm) intervals. Work quickly, before the paper buckles. Allow to dry as above.

PAPER STRETCHERS AND CLAMPS

Various types of store-bought paper stretchers and clamps are now available, with a variety of devices and methods to grip the paper edges and hold them in the frame. One major advantage to these store-bought devices is that paper can be easily stretched on location. That said, it is probably just as simple to stretch several sheets of paper before leaving the studio. As well, the use of store-bought paper stretchers and clamps is restricted to lighter-weight papers and to standard, specifically sized sheets.

Auxiliary equipment

To the artist, "auxiliary equipment" means anything which can potentially be of use in the execution of his or her art. In this chapter, we are referring to those bits of equipment that are specially designed to make aspects of art creation easier, from palettes, easels, and brushes to adhesives and cutting equipment. Most good art stores are packed with such equipment, providing the artist with a choice of products that can be overwhelming. The question of which devices are actually necessary depends on the media used and the type of work being created.

CHOOSING A PALETTE
Whenever possible, try to choose a palette that is close to the color of the ground that you will be working on. This way, you can get an idea of what the paint colors will look like against the ground color on the actual painting. For instance, a wooden palette would be perfect if you intend to work on a red or brown ground, and a white palette is best if you are going to be working on a white ground.

Which type of palette is best for working outdoors?
Because they are inexpensive and lightweight, both plastic and disposable palettes are particularly suited to working outdoors. One general downside to plastic palettes, however, is that they are slightly absorbent, and thus have a tendency to become stained with paint. Another good option for outdoor work is an enamelled-metal painting box—the inside lid of the box can be used as a palette and mixing area when opened out. Improvised palettes that are made from lightweight materials can also be used.

Watercolor palettes

CERAMIC Glazed ceramic palettes have rows of rectangular or round recesses for mixes. Individual ceramic saucers can also be purchased; some have ceramic lids and can be stacked.
Advantages: Easy to clean.
Disadvantages: Because the wells are small, only a limited amount of paint can be mixed at any one time.
Cost: Expensive.

PLASTIC Plastic palettes come in a much wider range of shapes and styles than ceramic ones. Some larger palettes have divided rectangular areas for wash-mixing, surrounded by depressions for paints; others have a clear area in the center for unrestricted mixing, with wells around the edge. Although these palettes are often used placed flat on a table, many have thumb slots so they can be held. Plastic palettes with several rows of deep wells are better for mixing larger quantities of washes, and can be stacked when not in use. Individual containers that are deep and have lids can be used to preserve a mixed wash for use at a later date.
Advantages: Light, easy to hold, and fairly resilient.
Disadvantages: Unless cleaned well, these palettes can develop stains.
Cost: Inexpensive.

METAL Palettes made of baked enamel are typically large, flat trays, and are perfect for unrestricted mixing; others have a series of recesses around the edge to hold paint. Folding versions are also available, and are useful when working on location; these have a thumb slot so they can be held.
Advantages: Virtually unbreakable. If cleaned well, they can last a long time.
Disadvantages: Metal palettes are heavy. As well, the white enamelled surface can scratch and stain.
Cost: Expensive.

A metal watercolor palette can be held using its thumb slot.

IMPROVISED PALETTES You will find that you can never have enough containers for mixing and holding paint. Inexpensive—and in some instances, better—alternatives to store-bought palettes include old ceramic plates and tiles, clean tin cans, yogurt and cream cartons, foil food and cake containers, plastic milk and drink bottles, dixie and waxed-paper cups, and the most traditional of palettes: large sea shells.
Advantages: Easy to find and recycle.
Disadvantages: Minimal or none.
Cost: Inexpensive.

Ceramic watercolor palettes

Plastic watercolor palettes

Improvised watercolor palettes

Palettes

Palettes are used as a surface upon which to place colors, and also to mix them. Different media require different palettes; for instance, wooden palettes, typically used for oil painting, should not be used for acrylic paints, because the paint seeps into the porous surface and is thereafter very difficult to remove. Similarly, watercolor, because of its liquidity, requires a palette with wells and recesses. Whatever your medium, it may take some trial and error to discover which type of palette best suits your needs. The main consideration is to avoid purchasing a palette with a limited amount of area for mixing.

Watercolor palettes

When working with watercolor, you will invariably need a palette with separate wells and recesses to hold the paint colors and mixed washes. Palettes of varying sizes are available in a series of materials and configurations. When mixing washes or large quantities of liquid paint, it is best to use a palette with a deep well.

Oil palettes

The main consideration in choosing an oil painting palette is that it be of sufficient size to accommodate all

DIPPERS
Small containers called dippers can be clipped onto a palette to hold oil mediums. Dippers are generally used in pairs—one for solvent or thinner, and the other for drying oil or painting medium—but they are sold separately as well. Another alternative is to use empty glass jars, food cans, or waxed paper cups, but beware of plastic or polystyrene containers, because thinners and solvents can melt them.

Oil palettes

Linseed oil is rubbed into a new wooden palette in order to seal it.

WOODEN PALETTES Wooden palettes can be found in three shapes: oblong, oval, and kidney-shaped, each with a thumb slot to facilitate holding. They can be made from solid mahogany, mahogany veneer, or birch plywood. Before use, a new wooden palette should be sealed by rubbing in generous amounts of linseed oil. This makes it easy to clean off paint, and prevents the new wood from sucking oil out of the paint on the surface. Cheaper wooden palettes of a similar shape with a white melamine veneer are also available, and are easy to use and clean.
Advantages: A good wooden palette will last indefinitely.
Disadvantages: Some artists find it difficult to mix and match colors on the dark wood.
Cost: Ranges from inexpensive to expensive.

Wooden oil palettes

DISPOSABLE PALETTES
These oblong-shaped pads contain disposable, tear-off sheets of oil-proof paper.
Advantages: Readily available and clean to use.
Disadvantages: These palettes cannot be cleaned. Thus, any unused paint that is needed for another painting session must be scraped off and transferred to another sheet.
Cost: Relatively inexpensive.

Disposable oil palettes

IMPROVISED PALETTES Like improvised watercolor palettes, household containers such as jars and tins can be excellent improvised oil palettes. Or, if you intend to mix large amounts of paint and need a large area to mix on, a sheet of melamine-covered hardboard (Masonite), chipboard or medium-density fiberboard (MDF) makes the perfect inexpensive mixing surface. Another option is a large sheet of thick counter glass with polished edges. A sheet of paper can be painted the same color as the support ground and slid beneath the glass, making it easier to mix and match tones and colors.
Advantages: Household containers are easy to find and recycle. The sheets provide a large mixing area.
Disadvantages: None.
Cost: Inexpensive.

Improvised oil palettes

A selection of plastic and metal dippers are clipped to an oil palette.

THESE TWO PAGES
• ACRYLIC PALETTES
• PORTABLE EASELS
• STUDIO EASELS
• TABLE EASELS
• DRAWING BOARDS

of your tube colors and mixes. If the palette is to be held, it needs to be comfortable, balanced, and light. The traditional kidney-shaped oil painting palette is designed to rest on the crook of the arm, held in place by hooking the thumb through a slot in the side.

Acrylic palettes

Acrylic palettes must be made from non-porous materials, such as plastic or glass, as acrylic paint will seep into a wooden palette and be difficult to remove. Acrylic paint dries out quickly on the palette, and so it must constantly be sprayed with water to keep it moist. During a break from painting, cover the palette with plastic wrap to help the paint retain its moisture.

Should I arrange my paints in any particular way on my palette?

It is wise to get into the habit of laying your paints out in the same order on your palette each time you paint. This way, you will always know the location of each color, and will not have to search them out each time you paint. One system is to lay the colors on the palette in the order in which they appear in the spectrum; or, you might arrange them from darkest to lightest. Another alternative is to align the warm colors on one side of the palette, and the dark colors on the other side. Decide which layout works best for you, then use it consistently.

Acrylic palettes

STAY-WET PALETTES Special palettes for acrylic paint have been developed to keep paint wet and workable for several days. These palettes come in the shape of a shallow tray, and have removable lids. A sheet of water-absorbent paper, or a sponge soaked with water is slipped into the base of the tray. A sheet of palette or membrane paper is then placed on top, through which water passes by osmosis, keeping any paint on the palette moist. When the sheet of membrane paper is full, it can be replaced.
Advantages: By keeping paint moist, the palette helps prevent wastage.
Disadvantages: These palettes are very small, and are of limited use.
Cost: Relatively inexpensive.

IMPROVISED PALETTES Palettes can be improvised from a number of sources: cans, glass jars, cream and yogurt pots, old ceramic plates, and glass, plastic, enamel, melamine, and metal sheets. A stay-wet palette can be made from a photographic or baking tray in which several sheets of blotting paper sit beneath a sheet of grease-proof paper. The paint can be kept wet while not in use by covering it with thin plastic wrap.
Advantages: Like all improvised palettes, they are easy to find and recycle.
Disadvantages: None.
Cost: Minimal or none.

Stay-wet palettes

Paint stays wet if covered with plastic wrap.

Improvised acrylic palettes

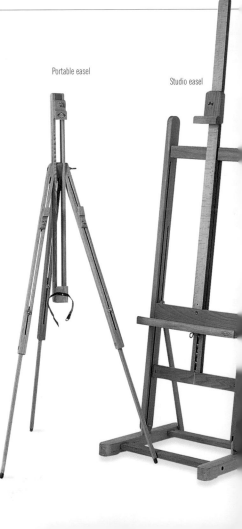
Portable easel

Studio easel

Easels

Regardless of the materials that you use or the type of work that you do, a good easel is a always a necessity. As well as being extremely useful, a strong, sturdy easel can provide a psychological jolt, boosting your inspiration and confidence. There is a wide range of sizes and types of easels available, so before buying, consider carefully the size and range of work you intend to do, and also the size of the space in which you have to work. Another equally important consideration is stability; nothing is more annoying when you are trying to paint than a wobbly easel. As a general rule, the larger the support, the more unstable the easel will be.

If I can only buy one easel, which is the best type for all-around use?

The goal is to buy an easel which is strong enough to support relatively large canvases, but which does not take up too much space and can be easily packed away. The best way to satisfy both of these criteria is to aim for something in between a studio easel and a portable or table easel. You might choose an A-frame studio easel which can be folded flat, as this can be transported easily. Another option is a larger box easel, which is both stable and portable.

Table easel

Drawing board

Portable easels

Characteristics: These easels are designed to be folded away. The larger ones can be used as studio easels, but will become unstable with large work. Most portable easels have three adjustable telescopic legs, and a central support to hold the canvas or board, secured between adjustable clamps. The box easel, which combines an easel around a box or covered tray for holding materials, is more stable. Portable easels are made by Winsor & Newton, Daler-Rowney, Mabef, Stanrite, and Savoir-Faire.
Advantages: These easels can be conveniently folded for carrying and storage.
Disadvantages: They cannot cope with large or heavy works.
Cost: Ranges from inexpensive to fairly expensive.

Studio easels

Characteristics: Studio easels have A- or H-shaped frames; A-frame easels are usually smaller than H-frame models. Large easels have an extension system and a winch mechanism for raising or lowering work; some also have lockable castors or wheels, drawers, and utility trays. Many studio easels can tilt several degrees out of the vertical, and some models convert into large, horizontal table easels. Three-legged radial easels are less bulky, and can be folded away into a relatively small space. Manufacturers of studio easels include The Best Easel Company, Mabef, Winsor & Newton, Daler-Rowney, and Trident.
Advantages: These easels are large, heavy, and stable; good ones can last a lifetime.
Disadvantages: They are impractical in a small space, and can be difficult to move.
Cost: Can be very expensive.

Table easels

Characteristics: Table easels resemble miniature studio easels, but without a cranking system. Both A- and H-frame shapes are made; there is also a model that is similar to the portable box easel, but without the legs. A simple table easel can be adjusted from the horizontal to about 45 degrees, and is perfect for watercolor work or drawing. A selection of easels is made by Daler-Rowney, Winsor & Newton, Trident, and Mabef; Stanrite makes a metal range.
Advantages: They are light, portable, and can be set up anywhere.
Disadvantages: They are not equipped for larger works.
Cost: Relatively inexpensive.

Drawing boards

Characteristics: A good drawing board, like a good easel, should last a lifetime. Drawing boards are used by fine artists to fulfil a range of needs, from acting as a solid work base for paper and boards to stretching paper, and as makeshift tables held on trestles. Most art stores stock a range of boards in a variety of sizes, made from hardwood or quality plywood. Drawing boards made from jointed timber with screwed back supports are increasingly rare, but they do crop up in secondhand or junk stores—if you see one, it can be a good investment; a dirty surface can be cleaned with careful sanding. Alternatively, it is easy to make your own selection of boards from a sheet of medium-density fiberboard (MDF).
Advantages: Provides a smooth, portable surface.
Disadvantages: None.
Cost: Relatively inexpensive.

• **SABLE** Springy, flexible, and
 reasonably priced.

• **KOLINSKY SABLE** Best-
 quality sable; springy; easily
 controllable.

• **SQUIRREL HAIR** Soft; not as
 resilient as sable; good for
 large wash brushes.

• **OX HAIR** Holds water well;
 good for flat and square-cut
 brushes.

• **GOAT HAIR** Holds water well;
 excellent for large wash
 brushes; commonly used in
 oriental brushes.

• **MONGOOSE HAIR** Very tough
 and firm; good for dry-brush
 and textural effects.

• **SABELINE** Contains both
 natural sable hair and
 synthetic fiber; not as long-
 lasting as pure sable.

• **SYNTHETIC FIBER** Can be
 used for a wide range of
 techniques; best used
 for flats.

Brushes

Paint brushes are available in many shapes and sizes, and are made from animal hair or synthetic fibers. There are many brush manufacturers—virtually all of the major art material manufacturers market their own ranges. While it is possible to work using only one or two carefully chosen brushes, different shaped brushes have been designed to facilitate specific tasks and techniques. Having a selection of these brushes on hand can make certain techniques less difficult. Cheap brushes are a false economy, so always try to buy the very best you can afford. Used correctly, properly cleaned, and stored carefully, good-quality brushes can last a long time.

Watercolor brush hair and fiber

Sable The best watercolor brushes are made from hair taken from the tail of the sable, a small, carnivorous animal found in Siberia and Northern Japan. Sable hair is extremely hard-wearing; the hairs shape well, and can hold a point. The hair also holds water well, and has excellent spring and flexibility.

Kolinsky sable The very best sable hair comes from animals found in the Kolinsky area of Northern Siberia. The temperature is cold and hostile, and in order to survive the harshness of the environment, the sables grow strong, thick, long hair. When used in brushes, the

Watercolor brush sizes and shapes

ROUNDS The round brush is the primary tool for watercolor artists. They are easy to find, and can be used to make a variety of different marks. A large round sable can make both a fine line and a broad wash. Different manufacturers produce different sized ranges, but the smallest brush available is 0000—these are tiny, containing just a few hairs—while the sizing at the larger end of the spectrum depends on the manufacturer. Generally speaking, the higher the number, the larger the brush.
Advantages: Can be used for many different tasks.
Disadvantages: Certain marks are better made using different brushes.
Cost: Smaller ones are inexpensive, while larger ones are more expensive.

RIGGERS Riggers are long, round, pointed brushes. They are an excellent choice for making long, continuous, calligraphic strokes of single or varying thicknesses.
Advantages: Perfect for the job for which they were intended.
Disadvantages: Of limited application.
Cost: Smaller ones are relatively inexpensive, while larger ones are more expensive.

MOPS Mops contain a good deal of hair, and are intended to hold and move large amounts of liquid paint around the support. They are commonly used for making broad washes. Mops can be graded using a similar system to that used for round brushes, or are simply labelled small, medium, or large.
Advantages: An excellent choice for making large washes.
Disadvantages: Cannot be used for small, detailed work.
Cost: Smaller ones are relatively inexpensive, while larger ones are more expensive.

LINING Also known as daggers, lining brushes are flat, with long hair. A sharp angle is cut across the brush, making it possible to make either thick or thin strokes, depending on how the brush is held.
Advantages: An adaptable brush capable of precise work.
Disadvantages: Needs a lot of care, or it will lose its shape.
Cost: Smaller ones are relatively inexpensive, while larger ones are more expensive.

FLATS As the name suggests, flat brushes are square cut. They are also known as one-stroke brushes, and can have long or short hair. Larger flats make good wash brushes, while smaller flats are especially good for one-stroke gouache painting. Flat brushes are usually graded by a width measurement.
Advantages: Good for precision work that requires straight lines.
Disadvantages: If not properly cared for, the bristles will become splayed, and the brush will not hold its shape.
Cost: Smaller ones are relatively inexpensive, while larger ones are more expensive.

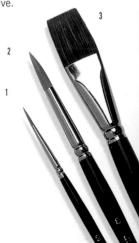

1. No. 2 sabeline round
2. No. 8 sabeline round
3. Ox hair flat
4. Squirrel hair flat
5. Mottler
6. Kolinsky sable round
7. Large squirrel hair pointed flat
8. Mixed-hair round
9. Prolene-sable blend flat
10. Wash
11. Rigger
12. Small prolene sword
13. Small goat hair mop
14. Small squirrel hair wash

hair holds a lot of water, and swells slightly when wet. The brushes have exceptional spring, and are easily controllable.

Squirrel hair Soft, but not as resilient as sable, small squirrel brushes soon lose their points, and can begin to look a little ragged. Squirrel hair is best used for larger wash brushes, which do not need a good point. Squirrel brushes can hold large quantities of water.

Ox hair Made from the ears of cattle, ox hair is often used mixed with other fibers. It cannot form a point, but it holds water well, and is especially suitable for flat, square-cut brushes.

Goat hair This type of hair is of no use for small brushes intended to hold a point, but it is an excellent choice for large wash brushes used to make very broad washes requiring a lot of paint, as the hair holds water well. Goat hair is often used in oriental brushes.

Mongoose hair In the past, this type of hair was sold under several names, including monkey hair and Siberian camel hair. It has recently become more popular, as it possesses a distinct mottled pattern, and is very tough and firm, yet responsive to pressure when used. This type of hair is especially good for dry-brush and textural effects.

Sabeline These brushes combine synthetic fibers and natural hair. Any type of hair or fiber can be used, but most are a mixture of sable and nylon, or fine-grade ox hair dyed to look like sable. Sabeline brushes do not last as long as traditional sable brushes.

WATERCOLOR BRUSH CARE
Watercolor brushes can be expensive, and should thus be looked after and treated with care. Rough treatment can damage brushes irreparably, so try not to use your best brushes for scrubbing watercolor pans; nor should they be used with additives like texture gels and aquapasto. If using liquid frisket, make sure to wash the brush thoroughly, or it can become ruined.

After painting, rinse the brush well under cold water. Dry, stubborn paint around the ferrule can be softened and removed with a little washing-up liquid or shampoo, followed by a good rinse in clean water. Remove dry liquid frisket by rinsing the brush in a little lighter fluid. Then, reshape the brush into its natural shape, remove any excess moisture with paper towel, and store the brush upright, resting on its handle in a pot or jar.

ORIENTAL Oriental brushes are made from goat, hog, or wolf hair set in a bamboo handle. They are generally flexible, and can be used for a variety of mark-making purposes. Large, flat brushes known as *hakes* (pronounced hah kays) are invaluable for wash work. Round, pointed oriental brushes are made to be held differently than traditional western brushes. In order to achieve the fluid, calligraphic marks seen in oriental painting, the brush is held upright at a right angle to the support, and the hand and arm do not rest against the support.

Advantages: When used correctly, these brushes can make marks with unique qualities.

Disadvantages: The brushes do not stand up to rough treatment well, especially the round ones.

Cost: Inexpensive, although larger brushes can be expensive.

SPONGES Both natural and man-made sponges make excellent mark-making tools. They can be used for making washes and creating texture, or for removing paint and making corrections. Look out for nylon foam rollers and brushes, as these will expand your mark-making repertoire even further.

Advantages: Adds another dimension to the work.

Disadvantages: Need to be washed well after use, so as not to contaminate new colors when used again.

Cost: Inexpensive.

Nylon foam brushes

Nylon foam rollers

Natural sponges

4 5 6 7 8 9 10 11 12 13 14

THESE TWO PAGES
• OIL BRUSH SIZES AND SHAPES

AT-A-GLANCE GUIDE TO OIL BRUSHES

• **NATURAL HAIR** Sable brushes have good spring, and are responsive to touch; they require thorough cleaning after use.

• **BRISTLE** Made from bleached hog bristles; springy, tough, and stiff; particularly good for use with oil paint.

• **SYNTHETIC** Made from polyester filament; a good economical alternative to natural-hair brushes; have similar characteristics to natural hair and bristles, and stand up well to oil paint.

Synthetic fiber Synthetic polymer and nylon brushes are now a very common sight in art stores. They are often made using fibers of different thicknesses. Thicker fibers give strength and spring, while thinner fibers are good for holding liquid. When properly cared for, round, pointed synthetic brushes can last a reasonably long time, but the fibers hold their shape and last longer when used in flats.

Oil brush hair and fiber

Natural hair The traditional, natural-hair oil brush was a mixture of ermine and weasel known as miniver. Today, a variety of soft animal hair is used, including sable, which has good spring and is responsive to touch. Oil sable brushes look much like those designed for watercolor painting, but the handles are generally longer. Natural-hair brushes are not essential for oil painting, but can be useful for painting in details in the final layers of a painting, and for applying color that has been thinly diluted. Oil paint, solvents, and thinners are hard on natural hair, so brushes need to be cleaned well after use.

Bristle Springy, tough, and stiff, bristle brushes are made from bleached hog bristles. The majority of bristle comes from China—the best comes from the Chungking area. These brushes are particularly good for oil painting, as they are tough enough to cope with the thickness and heaviness of the paint. Top-quality brushes have bristles that are split into microscopic points known as "flags," which help hold the paint on the brush. The flags also

Oil brush sizes and shapes

ROUNDS Round brushes have a multitude of uses, and are capable of making a wide range of marks. Good-quality round brushes hold their points, and have sufficient "belly" to hold plenty of paint. Small rounds produce fine, detailed work, while the largest ones are used to lay in large areas of color. Round brush sizes range from 000, the smallest size, up to size 24. Short rounds are also available.
Advantages: A good, all-around brush shape.
Disadvantages: Other brushes perform specific effects better.
Cost: Ranges from cheap to very expensive.

FLATS Long-bristle flats make direct, wedge-shaped marks when used flat, or thinner lines when turned on their edge. They are the perfect choice for working *alla prima*.
Advantages: These brushes can hold a lot of paint, and are easy to control and precise.
Disadvantages: Paintwork can look flat and monotonous.
Cost: Ranges from cheap to very expensive.

BRIGHTS Brights are flat brushes with short bristles. Like flats, they are easily controllable and precise, and are ideal for one-stroke brushwork using thick impasto paint. The size range runs from 0 to 20.
Advantages: Easily controllable and precise. These brushes are particularly good for controlling impasto work.
Disadvantages: They run out of paint quickly.
Cost: Ranges from cheap to very expensive.

FILBERTS Filbert brushes are flat, with a rounded or curved edge. Capable of precise work, filberts are good for "drawing" into a work, adding detail, or for one-stroke impasto work. The sizes range from 0 to 30. Shorter- and longer-bristle versions are also available.
Advantages: Can be used for a wide range of techniques.
Disadvantages: May take some getting used to because of their odd shape.
Cost: Ranges from cheap to very expensive.

1. No. 4 bristle round
2. No. 6 bristle filbert
3. No. 10 flat bristle
4. No. 12 flat bristle
5. No. 6 sable filbert
6. No. 2 nylon bright
7. No. 4 nylon round
8. Bristle priming brush
9. No. 8 bristle fan blender
10. Bristle flat varnish brush
11. Bristle medium flat
12. Sable decorators' brush

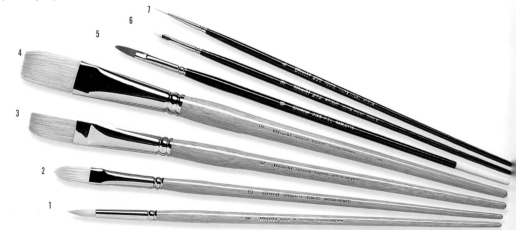

allow the paint to flow evenly and smoothly from the bristle to the support surface.

Synthetic The synthetic fibers used in oil brushes are made from polyester filaments. These brushes have similar characteristics to both natural hair and bristle, and are resistant to the caustic action of oil and thinners. They are often made with tapering interlocking filaments, to keep their shape and give the correct degree of strength and spring. A good economical alternative to natural-hair brushes, synthetic fiber brushes can withstand a great deal of contact with the canvas, but the cheaper versions tend to lose their shape more quickly than natural-hair brushes.

How can I tell a high-quality brush apart from a low-quality one?

There are a number of ways to tell a higher quality brush apart from one that is of lesser quality. In higher quality brushes, the brush hair is firmly attached to the inside of the ferrule; if there is too much space between the inside of the ferrule and the bristles, paint can become lodged, and will be difficult to remove. As well, none of the hairs should be splayed or split, and the handle should feel comfortable within your grip.

OIL BRUSH CARE

Oil brushes receive a fair amount of punishment, and thus require a good deal of care. Never leave a dirty brush standing on its bristles in a jar of solvent, and never allow paint or oil and gel mediums to dry on the bristles. Scrape as much paint as possible off of the brush with a rag or palette knife, then rinse well in clean solvent. Make sure that all of the paint is out of the bristles, paying particular attention to the area adjoining the ferrule. Rinse in lukewarm water, then work washing-up liquid into the bristles to remove all traces of solvent and paint. Rinse the brush well, shape the bristles, and then leave it to dry, resting on its handle in a pot or jar. Special brush-cleaning soaps and gels are available for reconstituting and conditioning all types of oil brushes.

FAN BLENDERS These fan-shaped, flat brushes are commonly used for softening the transition of one color into another. They are not used to mix paint on the palette, however—only to modify paint on the support. Sizes run from 1 through 12.
Advantages: They do a good job of blending.
Disadvantages: They are of limited use, and need to be kept very clean.
Cost: Relatively inexpensive.

MOTTLERS These brushes are actually large flats, and are also known as background brushes. They are used for blocking in large areas of flat, thin color when underpainting, or when working on large mural work.

Advantages: The best choice for covering large areas with paint.
Disadvantages: They need to be kept very clean.
Cost: More expensive than standard flats.

PRIMING BRUSHES Used for priming and gesso, these large flat bristle brushes come in sizes up to 4 in (100mm) wide.
Advantages: They cover a large area quickly and thoroughly.
Disadvantages: Household paintbrushes work just as well.
Cost: Expensive, given the alternatives.

VARNISH BRUSHES Varnish or "spalter" brushes are soft, and will shed hairs if not well made. The sizes range up to size 48, or 7 in (180mm). These brushes need to be kept clean, and should only be used for their intended purpose.
Advantages: Made specifically for the job, they are good for brushing out varnish thinly.
Disadvantages: They require a thorough cleaning after use.
Cost: Relatively expensive.

DECORATORS' BRUSHES Good-quality decorators' brushes are as good as—and often a good deal less expensive than— artists' brushes. Window-sash and angled lining brushes are particularly useful.
Advantages: Versatile and economical.
Disadvantages: Cheaper ones can be badly made, and may shed bristles into the work.
Cost: Inexpensive.

Scrape off surplus paint with a palette knife.

Rinse well in clean solvent.

ACRYLIC BRUSH CARE
Never allow acrylic paint to dry on a brush. When you have finished painting, wipe away all excess paint from the brush, then rinse it under cold water. Wash the brush with detergent, rinse, then reshape. Place the brush in a pot or jar to dry, resting on its handle. If acrylic paint does dry on your brushes, however, try soaking them in methylated spirits or denatured alcohol, or use a water-based cleaner such as Aquasol.

Remove excess paint from the brush.

Wash the brush using detergent, then rinse and reshape it.

Acrylic brushes

All of the brushes used for both watercolor and oil painting can also be used for acrylic painting. In addition, manufacturers have produced a range of synthetic bristle brushes specifically made for use with acrylics. These special brushes possess many of the attributes of natural hair, and resemble traditional hog-hair and sable-hair brushes, but are made from tough, springy, hard-wearing polyester and nylon fibers. The range of synthetic brush shapes and sizes is as wide as that found with hog-hair and other natural-hair ranges. Prices for synthetic brushes are substantially less than an equivalent-sized or -shaped sable, but they usually cost more than a hog-hair brush that is the same shape and size.

Acrylic brush sizes and shapes

If you are just beginning to learn how to paint with acrylics, start by purchasing a few brushes only; you can extend your range later, when you have more experience. A good range of starter brushes might include two different-sized flat brushes, two different-sized round brushes, and one middle-sized filbert. Painting knives are expensive, and thus are not recommended for inclusion in a starter kit, but you might want to try them when you become more experienced.

ROUNDS Rounds are available in soft natural hair, bristle, or synthetic fiber. Some manufacturers make a range of synthetic fiber brushes aimed specifically at the acrylic artist.
Advantages: These brushes are good for all-around application.
Disadvantages: Other brushes are better suited to more specific purposes.
Cost: Ranges from inexpensive to expensive.

FLATS Flats are available in several materials. Easy to control and to use, they have the capacity to hold large quantities of paint, and make a distinct chisel-shaped mark which can vary in width according to the amount of pressure applied.
Advantages: Easy to control and to use.

Disadvantages: Brush work can look exceedingly regular.
Cost: Ranges from inexpensive to expensive.

FILBERTS Flat brushes with rounded edges, filberts are very adaptable, and can make precise, flat marks; they can also be used on their edge to produce linear marks.
Advantages: A good multi-purpose brush.
Disadvantages: Practice is necessary in order to realize the full potential of this brush.
Cost: Ranges from inexpensive to expensive.

FAN BLENDERS Because of the rapidity with which acrylic paint dries, blending colors can be problematic. These brushes are particularly suited to this purpose, and provide good results.
Advantages: Perfect for the job for which they are intended.
Disadvantages: Of limited application and use.
Cost: Ranges from relatively inexpensive to expensive.

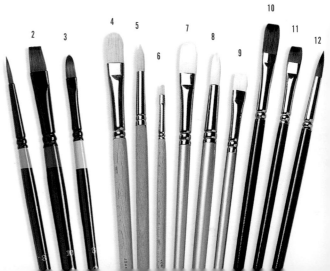

1. Chromacolor nylon round
2. Chromacolor nylon flat
3. Chromacolor nylon filbert
4. Bristle filbert
5. Bristle round
6. Bristle flat
7. Nylon filbert
8. Nylon round
9. Nylon flat
10. Synthetic flat
11. Synthetic bright
12. Synthetic round

Knives and shapers

Palette knives and painting knives are the two types of knives typically used with acrylic paints. Palette knives are essentially used for mixing paint on the palette, while painting knives, with their flexible blades, are used to apply thick, highly textured wedges of acrylic paint to the support. The blades of both types of knives are typically made from stainless steel, but plastic knives specially made for acrylics are also available, and are easier to clean than steel blades. A relatively new product, paint shapers have flexible rubber tips in place of bristles, and can be used to make a range of unique marks.

Can I use my oil painting knives on acrylic paints?
As is the case with brushes, the same knives that are used for oil painting can be used for working with acrylic paints, but only if the blades are made from stainless steel.

How can I use my oil painting knife to maximum effect?
Each part of the angular blade of an oil painting knife can be used to make a different sort of mark: the tip can be used for fine detail work and stippling, the flat part to make broader strokes, and linear marks can be made using the edge.

Palette and painting knives

Characteristics: Palette knives, also known as mixing knives, are used to spread and mix paint and additives on the palette, and to scrape up and clean away unwanted paint after a work session. Small plastic versions are available, but the best ones have flexible, polished steel blades and wooden handles.

Painting knives are similar to palette knives: they have a flexible, shaped blade that is produced in a variety of shapes and sizes, each making its own unique type of mark. The blade is cranked, placing it away from the handle, and thus ensuring that the hand stays free of the paint work.

Advantages: Palette knives are essential for cleaning palettes. Painting knives will extend your repertoire of techniques.

Disadvantages: Painting knives can take some getting used to.

Cost: Both palette and painting knives are reasonably inexpensive.

Metal palette and painting knives

Plastic palette and painting knives

Paint shapers

Characteristics: Paint shapers look like traditional brushes, with wooden handles and chrome ferrules, but instead of holding bristles, they hold a flexible rubber tip. The tips come in both soft and firm rubber, and are available in a range of shapes and sizes. Pointed, round, chiselled, and angled ends move the paint around, more in the manner of a palette knife than a brush. They can be used with all types of painting media, including pastels. Special shapers are also made for use with clay; these can be used with paint as well.

Advantages: Easy to clean and durable, these implements make a range of distinctive marks, and are great fun to use.

Disadvantages: Brushes are better for certain jobs.

Cost: Inexpensive.

A shaper can be used to make distinctive marks.

Interesting patterns can be made using a flat shaper.

Flat shapers

Pointed and chisel-tipped shapers

Miscellaneous equipment

PAINT BOXES AND ART BINS Art materials accumulate at a surprising rate, and need to be kept tidy and safe. Traditional wooden boxes have partitioned sections for paints and brushes, and many accommodate a palette as well. In some boxes, the lid converts into a rudimentary easel that can hold small boards and panels. Special boxes for holding pastels and watercolors are also available. Cantilevered art bins, made from tough plastic, are relatively new, and are often identical to the storage boxes found in hardware stores.

TACK GUNS Also known as staple guns, these guns are indispensable for stretching canvas and watercolor paper. Some models take a range of tacks or staples with varying lengths of shank; do not use tacks or staples with very deep shanks, as these are more difficult to remove. Rexel, Arrow, Rapid and Stanley Tools all make good guns. If you intend to frame your own work, invest in a framers' gun that fires points at an angle to secure glass and backboards into frame rebates. Fletcher, Unifix, and Rocafix make framers' guns that can double as conventional tack or staple guns.

Art bin

Paint box

Tack gun and staples

PORTFOLIOS Carrying, protecting, and storing work is a constant problem for the artist. A plan chest is ideal for this purpose, but these are large and expensive; portfolios are the next-best solution. The most basic portfolios consist of two hinged sheets of covered cardboard, with flaps to cover work and ties to secure it. The most expensive ones are made of simulated leather, and have a system of zippers for opening and closing them. These portfolios often contain acetate or clear vinyl

Portfolios

Mahl stick

sleeves for holding work; the larger ones generally have carrying handles and, occasionally, shoulder straps. Studio cases and portfolios made from fluted or corrugated plastic sheet are less expensive alternatives. All types of portfolios can be found in a range of sizes.

MAHL STICKS The mahl stick is a rod, usually made from bamboo, with a ball-shaped pad at one end. It is used as a rest for the hand when working over a wet or delicate part of a painting or drawing. The stick is held in the hand which is not painting, and the ball end is positioned so that it is touching the canvas or easel. The hand that is painting rests on the stick.

DAYLIGHT SIMULATION BULBS The blue light cast by these bulbs and fluorescent tubes simulates natural northern light, making color matching more accurate than under yellow halogen bulbs. The light is also restful for the eyes.

Daylight simulation bulb

Acrylic medium and gel

ADHESIVES AND ADHESIVE TAPE
Not all of the adhesives and adhesive tapes on the market are useful to the artist. Those listed here, however, should have a place in the studio.

Acrylic medium and gel: Both acrylic matte medium and gel can be used to glue paper and card, as both dry reasonably quickly and leave a clear film. Acrylic mediums are produced by most acrylic paint manufacturers.

PVA: Polyvinyl acetate adhesives work well with materials that have a porous surface, including wood, fabric, and card. Some have a tendency to yellow, however, so avoid getting adhesive onto uncovered surfaces. Brands include Unibond, Ocaldo, and Ocavin medium.

Copydex: This all-purpose white latex cement is ideal for fabric, paper, and card. It can be messy to clean up, so use with care.

Spray adhesive: Spray adhesives are quick and efficient, but they can soak through and stain thin papers. Many can be pulled off and repositioned, if need be. Several brands are available, including the Spray Mount range made by 3M.

Glue sticks: Made from solid polymer resin, glue sticks are relatively low-tack, and are excellent for the non-permanent sticking of work when creating collage, or for securing paper and photographs into sketchbooks or photo albums. Brands include Uhu, Tipp-ex, Pritt, and Tombow.

Starch paste: Starch paste is clean to use, and is suitable for sticking paper and making papier mâché. The paste dries slowly, and softens if re-wet. Acid-free starch paste is suitable for conservation work.

Masking tape: This tape is manufactured in a range of widths, from ¼ in (6mm) up to 2 in (50mm), as is low-tack drafting tape.

Adhesive paper tape: Brown adhesive paper tape is used for stretching paper, and is economical if bought in 656 ft (200m) rolls. Do not get any water onto the roll, or the tape will stick to itself and be unusable.

Invisible and magic tape: These tapes are useful for sticking together rips in working drawings and diagrams. The tape surface accepts ink, graphite, colored pencil, and pastel.

Framing tape: Acid-free, linen-, cloth-, or paper-backed tapes are used to secure work onto window mounts. The adhesive is starch-based, and is activated by water.

Duct tape: Material-backed duct tape can be used to facilitate a range of studio repairs quickly and cleanly.

Adhesives

From top: invisible tape, masking tape, duct tape, adhesive paper tape; right: framing tapes

CUTTING EQUIPMENT
In the studio, sharp knives and scissors need to be permanently on hand for, among other tasks, cutting card, paper, and board; trimming and cutting canvas; cutting stretched paper from boards; cutting masking tape, stencils, and paper masks; and sharpening pencils and pastels. Stanley Tools produces a high-quality, extensive range of heavy-duty utility knives with disposable and replaceable blades. Swan-Morton makes an excellent range of scalpels that take replaceable blades; these are ideal for precision jobs, as are the range of craft knives from Excel, X-Acto, or Xcelite. Edding and Plasplugs also make disposable knives.

Scissors are needed for trimming materials and paper. Two sizes of good-quality scissors with stainless steel blades should cover most needs; makers include Jakar, Fiskars, and Dahle. Razor blades are also useful for scratching away paint when making corrections.

If you do a good deal of cutting, you should invest in a cutting mat. They are available in a range of sizes; buy the largest you can afford. The mats come in translucent white, opaque green, and black, and have grid lines to help with precise cutting and a self-sealing surface. Good-quality mats are made by Dahle, Jakar, Uchida, and Edding, among others.

Disposable knife

Single-edged razor blades

A range of scalpels, craft knives, and blades

Scissors

Cutting mat

Presentation and conservation

After having labored over an artwork, it is important to conserve it properly, so that it remains in the best condition possible for the longest period of time. Artworks should be hung and stored in areas where there is no direct sunlight, as sunlight causes pigment discoloration. The temperature should be on the cooler side, as the hotter a painting gets, the faster it will physically degrade. Avoid placing artworks in a room in which drastic temperature changes may occur. It is best if the room is fairly damp (drier conditions put stress on the paint and ground layers), but not so damp as to create an environment where mildew can form.

Framing

A frame offers the artwork protection from knocks and scrapes, and helps avoid the build-up of dust and other potentially damaging atmospheric agents. It acts as a boundary between the artwork and the surrounding environment, and makes a suitable transition from one to the other. On an aesthetic level, a frame contains the picture within its own space, helping to make sense of the image in the context of its composition and color. While the choice of how to frame a piece is ultimately subjective, conventional wisdom dictates that the frame should complement the piece, not overwhelm it.

Framing materials

MITER SAWS A good miter saw is the most important tool for framing. The saw is mounted on a firm base, but can be moved in such away as to change the angle of cutting through a full 90 degrees, making it possible to select the correct angle for 4-, 5-, 6-, 8-, or even 12-sided frames. The base of the saw often incorporates a clamp to hold the molding, and the whole unit can easily be secured to a workbench.

HAND TOOLS A number of hand tools are necessary for framing, including a tack or pin hammer; a nail punch, to sink the heads of tacks and pins; and an awl, for making holes. A pair of pincers or pliers is useful for removing stubborn tacks, screwing in screw eyes, and cutting and winding picture wire. A drill with a set of fine bits is necessary as well, for joining angled moldings. A small hand drill or a cordless electric drill offers good control when making small frames or using fine moldings.

You will also need clamps, to hold the frame together while it is being joined. Several types are suitable, but the easiest to use on small-to-medium-sized frames is the strap clamp, available in steel or plastic. For larger frames, it may be necessary to use a combination of individual corner- and long, sash-type clamps. A rigid steel rule is the best tool for making precise measurements.

Miter saw

Tack hammer

Nail punch

Bradawl

Pliers

Electric drill

Hand drill

Steel rule

A strap clamp is used to hold the frame together.

Spring miter clips are useful for joining awkward profiles.

Traditional corner clamps are suitable for most moldings.

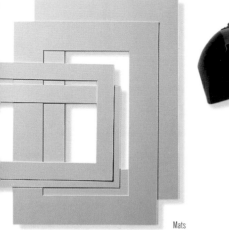

Mats

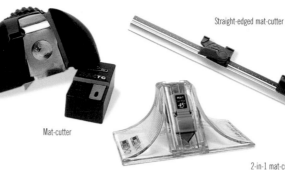

Mat-cutter

Straight-edged mat-cutter

2-in-1 mat-cutter

MATS The mat (also known as the mount) is the wide "frame" of thick card that surrounds the image and separates it from the frame. Its purpose is twofold: to create a buffer between the picture and the glass, and to provide an aesthetically pleasing border around the picture, creating a finished look. The width of the mat has a direct effect on the image, as does its color or finish, and thus both need careful consideration.

The mat has a more direct influence on the image than the frame, so it should be chosen first; its color should not clash with the frame, and should harmonize with the work. Choosing a mat with a color closely related to a reasonably dominant color in the picture can work, as can a totally unrelated color. Mat card is sold in varying thicknesses and in several sizes, up to 64 x 44 in (1630 x 1120mm). Most mat board is of a neutral pH. The more expensive boards are made from 100% cotton, and are buffered with calcium carbonate with a 7 pH.

MAT-CUTTING TOOLS Several manufacturers produce a variety of mat-cutting systems, and all operate in a similar way. These typically consist of a calibrated straight edge, along which the cutter moves. Some systems need to be held against the card being cut, while others hold the card securely in place. Circular and oval mat-cutters are also available. Well-known manufacturers of mat-cutting systems include Dexta, Jakar, Olfa, Maped, Alto, Nielsen & Bainbridge, and Logan.

MOLDINGS Frame moldings are available in simple formats, both finished and unfinished, and in more elaborate designs as well. One advantage of plain, unfinished wooden moldings is that they are less expensive than finished moldings, and can be finished creatively. Plain wooden moldings are made in a wide variety of machine-made hardwood profiles, ranging from thin and simple to wide and moderately ornate. Machine-made softwood moldings are also available; these are intended for trimming doors and windows, however, so a rabbet will have to be cut. Builders' moldings, obtainable from lumberyards, can also be used, and several different profiles can be glued together to create the style required. Finished moldings can also be bought; while impressive, these can be exorbitantly expensive, and are perhaps best left for use by the professional framer.

GLUES AND TAPES The glue most commonly used in woodwork is quick-setting polyvinyl acetate—PVA—which is easy and clean to use, and can be removed by wiping with a damp cloth. When using PVA, the wood must be clamped until the glue is dry. PVA can also be used for sticking card and paper when making mats, and it can be diluted with water, if need be. Acrylic matte painting mediums can be used on paper and card in a similar way, and will dry without staining.

A range of adhesive tapes is used for framing pictures: acid-free adhesive linen framing tape is used to attach artworks to mats and backing boards; archival mounting tape and hinging tissue are used in a similar way; and framing tapes are used to seal the side of rabbets between the glass and the wooden molding.

Simple wooden moldings can be finished creatively.

Mat sample book

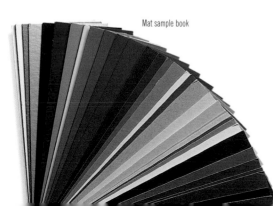

Framing tapes are used to attach artworks to mats and boards. PVA wood glue is used for assembling wooden frames.

Intricate decorative moldings are impressive, but can be expensive.

Lightfastness and standards

Every pigment, whether man-made or organic, is classified as to its degree of lightfastness, or permanence. The grade of lightfastness given to the pigment is an indicator of the extent to which the color will gradually fade when subjected to light.

Reputable manufacturers indicate the degree of lightfastness of a color on its label. The lightfastness indicated for a specific color from one manufacturer may differ from the degree indicated for the same color from another manufacturer; this is because the two versions of the color may have been mixed using slightly different pigments, each with different degrees of lightfastness.

Grading lightfastness

The degree of lightfastness indicated on a paint label is typically indicated by a series of stars or letters: AA or **** = extremely permanent; A or *** = durable, normally considered permanent; B or ** = moderately durable; and C or * = fugitive. In recent years, the ASTM (American Society for Testing and Materials) has introduced its own code for lightfastness: ASTM I = excellent lightfastness, ASTM II = very good lightfastness, and ASTM III = not sufficiently lightfast. The ASTM coding is relatively new, and appears on some paint labels, but not on all.

Reading the material

In addition to the degree of lightfastness ratings, paint labels may also provide other information regarding the make-up of the paint, and its specifications. The following information is also usually included on a paint label:

PAINT QUALITY
The paint is typically labelled as either students' or artists' quality.

INGREDIENTS AND COVERING POWER
The pigments used in the paint color and the vehicle in which they are contained is typically listed on the paint label, as is the degree of lightfastness and transparency.

COLOR NAME
The name of the paint color is invariably included on the label. The word "hue" as part of the color name indicates the use of a synthetic pigment. While many color names are consistent regardless of who makes the color, some names are restricted to specific manufacturers, being specially formulated by that manufacturer. Winsor Blue, for example, is a proprietary color that is produced only by Winsor & Newton.

ASTM STANDARD
This number or letter (or a combination of both) code indicates that the product conforms to certain criteria set out by the ASTM. For example, the presence of the code D4236 indicates that the information on the paint's label conforms to the practice for labeling art materials for chronic health hazards.

PIGMENT CODE
Every pigment has a unique code, which often appears on the paint label. For example, the label on Winsor & Newton Artists' Cadmium Yellow watercolor specifies that it is made from cadmium zinc sulphide PY35 and cadmium sulphoselenide PO20.

SERIES NUMBER OR LETTER
The series number or letter on a paint label indicates the quality and cost of the pigments used. The higher the number or letter, the better the pigment quality, and the the more expensive the paint will be. The higher end of the scale ca be quite costly, so always check t series number or letter before making a purchase.

Health and safety

When working with artists' materials and equipment, health and safety is largely a matter of common sense. On the whole, artists' materials and equipment are not dangerous if used properly. However, care must be taken with those materials that are sharp, flammable, corrosive, irritating, or potentially harmful if ingested.

Changing times

Many of the more hazardous artists' materials have now been replaced by modern, safer alternatives. Stringent safety legislation and codes have also been imposed by many governments, but it should be remembered that what is considered hazardous in one country may not be regarded as such in another.

Let the buyer beware

Reputable artists' materials manufacturers conform to safety legislation, and use internationally recognized labels on their products and in their catalogs which inform the user as to the product's safety. However, not all manufacturers provide this information on their products' labels; in such cases, it is up to the user to educate him- or herself. Don't be afraid to contact the manufacturer directly if you have a question about safety.

Workshop practice

Reading all product labels and manufacturers' catalogs will help ensure that you are using a material properly, and are working safely.

- Always work in a well-ventilated area. This is especially important when working with solvents and oils, and when using printmaking materials such as acid.
- When working with harmful or irritant materials, wear suitable protective clothing. If you find certain materials cause an allergic reaction, wear a barrier cream, or find a non-irritating substitute.
- Always avoid breathing in vapors or dust—especially pigment dust. Working in a well-ventilated area helps, as does working in a clean environment and wearing a suitable ventilator.
- Avoid materials coming into contact with your eyes—especially when working with solvents or acid. Wear goggles or safety glasses if in doubt.
- Take care when eating, drinking, or smoking in the studio. It is easy to transfer paint to your mouth when eating, or to mistakenly dip a brush into the cup of coffee standing alongside your palette. Smoking in the studio is not a good idea either, as vapor and dust taken in through the heat of a cigarette can be harmful. Certain oils, waxes, and solvents are flammable, and thus care must be taken never to overheat these materials, or to bring them into contact with a flame. If using cutting implements, make sure that they are sharp, and use good-quality, non-slip straight steel edges. Keep all artists' materials away from young children, unless they are intended and made specifically for their use.

PRODUCT LABELS
Not only do product labels list the ingredients contained within the product—they also indicate whether any of its components are flammable or toxic. It is very important to read all product labels very carefully.

The contents are flammable.

The contents are toxic.

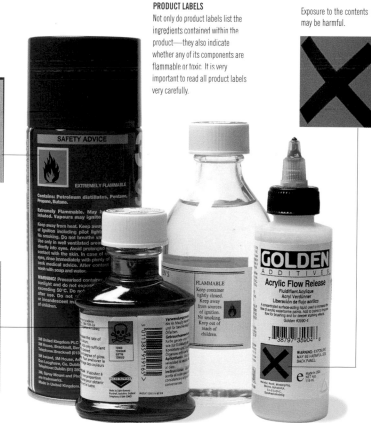

Exposure to the contents may be harmful.

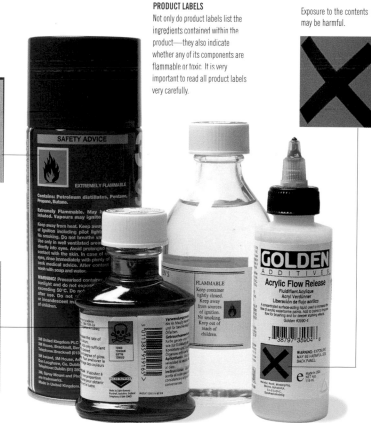

Glossary

Acrylic paint A water-based paint in which the pigment is bound in a synthetic acrylic resin.

Additive A liquid or gel that can be added to paint to alter or enhance its characteristics.

Airbrush A tool through which compressed air is mixed with liquid paint and sprayed onto a surface.

Alcohol Can be mixed with watercolor paint to speed up the drying process of paint.

Alkyd A synthetic resin made from polyhydric alcohol and polybased acid.

Alla prima Derived from the Italian phrase "at the first," this term refers to a painting that is completed in one session, without underpainting.

Aquatint Powdered resin that is used to coat an etching plate.

ASTM The American Society for Testing Materials.

Atomizer A tube through which air is blown in order to atomize a liquid and blow it onto a surface.

Binder The liquid medium that holds together pigment to form paint.

Bistre A brown pigment used in chalks and crayons, made by boiling the soot from burned beech wood.

Bleed The creeping of paint from its designated area, beneath a paper mask for example; or the effect of a dark or more powerful color showing through a color that has been painted over it.

Blend The act of smoothing together two different colors so that one changes imperceptibly into the other.

Blender A type of fan-shaped brush used for blending colors together.

Bloom The cloudy, white effect sometimes seen on varnished pictures when they have been subjected to a damp atmosphere.

Body color An opaque paint, such as gouache, that has good covering power. Watercolor with Chinese white added to it is also known as body color.

Bright A short chisel-shaped brush.

Broken color Color that is applied in such a way as to allow another color or surface to show through in places.

Burnishing The process of rubbing with a soft cloth or tool to give a surface a sheen.

Canvas A fabric made from cotton or linen that is used as a support for painting.

Carré A short, square crayon found in white, black, and shades of brown.

Cissing The effect often seen on smooth, heavily sized papers where the surface seems to repel the watercolor wash.

Complementary colors Those colors that sit opposite each other on the color wheel. They include red-green, orange-blue, and yellow-violet.

Cool colors The colors on the green-blue side of the color wheel.

Copal A hard resin used to make varnish.

Cotton duck An inexpensive cotton canvas.

Crosshatching A shading technique in which two or more series of parallel lines are overlapped.

Dammar A resin tapped from pine trees used to make mediums and varnishes.

Dark-over-light The process of applying dark paint over light paint.

Dechirage The tearing of papers, typically for use in collage.

Decollage The peeling away of glued papers.

Diluent A liquid used to dilute paint; usually mineral spirits or turpentine.

Drybrush A technique in which most of the paint is squeezed from a brush and then applied to a support surface.

Earth colors Colors made from pigments that are mined from the earth. These include sienna, ocher, and umber.

Encaustic From the Greek word "*enkaustikos,*" meaning "to process with heat."

Engraving A form of printmaking in which an image is taken from a metal plate, into which a design has been cut using sharp metal tools.

Etching A type of printmaking in which an image is etched onto the surface of a metal plate by the caustic action of acid.

Fat-over-lean An expression used to describe the oil painting technique of using paint with little or no oil added in the initial stages. More oil is gradually added as the work progresses.

Ferrule The metal tube into which the bristles and handle of a brush are secured.

Filbert A flattened paintbrush with a curved or tapered end.

Filler An inert pigment like whiting or chalk that is used to add bulk or extend another pigment.

Fixative A resin- or shellac-based solution that is sprayed onto drawings to affix loose pigment dust to the surface.

Flat A chisel-shaped flat brush.

Format The proportions of a support.

Frottage A technique that allows the texture of a surface to be transferred to a sheet of paper by rubbing.

Fugitive colors Colors that are not lightfast.

Gesso A mixture of glue-size whiting and white pigment, traditionally used to prime

a rigid support. Today, acrylic gesso is made for use on any support.

Glaze A thin, transparent wash of color.

Glycerine A substance used in the manufacture of watercolor.

Gouache A water-based opaque paint.

Graphite A carbon-based mineral used in the manufacture of pencils.

Grattage Picking or pulling at the surface of paper or card to show the layers beneath.

Grisaille A monochromatic underpainting.

Ground A prepared painting surface.

Gum arabic A water-soluble gum obtained from the Acacia tree.

Hatching A shading technique in which a series of lines are placed parallel to one other.

Hue The name of a color. The term is also placed after a color name, to denote that the color has a synthetic pigment component.

Impasto From the Italian meaning "dough," this term describes the technique of using paint thickly to create a textured surface.

Intaglio The process of taking an image from a surface that has been engraved or etched, with the ink being held in the furrows or recesses of the support.

Lean Paint that has little or no added oil or medium.

Lightfast A term applied to those pigments that will not fade when exposed to light.

Lithography A type of printmaking that relies on the antipathy of grease and water.

Mask A material placed onto a support to prevent paint from making contact.

Mat The cardboard mount or window that separates an artwork from its frame.

Matte A dull, non-shiny surface.

Medium Liquid in which pigment is suspended (plural "mediums"). The term is also used to describe the type of painting, drawing, or printing materials being used (plural "media").

Mixed media Work in which more than one type of medium or material has been used.

Opaque Non-transparent in quality.

Optical mixing The placing of colors onto a support in such a way that a different color is seen. The transformation takes place within the mind of the onlooker.

Palette The surface upon which colors are mixed. The term also applies to the range of colors used by an artist.

Permanence Refers to a pigment's resistance to fading.

Pigment A finely ground, colored dust used to make paint, pastel, and colored pencil.

Primary colors Red, yellow, and blue are the three primary colors. These colors cannot be mixed from other colors.

Primer The protective coating used to prepare a support prior to beginning an artwork.

PVA Polyvinyl acetate, a man-made resin used in adhesives, and as a binder for certain types of acrylic paint.

Resist A technique that involves using two materials which, under normal circumstances, repel one another.

Rigger A type of fine, long-bristle brush originally used for painting in the rigging in pictures of ships.

Round A type of brush in which the bristles or hair is held together in a circular or round configuration.

Sanguine A red-brown chalk made from iron oxide.

Scumble The technique of dragging semi-dry paint over the top of a dry layer.

Secondary color A color obtained by mixing together any two primary colors.

Sepia A brown pigment obtained from cuttlefish ink.

Sgraffito Derived from the Italian term for "scratch," this technique involves scratching through one layer of a medium to reveal another, or the surface beneath.

Size A glue obtained from animal skins.

Support The surface upon which an artwork is made. Also known as the substrate.

Tempera A paint made by mixing together pigment with an emulsion.

Tertiary colors Colors that are made by mixing a primary color with a secondary color.

Thixotropic A jelly-like liquid that becomes more fluid with vigorous brushing.

Tint A color that has been made lighter by adding white.

Tone The lightness or darkness of a color.

Tragacanth A type of natural gum, similar to gum arabic.

Tusche A greasy ink used in lithography.

Value Another word to describe the tone of a color.

Varnish A protective coating painted onto the surface of a dry painting.

Vehicle The medium that carries pigment and allows it to be distributed around a support.

Warm colors The colors on the red, orange, and yellow side of the color wheel.

Wash A diluted transparent color that is applied to a support.

Wetting agent A liquid used in watercolor painting that is added to water to prevent cissing.

Resource directory

Many of the art materials mentioned in this book can be purchased at good art supply stores. If you are unable to find a specific material, the suppliers listed below can direct you to the retailer nearest you.

North America

Asel Art Supply
2701 Cedar Springs
Dallas, TX 75201
Toll Free 1-888-ASELART
Fax (214) 871-0007
Web www.aselart.com
Wide range of art supplies.

Cheap Joe's Art Stuff
374 Industrial Park Drive
Boone, NC 28607
Toll Free 1-800-227-2788
Fax 1-800-257-0874
Web www.cjas.com
Wide range of art supplies.

Chroma Colour (North America) Ltd
2-3434 34th Avenue N.,
Calgary, Alberta TIY 6X3
Canada
Toll Free 1-800-665-5829
Fax (403) 250-7194
Web www.chromacolour.com
Chroma colors and accessories.

D'UVA Fine Artists Materials
1900 Broadway Blvd., NE
Albuquerque, NM 87102
Toll Free 1-877-277-8374
Fax (505) 247-8917
Web www.lithocoal.com,
www.chromacoal.com
Heat-fixable coal, powders, and pastels; watercolors, inks, pigments.

Daler-Rowney USA
4 Corporation Drive
Cranbury, NJ 08512-9584
Toll Free 1-800-278-1783
Fax (609) 655-5852
Web www.daler-rowney.com
Wide range of art supplies.

Daniel Smith
P.O. Box 84268
Seattle, WA 98124-5568
Toll Free 1-800-426-7923
Fax 1-800-238-4065
Web www.danielsmith.com
Wide range of art supplies.

Dick Blick Art Materials
P.O. Box 1267
695 US Highway 150 East
Galesburg, IL 61402-1267
Toll Free 1-800-828-4548
Fax 1-800-621-8293
Web www.dickblick.com
Wide range of art supplies.

Enkaustikos!
3 North Washington Street
Rochester, NY 14614
Toll Free 1-800-536-2830
Fax (716) 546-5028
Web www.fineartstore.com/enkaustikos
Encaustic materials and tools.

Flax Art & Design
240 Valley Drive
Brisbane, CA 94005-1206
Toll Free 1-800-343-3529
Fax 1-800-352-9123
Web www.flaxart.com
Wide range of art supplies.

Golden Artist Colors
188 Bell Road
New Berlin
NY 13411-9527
Tel (607) 847-6154
Fax (607) 847-6767
Web www.goldenpaints.com

Grumbacher Inc.
2711 Washington Blvd.
Bellwood, IL 60104
Toll Free 1-800-323-0749
Fax (708) 649-3463
Web www.sanfordcorp.com/grumbacher
Water-soluble oil paints; acrylic, oil, and watercolor paints; brushes, pens.

Hobby Lobby
More than 90 retail locations throughout the US. Check the Yellow Pages or the Web site for the location nearest you.
Web www.hobbylobby.com
Wide range of art supplies.

Jerry's Artarama
P.O. Box 58638
Raleigh, NC 27658
Toll Free 1-800-827-8478
Fax (919) 873-9565
Web www.jerryscatalog.com
Wide range of art supplies.

New York Central Art Supply
62 Third Avenue
New York, NY 10003
Toll Free 1-800-950-6111
Fax (212) 475-2513
Web www.nycentralart.com
Wide range of art supplies.

Pearl Paint
308 Canal Street
New York, NY 10013
Toll Free 1-800-221-6845
Fax (212) 274-8290
Web www.pearlpaint.com
Wide range of art supplies.

Pentel of America, Ltd.
2805 Torrance Street
Torrance, CA 90503
Toll Free 1-800-231-7856
Fax (310) 320-8579
Web www.pentel.com
Watercolor paint, technical markers, fiber-tip pens, graphite pencils, chalk pastels.

Takach Press Corporation
2815 Broadway S.E.
Albuquerque, NM 87102
Toll Free 1-800-248-3460
Fax (505) 242 3454
Web www.takachpress.com
Printmaking materials and tools.

The Artist's Place
16000 Yucca St.
Hesperia, CA 92345
Toll Free 1-800-278-7522
Fax (760) 947-7111
Web www.artistplace.com
Wide range of art supplies, including encaustic materials and tools.

Utrecht Art Supplies
5 Corporate Drive
Cranbury, NJ 08512
Toll Free 1-800-223-9132
Toll Free Fax 1-800-382-1979
Web www.utrechtart.com
Wide range of art supplies.

Winsor & Newton Inc.
PO Box 1396
11 Constitution Avenue
Piscataway, NY 08855
Toll Free 1-800-445-4278
Fax (732) 562-0940
Web www.winsornewton.com
Wide range of art supplies.

Zim's Crafts, Inc.
4370 South 300 West
Salt Lake City, UT 84107
Toll Free 1-800-453-6420
Fax (801) 268-9859
Web www.zimscrafts.com
Wide range of art supplies.

United Kingdom

AP Fitzpatrick Fine Art Materials
142 Cambridge Heath Road
London E1 5QJ
Tel 020 7790 0884
Fax 020 7790 0885
E-mail apfcolours@aol.com
General art supplies, including Lascaux paints.

Arts Encaustic
Glogue, Pembrokeshire
Wales SA36 0ED
Tel 1239 831401
Fax 1239 831767
E-mail info@encaustic.com
Encaustic materials and tools.

Bell Creative Supplies
Unit 5, Haslemere Pinnacles Estate
Coldharbour Road
Harlow, Essex CM19 5SY
Tel 01279 427 324
Fax 01279 437 550
E-mail BellCS@aol.com

Wide range of art supplies, including Chromatix, Frisk, and airbrush products; mail order to the US available.

Berol Ltd.
Oldmeadow Road
King's Lynn,
Norfolk PE30 4JR
Tel 01553 761221
Fax 01553 766534
Graphite, charcoal, colored and water-soluble pencils, blenders, brushes, Rotring pens, markers, and inks; drawing supports.

Chroma Colour International UK Ltd
Unit Pilton Estate
Pitlake, Croydon CR0 3RA
Tel 0208 688 1991
Fax 0208 688 1441
Web www.chromacolour.com
Chroma colors and accessories.

ColArt
Whitefriars Avenue
Wealdstone,
Harrow HA3 5RH
Tel 020 8427 4343
Fax 020 8424 3328
Wide range of art supplies.

Daler-Rowney
P.O. Box 10
Bracknell, Berkshire R612 8ST
Tel 01344 424 621
Fax 01344 860 746
Web www.daler-rowney.com
Wide range of art supplies.

Falkiner Fine Papers Ltd
76 Southampton Row
London WC1B 7AR
Tel 0207 831 1151
Fax 0207 430 1248
Specialist papers.

Global Art Supplies
Unit 8 Leeds Place
Tollington Park,
London N4 3QW
Tel 020 7281 2451
Fax 020 7281 7693
E mail mail@gas.demon.co.uk
Distributor of a wide variety of art supplies, including Genesis heat oils, and PH Martin, Fredrix, and Golden products.

Inscribe
Wollmer Industrial Estate
Bordon
Hants GU35 9QE
Tel 01420 475747
Fax 01420 489867
Wide range of art supplies, including oriental products.

Jakar International Ltd (Caran D'Ache)
Hillside House
2-6 Friern Park
London N12 9BX
Tel 020 8445 6376
Fax 020 8445 2714
Graphite, water-soluble, and pastel pencils; markers, fibertip pens.

Khadi Papers
Chilgrove, Chichester
West Sussex PO18 9HU
Tel 01243 535314
Fax 01243 535354
Handmade papers from India, Nepal, Bhutan and Thailand.

A Levermore & Co.
24 Endeavour Way
London SW19 8UH
Tel 020 8946 9882
Fax 020 8946 6259
Web www.levermore.co.uk
Oil sticks, stencils, staple guns.

Pentel (Stationary) Ltd
Hunts Rise,
South Marston Park,
Swindon, Wiltshire SN3 4TW
Tel 01793 823333
Fax 01793 820011
Watercolor paint, technical markers, fiber-tip pens, graphite pencils, chalk pastels.

C. Roberson & Co. (Schminke products)
1A Hercules Street
London N7 6AT
Tel 020 7272 0567
Fax 020 7263 0212
Oil, watercolor, and gouache paints; pastels.

Royal Sovereign Ltd
7 St Georges Industrial Estate
White Hart Lane
London N22 5QL
Tel 020 8888 6888
Fax 020 8888 7029
Pastels, colored inks, gouache, acrylic paints, markers, shapers, protective sprays.

Russel & Chappell
68 Drury Lane
London WC2E 5SP
Tel 020 7836 7521
Fax 020 7497 0554
Wide range of canvas supports.

St. Cuthberts Mill
Wells, Somerset BA5 1AG
Tel 0174 967 2015
Fax 0174 967 8844
Web www.inveresk.co.uk
Watercolor and pastel papers.

Swan Stabilo
645 Ajax Avenue
Slough
Berkshire SL1 4BG
Tel 01753 605656
Fax 01753 605657
Markers, fibertip pens.

The John Jones Art Centre Ltd.
The Art Materials Shop
4 Morris Place
Stroud Green Road
London N4 3JG
Tel 020 7281 5439
Fax 020 77281 5956
Web www.johnjones.co.uk
Wide range of art supplies.

Unison Colour
Thorneyburn
Tarset, Northumberland NE48 1NA
Tel 01434 240 203
Fax 01434 240 457
Soft pastels.

Winsor & Newton
Whitefriars Avenue, Wealdstone
Harrow, Middlesex HA3 5RH
Tel 0208 427 4343
Fax 0208 863 7177
Web www.winsornewton.com
General art supplies, including Liquitex products.

Index

Credits

Quarto would like to thank and acknowledge the following suppliers and retailers, who generously loaned samples of materials and equipment for use and photography: AP Fitzpatrick Fine Art Materials, Arts Encaustic, Berol Ltd., Chroma Color International Ltd., ColArt, D'Uva Litho Coals, Enkaustikos!, Falkiner Fine Papers, Flax Art & Design, Global Art Supplies, Golden Artist Colors, Inscribe, Jakar International Ltd., A. Levermore & Co, Pentel (Stationary) Ltd., Royal Sovereign Ltd., Russel & Chappell, St Cuthberts Mill, Swan Stabilo, Takach Press Corporation, Unison Colour, Utrecht Art Supplies, and Winsor & Newton.

Special thanks goes to Daler-Rowney Ltd., Bell Creative Supplies, and The John Jones Art Centre Ltd., for supplying the majority of the materials and equipment used in the photographs and demonstrations. We are especially grateful to Sandra Maudsley (Daler-Rowney Ltd.), Simon Wilson and Steve O'Brien (Bell Creative Supplies), Andy Milne (The John Jones Art Centre), and Michael Bossom (Arts Encaustic) for their time, advice, and assistance.

The following artists demonstrated the step-by-step sequences in the core techniques sections: Michael Bossom (encaustic), Liane Payne (monoprinting, relief printing), Charlie Fox (screenprinting), Elisabeth Harden (intaglio, lithography).

p76 Monoprint, woodcut, and linocut: Liane Payne;
p77 *left* Intaglio etching: Anne-Catterine Le Deunff; *middle* and *right* Lithograph and screenprint: Charlie Fox.